Voices of
German
Expressionism

)

Voices of German Expressionism

edited by

Victor H. Miesel

Tate Publishing

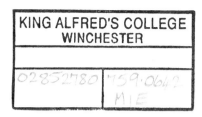
First published 1970 by Prentice-Hall, Inc.
This edition first published 2003 by order of the Tate Trustees
by Tate Publishing, a division of Tate Enterprises Ltd,
Millbank, London, SW1P 4RG
www.tate.org.uk

The publishers would like to thank the estates of the artists featured in this
volume for their kind co-operation in its reissue.

The publishers have made every effort to trace all the relevant copyright
holders. We apologise for any omissions that might have been made.

British Library Cataloguing in Publication Data
A catalogue record of this book is available from the British Library

ISBN 1 85437 481 8

Distributed in North America by Harry N. Abrams, Inc., New York

Library of Congress Cataloging in Publication Data
A catalog record of this book has been applied for

Cover design by Rose Design
Printed in Hong Kong by South Sea International Press Ltd

Contents

Contents

Contents

Preface

It is good news to have *Voices of German Expressionism* in print again. Despite more recent publications*, for those who want a conveniently concise overview not only of key documents, but also a suggestive sampling of creative writing by the major visual artists of German Expressionism, *Voices* should be welcome. The voices of these artists deserve to be heard directly with relatively little medium, if only because so many art lovers are still moved by their works. Moreover, abbreviated as the evidence provided by this anthology is, I hope it reveals that these visual artists have also created a literature that goes beyond the utility of the scholar's document or what booksellers would call "something with association interest". It is literature in its own right.

I also hope that the republication of Voices will encourage a new generation of anthologies of a similar format but greater bulk, works that have more generous extracts from the writings of those included and, more importantly, extracts from those excluded due to the inevitable constraints of a project of this size. The following is a short list of the much lamented missing: Lyonel Feininger, Wilhelm Lehmbruck, Paula Moderson-Becker, Gabrielle Münter, Alfred Kubin, Erich Heckel, Otto Mueller, Otto Dix, Egon Schiele.

Obviously more artists' voices need to be heard. In addition, surely anthologies more adventurous in selection and methodology than Voices would be useful and interesting. For example, Long and Rigby's inclusion of writings by Expressionist architects and city planners encourages one to propose translations of writings by those German photographers, film-makers, and poster and product designers who arguably could be called "Expressionists". Why not a rethinking of German Expressionism with anthologies that would "push the envelope" and "move outside the box"? After all, there seem to be so many uncanny parallels between our own era and the conventionally designated golden years (c.1900–33) of German Expressionism that few need feel uncomfortable about an experimental compiling of anthologies under rubrics evoking other-worldly, timeless "new-age" aspirations or, at the other extreme, rubrics that are a timely reflection of anguish over lifestyles, health, environment, and ethnic and sexual politics.

Let me cite just one example. Perhaps it would be instructive to hear from Hugo Hoppner (1868–1948), who was better known as

Fidus to the estimated ten per cent of German families owning at least reproductions of his works in the years between 1900 and 1940. Admittedly, many, if not most, art historians would prefer to call Fidus a "mere illustrator", a mediocre practitioner of Art Nouveau-style or *Jugendstil* kitsch. However, if one is willing to be respectfully mindful of the fact that most German Expressionists were fiercely serious, at least some of the time, about reforming and even revolutionising life (not just art), I suggest that we give some attention to Fidus and others like him. Consider his famous androgynous sun worshipper or his *Temple of the White Brotherhood,* or his celebration of the physical and spiritual uplift of nudism, pantheism, health-food, heroic even savage athleticism, tribal pride, ecstatic dance rituals, and – to quote from a particularly striking swastika emblazoned image – "SEXUAL RELIGION: I SEXUAL MYSTICISM, II SEXUAL MORAL PHILOSOPHY, III SEXUAL MAGIC".

In any case, I hope that republishing *Voices of German Expressionism* will contribute to a reanimated engagement with both the art and literature of Expressionism. Let me emphasise that the words of these visual artists speak eloquently in many voices about many things. We sometimes hear sweet reasonableness, and sometimes delirious clamour about technical matters, art theory, socio-political matters, the nature and destiny of man, apocalyptic visions and much more. A number of these artists liked and needed to write. Many kept journals most of their life. A few wrote poetry and others wrote dramas that ranged from cabaret skits to quasi-religious total-art productions. Their concerns and their enthusiasms are still very much part of our life today.

VICTOR H. MIESEL, February 2003

* Such as Rose-Carol Washton Long, Ida Katherine Rigby (eds.), *German Expressionism: Documents from the End of the Wilhelmine Empire to the Rise of National Socialism,* University of California Press, 1995.

Introduction

I

This anthology consists of essays, letters, dramas, and poems relating in different ways to the revolutionary art produced in Germany from 1900 to 1933. Usually called "German Expressionism," this art was created during one of the most crucial periods in world history by a generation that was also responsible for revolutions in music, literature, science, and politics.

At the outset it should be emphasized that the items in this anthology have not been selected in order to define a single Expressionist style or attitude. On the contrary, the main purpose of this book is to permit artists, along with a few critics, to demonstrate in their own words individual points of view, points of view which not infrequently changed with changing social and political conditions.

The Expressionist movement in the visual arts began in Germany during the first decade of the twentieth century, when young artists in Berlin, Vienna, Munich, and Dresden rejected both classical and realist doctrines. The movement developed rapidly and reached a high-water mark of influence during the years immediately preceding and following World War I. Styles within the movement ranged from the representational to the nonobjective, but all shared a common determination to subordinate form and nature to emotional and visionary experience. In this sense all the Expressionists were the direct heirs of Vincent Van Gogh and Edvard Munch. Years before, Van Gogh had insisted that the artist's real task was to interpret "fundamental emotions like joy, sorrow, anger and fear." All Expressionists agreed. And the experience which Munch described back in 1889 was one which every Expessionist understood:

> One evening I was walking along a path. On one side lay the city and below me the fjord. I was tired and ill. I stopped and looked out across the fjord. The sun was setting. The clouds were died red like blood. I felt a scream pass through nature; it seemed to me that I could hear the scream. I painted the picture—painted the clouds as real blood— the colors were screaming. This became the picture *The Scream* from my *Frieze of Life*.

Emotional needs, psychological pressures, and private obsessions are

everywhere apparent in the work of Expressionists. But their artistic intentions were not limited to catharsis and self-revelation. Expressionists as different as Kandinsky and Kokoschka agreed that art should be didactic or diagnostic, that it should somehow improve the world. Writing about Munch, Kokoschka observed: "He kept his eyes wide open, his gaze reached into our time of transition, into our most intimate self where fear lodges in our hearts. . . . The concern is, after all, with the question of insight into the problem of our society; anything that does not lead to its solution has become senseless." * Interestingly enough, Kokoschka attacked Kandinsky in the same article because the latter's abstractions were so unlike Munch's painting and therefore diametrically opposed to the true function of Expressionism as an art of communication and revelation. Nevertheless, Kandinsky's awareness of art's responsibility to society and of its significance as a cultural force was fully equal to Kokoschka's. The following is only the most famous of Kandinsky's many remarks on the subject:

> When religion, science, and morality are shaken (the last by the strong hand of Nietzsche) and when outer supports threaten to fall, man withdraws his gaze from externals and turns it inwards. Literature, music, and art are the most sensitive spheres in which the spiritual revolution makes itself felt. They reflect the dark picture of the present time and show the importance of what was at first only a little point of light noticed by the few.†

Little wonder, then, that Expressionists became involved not only in social protest but also in revolutionary programs, programs which sometimes resulted in the complete transformation of their art. Indeed, the social and political involvement of Expressionism was crucial; thus, this anthology includes, in addition to artist's manifestoes, several essays by nonartists and even anti-Expressionists on the relationship of the movement to socialism, communism, and Nazism. Expressionists never subscribed to the idea of art for art's sake so popular with the French avant-garde. They were as much in revolt against

* Oskar Kokoschka, "Edvard Munch's Expressionism," *College Art Journal,* I (1953), 17.
† Wassily Kandinsky, *Concerning the Spiritual in Art,* The Documents of Modern Art (New York: George Wittenborn, Inc., 1947), p. 33. Reprinted by permission of the publisher. First published: *Über das Geistige in der Kunst* (München, 1912).

Art Nouveau or *Jugendstil* aestheticism, in spite of its expressive distortion, as they were against classicism and realism. Whether their efforts were filled with neurotic anguish or ecstatic spirituality they wanted at all costs to reach out beyond their individual egos and beyond their art to establish contact with mankind, life, and even God. It was an ambition which looked back to the Middle Ages as a time when the artist was supposedly an anonymous craftsman serving the people. It was also an ambition which anticipated both Dada disgust with art and communist advocacy of socially responsible "production art." Whatever formal innovations Expressionists cultivated they never tired of insisting that these were the direct result of their desire to communicate. So intense was this desire that many Expressionists refused to limit themselves to only one means of expression. Kokoschka, Barlach, Kandinsky, Klee, and Meidner either wrote plays, poetry, theoretical treatises, or all three. (Feininger composed music.)

Of course, Expressionists recognized the dangers of dilettantism and especially the danger of mixing literary and visual approaches. Several selections in this anthology indicate their concern for technical and formal improvement. Yet, in the final analysis few would have disagreed with Klee (who was second to no one in his tireless study of techniques and forms) when he wrote as a private credo: "First of all the art of living, then as my ideal profession poetry and philosophy, and finally as my real profession art."

II

German Expressionism was never a unified movement. In the visual arts two distinct groups became famous: *Die Brücke* ("The Bridge") and *Der Blaue Reiter* ("The Blue Rider"). The first was formed in Dresden and included Ernst Ludwig Kirchner, Erich Heckel, Karl Schmidt-Rottluff, Max Pechstein, and Emil Nolde (see the introduction to Part One, *"Die Brücke"*). The second originated in Munich in 1912 and its most prominent members were Wassily Kandinsky, Franz Marc, August Macke, and Paul Klee (see the introduction to Part Two, *"Der Blaue Reiter"*). However, neither group lasted very long and by 1913 both had been dissolved. Meanwhile, in Berlin in 1910 Pechstein helped organize the *Neue Sezession* ("New Secession") to protest against the reactionary policy of the once liberal Berlin *Sezession*. *Brücke* and *Blaue Reiter* painters, Expressionists and non-Expressionists exhibited with the New Secession. Even

broader was the composition of yet another Berlin group, *Der Sturm* ("The Storm"). So-called *Sturm* artists had in common primarily the fact that their work was exhibited in the gallery by that name opened in 1912. German Expressionists, French Cubists, Italian Futurists, and Russian Constructivists all could be called *Sturm* artists, and all seemed to be considered "Expressionists" by the gallery's guiding light Herwarth Walden.* After the war Expressionists were found in revolutionary action groups, at Dada demonstrations, and as professors not only at the Bauhaus but at state academies throughout Germany. And today, Max Beckmann, once closely associated with the avowedly anti-Expressionist *Neue Sachlichkeit* ("New Objectivity") movement of the 1920s, is hailed as one of Expressionism's greatest masters.

At this point it must be admitted that the term "Expressionism," like many important terms in the history of art, is a troublesome one. Furthermore, almost all Expressionist artists at one time or another maintained that their art should *not* be called "Expressionist."

The word itself (*expressionisme*) is French, not German, and the idea of "self-expression" was developed in France, first in the studio of Gustave Moreau and then by his most gifted student Henri Matisse. In 1905, Matisse and others (Derain, Vlaminck, Braque) shocked the French public with their relatively violent use of color and brushwork. They were at once nicknamed *"Fauves"* ("Wild Beasts"). Later they were sometimes called Expressionists, but by that time the term was so Germanic that it seemed unsuitable for painters who were so "French," i.e., so tasteful, sensuous, and gay.

Actually, the word was not introduced into Germany until about 1911, and then not for German artists but for younger French painters like Vlaminck, Braque, and Picasso. Nevertheless, in spite of initial opposition from critics and continuing protests from artists the German public found the term irresistible. In 1912, it was given particular prominence at the gigantic and influential Cologne Sonderbund exhibition. The catalog stated:

> The intention of this year's fourth exhibition of the Sonderbund is to present a survey of the latest movement in art, that movement which appearing after atmospheric naturalism and impressionism simplifies and intensifies expressive shapes and strives for a new rhythm and use of

* Herwarth Walden (Georg Levin, 1878–1942?). Publisher, writer, composer, and aggressive advocate of modernism, he founded the periodical *Der Sturm* and *Sturm* Gallery to further the cause of the avant-garde in Germany.

color in terms of decorative and monumental forms, that movement in other words which has been called Expressionism.

At the Sonderbund, Van Gogh, as might be expected, was singled out for special honor—115 of his paintings were hung. Gauguin, Cézanne, as well as younger modern masters from Munch to Picasso were also well represented. And what is most important for our topic, Germans were included. Huge murals by Kirchner and Heckel decorated the exhibition chapel and thanks to their size and location they received prime attention at the show.

After this event German writers quickly transformed Expressionism into an elastic concept comprising an anticlassical, antirational, and finally anti-French outlook, a mystical and a revolutionary world view embracing painters, sculptors, architects, composers, dramatists, poets, even whole periods, races, and cultures. The prehistoric and Romanesque periods, Nordic and Negro races became "Expressionistic." Essentially, however, the word was changed into something German for Germans. It was framed by ideas like *"Kultur," "Geist," "Reich,"* and *"Volk,"* ideas which had a special significance for Germans since they all pertained to a widely-held ideal of divinely sanctioned national character and destiny.

III

By 1918, the concept of "Expressionism" had mushroomed from a modest French studio idea into a rallying cry for German aspirations. Indeed, many of the items in this anthology indicate that Expressionists, irrespective of their opinions about "Expressionism," shared not only certain aesthetic assumptions but the concerns and ambitions signified by the broadest possible definition of that word. They frequently made common cause with all those who, starting with a hatred for the philistinism of Kaiser Wilhelm II and the materialism of German society, ended by challenging the entire development of postmedieval Europe. This passionate dissatisfaction is sometimes called "Faustian" after the hero of Goethe's drama *Faust,* a man whose limitless ambition was both his damnation and salvation.* More to the point, it can be linked to the criticism of modern life which de-

* The German historian Oswald Spengler deserves most of the credit, or blame, for popularizing the "Faustian" concept. See his remarkably influential *Decline of the West (Der Untergang des Abendlandes)*, which was written during the heyday of Expressionism, 1913–18.

veloped throughout Europe during the second half of the nineteenth century. The German Nietzsche, the Russian Dostoievsky—as well as French, Italian, and English thinkers—despised their age. For that matter, some of the most dramatic gestures of dissent came from Frenchmen—from Gauguin, who repudiated Europe in favor of Tahiti, to Rimbaud, who gave up art (in his case, poetry) at the age of nineteen and moved to Africa.

All Europe was in a state of ever-increasing discontent. Rapid industrialization and urbanization, such revolutionary discoveries as Freud's theory of dreams (1900) and Einstein's theory of relativity (1905), a succession of political crises: these were events which filled Europeans everywhere with apprehension. Nowhere, however, was the reaction more intense than in Germany, where anxiety about the future developed into extremes of utter despair and wild expectation. As a part of this excitement, Expressionism emerged and flourished. And as a climax to this excitement, Nazism triumphed.

Actually, the Nazis and the Expressionists belonged to the same generation, a generation which not only suffered from certain cultural traditions of long standing but which suffered through a period of extraordinary national disruption as well. The heritage of Christianity, classical humanism, and the Enlightenment had been systematically discredited by nineteenth-century German intellectuals. In place of these traditions there appeared a combination of nature mysticism and racism which in some circles became a new religion, a German religion.* Concrete historical factors underlay the development of this new faith of course, and facilitated its subsequent graduation into the state religion of the Third Reich.

For one thing, the history of Germany between 1870 and 1918 was marked by extremes of unprecedented success and failure. In 1870, an easy victory over France had apparently changed Germany, al-

* One of the key ideas of this new faith was *"Volk,"* a word which connoted much more than "folk," "people," or "nation." *"Volk"* signified the union of a people in terms of a transcendental essence, something which pervaded the cosmos and involved the individual's innermost being as well as his ties to nature, history, and his fellow man. This idea became so much a part of German thought that it was used by Nazi and anti-Nazi alike. Thus, when Paul Klee (who was most certainly neither a Nazi nor a racist) complains about the plight of the modern artist—"No *Volk* supports us,"—he is not complaining about a lack of popular or national patronage. He is talking about something infinitely more serious, the alienation of the artist from a major link with the life force and the higher meanings of the universe.

most overnight, from a semifeudal collection of principalities into a nation-state and world power. Yet, in less than 50 years, not only were the German Empire and her "sister," the Austrian Empire, destroyed, but Germans in the midst of defeat and poverty were expected to adjust to a republican form of government. In a sense, however, the German Empire had been defeated before World War I ever broke out. As an instrument of political and economic power it may have been formidable, but to idealistic Germans the Empire, conceived as an embodiment of Divine Order, was a terrible disappointment. When war broke out Germans were at odds with each other: socialist workers versus the middle classes, youth groups versus their elders, Protestants versus Catholics, Prussians versus Bavarians. The masses probably supported the war less out of love for the Empire than out of the conviction that it was a defensive war against French revenge and Russian tyranny. Many intellectuals, it is true, welcomed the war, but not as a means to preserve or extend the Empire. Some had been looking forward to war for years, but purely out of an idealistic conviction that some catastrophe was absolutely necessary for the regeneration of a corrupt Germany. Thinkers and artists felt that they could no longer endure the degradation of modern life, that condition described in Kafka's *Metamorphosis* and Musil's *The Man Without Qualities*. Thus, when war broke out the author Stephen Zweig recorded: "Each individual experienced an exaltation of his ego, he was no longer the isolated person of former times, he had been incorporated into the mass, he was part of the people [*"Volk"*] and his person, his hitherto unnoticed person had been given meaning!" Numerous letters from students who were front-line soldiers testify to this feeling. Some went on to insist that they would prefer a defeat with purification and regeneration to a victory which would preserve the old regime. The Expressionist painter Franz Marc stressed in his letters from the front that the war was nothing if not a moral experience, a form of penance, a preparation for a breakthrough to a higher spiritual existence.

One should remember that the Expressionists belonged to the "war generation," and that the majority of them served in the army. Furthermore, the success of Expressionism was a kind of war phenomenon. It came in two waves, the first just before the outbreak of hostilities and the second after Germany's disastrous defeat. However, few Expressionists were patriots in the conventional sense and some were

very aggressive pacifists from the very beginning of the war. By 1916, none of them would have disputed the moral of Erich Marie Remarque's *All Quiet on the Western Front*—that war assured not the victory of the spirit over matter but its opposite, the annihilation of all spiritual values and the complete triumph of the soul-killing mechanism of modern technology.

These tragic events made nihilists out of many Germans. But Expressionists, with amazing resiliency, refused to give up. They welcomed the Russian Revolution (1917) and the German Revolution (1918). They were prepared in every respect to start anew. They acted as if the longed-for breakthrough had finally occurred and they were at last beginning to shape a new and better world. But, as everyone knows, the Third Reich, the new Germany, was not to be shaped by Expressionist poets and painters. As a matter of fact, by 1920 critics claimed that Expressionism was dead.

Walter Sokel, in his excellent study of German Expressionist drama, has formulated the demise of the movement as follows:

> German Expressionism sought to be two things in one: a revolution of poetic form and vision and a reformation of human life. These two aims were hardly compatible. As a part of the stylistic revolution of modernism, Expressionism was too difficult and *recherché* to serve its didactic and proselytizing ambitions. . . . The ideal of the "new man" clashed with the ideal of the "new form," and each interfered with and diluted the other. . . . Shortly after 1920 the goals of Expressionism—attachment to an objective reality and free creation of a surreality—appeared distinct and irreconcilable. The ethical and the aesthetic wings of Expressionism divorced and this divorce spelled the end of the movement.*

However, if one studies the visual arts, a case can be made for the idea that the Bauhaus, the most radical and also most effective art school in the world during the 1920s, was at least partially a realization of Expressionist ambitions. In spite of major shifts of emphasis during its fourteen-year history, with Feininger, Klee, and Kandinsky on its faculty, the Bauhaus continued to foster the "two things in one" —formal revolution *and* human reformation—which Sokel defined as the aims of Expressionism. It is tempting to suggest that Germany faced a choice during these years between a national revival inspired by the creative idealism of the Bauhaus and one inspired by the

* Walter Sokel, *The Writer in Extremis* (Stanford: Stanford Univ. Press, 1959), p. 227f. Reprinted by permission of the publisher.

hatred and resentment of nihilists. That she chose the latter seems less the fault of artists than the responsibility of "practical" men of affairs, businessmen, and generals.

Opinions in this anthology vary concerning the connection between Expressionism and Nazism (see Part Six, "Expressionism and the Third Reich"). However, the fact remains that the Nazi party condemned the whole movement as degenerate. It is also a fact that very few Expressionists of any note were ever attracted to the party. On the contrary, Ernst Kirchner might have been speaking for the vast majority of Expressionists when he wrote in 1938: "Events in Germany have deeply shocked me and yet I am proud that those brown-shirted iconoclasts [Nazis] are also attacking and destroying my pictures. I would feel insulted if that kind tolerated me."

IV

In retrospect, it is obvious that Expressionism was not a uniquely German phenomenon. It was part of a general upheaval which affected every sector of life in every modern nation of the world. Rouault's paintings, Stravinsky's early music, some of Eugene O'Neill's dramas, much of Picasso's art can be called Expressionistic. Moreover, Germans were receptive to every latest artistic development no matter what its national origin. Walt Whitman's poetry inspired the painters of the *Brücke*. The *Blaue Reiter* welcomed as members artists of all nationalities. And no German ignored French art! At Matisse's art school Germans were outnumbered only by Scandinavians. Nevertheless, we have seen that the concept of Expressionism took on an overwhelmingly Germanic connotation. To be sure, German critics developed and publicized the idea. But, more importantly, it was in Germany between 1900 and 1920 that subjectivity and emotionalism *in all the arts* became more widespread and accepted than anywhere else.

In music, furious outbursts of Expressionism occurred in Richard Strauss' operas *Salome* (1905) and *Electra* (1909). Incidentally, both works made their debuts in Dresden, the home of the *Brücke* group. More shocking than Strauss' music were the compositions of the Viennese composer Arnold Schönberg. Believing that traditional harmony hampered his self-expression he abolished it, and the atonality of his Opus 11, "Three Piano Pieces," (1908) was a landmark in the history of modern music. Still dissatisfied, he continued to strive for greater

expressive power. In "The Lucky Hand" (*"Die Glückliche Hand,"* 1913) he reinforced the emotional impact of dissonance with spectacular displays of colored light. Schönberg stated that he felt himself to be the slave of some internal power and that he wrote only what he felt in his own heart. Indeed, his whole conception of art was Expressionistic: "A work of art can achieve no finer effect than when it transmits to the beholder the emotions that raged in the creator in such a way that they rage and storm in him." * Schönberg for that matter had close ties with Expressionist painters. A good friend of Kandinsky, he did some painting himself and even exhibited with the *Blaue Reiter* group in Munich. Later he was invited to teach at the Bauhaus, but unfortunately declined the offer.

Expressionist characteristics also appeared in Gustav Mahler's music, in his symphony no. 8 (1908), for example, and in compositions by Alban Berg—especially the orchestra pieces written between 1913–1914. Indeed, Berg's opera *Wozzeck* (1925) is considered by some to be one of the masterworks of Expressionism in music.

Expressionist points of view also dominated German drama and poetry during the first two decades of the twentieth century. Plays were written and performed which violated convention in every respect. The stage became an arena for grotesque and violent situations, dream sequences, and symbolic action. The syntax and logic of language were disrupted. Unreal settings, fantastic costumes, and exaggerated acting techniques were developed. Some plays involved proposals for the world's redemption (for instance, Reinhard Sorge's *The Beggar,* 1912); some were powerful parodies of the world's insanity (e.g., Bertold Brecht's *Baal,* 1918); others had a prophetic function (e.g., Georg Kaiser's *Gas I,* 1918 and Ernst Toller's *Masses and Man,* 1919). Such dramas transformed the theater into a place of explosive revelation and mystical enlightenment. The plays of the painter Kokoschka and the sculptor Barlach were very much a part of Expressionist theater; while the ideas of Kandinsky in this area, although not immediately influential, are the most revolutionary of all (see *The Yellow Sound,* 1909, in Part Four of this anthology).

Among outstanding Expressionist poets can be mentioned Jakob van Hoddis and Alfred Lichtenstein. Hoddis' poem *The End of the World* and Lichtenstein's *Twilight,* both written in 1911, have been

* It is worth noting that in Thomas Mann's *Dr. Faustus* the musical ideas of the Expressionist hero Adrian Leverkühn were all taken from Schönberg.

credited with beginning the German Expressionist movement in poetry with their apocalyptic subjects and disconnected imagery. Other poets in the movement were Gottfried Benn, Else Lasker-Schüler, Franz Werfel, Georg Trakl, and Georg Heym. Heym's masterpiece *Umbra Vitae* (1912), incidentally, so impressed Kirchner that he did a series of woodcuts in honor of it. These poets and painters frequently expressed great admiration for each other's work; their themes and their styles complemented each other.* And on occasion friendships, one might almost say "Expressionist friendships," developed, as for example in the case of Franz Marc and Else Lasker-Schüler.

Most Expressionist literature was published in avant-garde periodicals, yearbooks, and anthologies. The editorial policies, the format, and even the names of these publications added to the emotional force of the literature. And furthermore, many of these periodicals also featured illustrations or independent graphic work by Expressionist artists. The journal *Die Aktion,* founded in 1910 by the political activist Franz Pfemfert, and the journal *Der Sturm,* also founded in 1910 by the musician-poet-publicist Herwarth Walden, were pioneers in Germany of this kind of "united front" of revolutionary, political, and cultural activity. Scores of publications followed their example. A sampling of their titles almost reads like a definition of Expressionism: *The Cry, The New Pathos, Revolution, New Youth, Salvation, Joy,* and *Bankruptcy.* On the pages of such periodicals the latest works by poets, painters, and intellectuals reinforced each other: poems by Heym and Benn, essays on art by both artists and art historians (e.g., Wilhelm Worringer†), articles by leading architects like Adolf Loos and Bruno Taut, pieces by novelists Heinrich and Thomas Mann as well as by revolutionaries Karl Liebknecht and Rosa Luxemburg, and, last but not least, prints by Feininger, Heckel, Klee, Kokoschka, and many others.

It has already been stated that Expressionists hoped to transcend both the individual artist and art itself. That is, the artist conceived as a genius cut off from the "common herd" and art as a precious object to be enshrined in a museum. Insofar as they hoped to realize this

* E.g., Else Lasker-Schüler wrote a poem about George Grosz; Grosz dedicated a picture to Gottfried Benn.

† Worringer (1881–1965) was one of the few art historians admired by the Expressionists, especially those of the *Blaue Reiter.* His books and articles, especially *Abstraction and Empathy (Abstraktion und Einfühlung,* 1907), greatly influenced Expressionist theories of art.

ambition as part of the reformation of an entire nation, their failure was both spectacular and complete. Some Expressionists hoped at least to surpass Wagner in the creation of a truly all-encompassing art form, a *Gesamtkunstwerk*. They also failed. There is no Bayreuth for Expressionism, certainly not in the sense of a place dedicated to the festive and ritualistic display of an Expressionistic *Gesamtkunstwerk*. There was the Bauhaus, though, which brought painters, craftsmen, and architects together into a kind of collective creativity. But the fanciful notion that the Bauhaus itself be identified as the *Gesamtkunstwerk* of German Expressionism would probably be rejected by too many people. Perhaps Expressionist periodicals and yearbooks qualify for the honor? Nowhere else did the efforts of Expressionists combine to such good effect. Their appeals, attacks, and crys of pain, anger, and love seem least pretentious and most convincing within the modest yet public space of a periodical page. Neither the great spaces of a museum nor the intimacy of a limited edition seems quite right for their message. To be sure, their art was "Faustian" and visionary but it was also very much a part of that life which a periodical signifies— the passing scene, current affairs, and issues of immediate concern.

In any case, it is hoped that as one reads the writings of German Expressionist artists in this anthology, the range and depth of their thought are appreciated. The reader will discover that most of them do not speak as eccentric and crazed "geniuses" but as intelligent and responsible individuals determined to respond constructively to a world drifting into chaos.

Die Brücke

Die Brücke ("The Bridge") was the first of those German associations which were later classified as "Expressionist." It was organized in Dresden in 1905 by Ernst Kirchner, Erich Heckel, and Karl Schmidt-Rottluff; among other artists who subsequently joined were Emil Nolde, Max Pechstein, and Otto Müller. Essentially it was conceived as an international, revolutionary youth group dedicated to cultural progress. The opening sentences of its manifesto (written by Kirchner in 1906) made the following appeal:

> Putting our faith in a new generation of creators and art lovers we call upon all youth to unite. We who possess the future shall create for ourselves a physical and spiritual freedom opposed to the values of the comfortably established older generation. Anyone who honestly and directly reproduces the creative force that is within him is one of us.

In comparison to the Blaue Reiter, however, Brücke artists were less cosmopolitan and, in their art, less revolutionary. Their links to older "Nordic art"—Dürer, Grünewald, and Rembrandt seemed especially important to them—and their styles always remained representational. Nevertheless, using ideas from Van Gogh, Munch, Fauvism, and Cubism, they created images which effectively conveyed modern psychological and social realities. Their favorite theme was the human figure in relationship to either nature or urban life. Some of their best work took the form of prints, especially woodcuts, which conveyed with brutal power their various passionate concerns—religious, political, and sexual.

Ernst Ludwig Kirchner

Born 1880 at Aschaffenburg, Germany. Died in 1938 at Davos, Switzerland, a suicide. Studied architecture in Dresden 1901–1905 and painting in Munich 1903–1904. Co-founder of *Brücke* 1905, Dresden. Moved to Berlin 1911. In the army 1914–15; discharged after physical and mental collapse. Moved to Davos, 1917. Member of the Prussian Accademy of Fine Arts 1931, but expelled by Nazis in 1937.

Kirchner was the most gifted painter and printmaker of the *Brücke* as well as its principal spokesman. His expressionist style, like that of many of the other members (Nolde is the most important exception), developed from a curvilinear "soft manner" into a harshly angular and nervously spiky "hard style."

Kirchner may be credited not only with writing the first statement for the *Brücke,* its manifesto of 1906, but also with its last: "The Chronicle of the *Brücke,*" 1913.* Shortly after this little history was written the association disbanded with most of the membership upset by Kirchner's chronicle. Although it doubtlessly is biased—Kirchner was always much too sensitive about his own reputation—the account nevertheless remains a very important personal document.

The three letters, 1916–1919, were written during years which were extremely difficult for Kirchner.† In 1915, after a complete breakdown, he was discharged from the army; two years later, virtually an invalid, he left Germany for Switzerland, where he sought refuge not just from the war but from

* "The Chronicle of the *Brücke*" was privately printed. Only a few copies still exist. The original German version, "Chronik der *Brücke,*" can be found in J. K. Roethel, *Moderne deutsche Malerei* (Wiesbaden, 1957). Copyright by Roman Norbert Ketterer, Campione d'Italia. Translated for this volume by the editor with permission of Roman Norbert Ketterer.

† See *Maler des Expressionismus in Briefwechsel mit Eberhard Grisebach* (Hamburg, 1962), pp. 53f, 76f for letters no. 1 and no. 2, respectively. For letter no. 3 see *Briefe an Nele und Henry Van De Velde* (München, 1961), pp. 19–22. Copyright by Roman Norbert Ketterer, Campione d'Italia. Translated for this volume by the editor with permission of Roman Norbert Ketterer.

modern civilization in general. There he lived for the rest of his life, almost like a hermit, in a futile attempt to win back his health.

Kirchner also wrote a number of essays about his own work. Among the most carefully thought out of these were two published under his pen name Louis de Marsalle: "Drawings by E. L. Kirchner" and "Concerning Kirchner's Prints." * Neither essay is particularly expressionist in tone. Instead they demonstrate how much systematic, disciplined effort any art—expressionist art not excepted—requires in order to be effective.

"The Chronicle of the Brücke" (1913)

In 1902 the painters Bleyl † and Kirchner got to know each other in Dresden. Heckel joined them thanks to his brother, who was a friend of Kirchner. Heckel brought along Schmidt-Rottluff, whom he had known back in Chemnitz. They all worked together in Kirchner's studio. Here they had the opportunity to study the nude, the basis of all visual art, freely and naturally. Based on such drawing a mutual feeling arose that only life should provide inspiration and that the artist should subordinate himself to direct experience. Each man drew and wrote his ideas one next to the other, in a book "Odi profanum" ‡ and in this way their individual qualities were collated. Thus, they developed naturally into a group which came to be called "Brücke." Each stimulated the other. From southern Germany Kirchner brought the woodcut which he revived under the stimulus of old prints in Nürnberg. Wooden figures were once more carved, now by Heckel; while Kirchner enriched this technique by using polychromy in his own work, he also sought the rhythm of closed form in stone and

* Louis de Marsalle, "Zeichnungen von E. L. Kirchner," *Genius* (Munich, 1926), pp. 217–34; and "Über Kirchners Graphik," *Genius* (Munich, 1921), pp. 250–63. Copyright by Roman Norbert Ketterer, Campione d'Italia. Translated for this volume by the editor with permission of Roman Norbert Ketterer.

† Fritz Bleyl. He generally remained aloof from *Brücke* projects. In 1909, he resigned to become a teacher of architecture.

‡ Unfortunately, this book has disappeared. The title was taken from Horace's ode *Contentment*, which starts *"Odi profanum vulgus"*—"I hate the common herd. . . ."

pewter. Schmidt-Rottluff made the first lithographs on stone. The first
exhibition of the group was held in its own rooms in Dresden; people
ignored it. However, Dresden's old culture and the charm of its land-
scape provided much stimulus. Here the *Brücke* also found its first art
historical support—Cranach, Beham and other German masters of the
Middle Ages. On the occasion of an exhibit by Amiet in Dresden he
was made a member of the *Brücke*. Nolde followed him in 1905.* His
fantastic individuality gave a new trait to the *Brücke*. He enriched
our exhibitions with his interesting etching technique and learned
about woodcuts from us. On his invitation Schmidt-Rottluff visited
him at Alsen. Later Schmidt-Rottluff and Heckel went to Dangast.
The harsh air of the North Sea induced especially Schmidt-Rottluff to
develop a kind of monumental impressionism. Meanwhile, in Dresden
Kirchner continued his closed compositions; he discovered a parallel
to his own work in Negro sculpture and South Sea beam carvings in
the ethnographic museum. The intense desire to free himself from
academic sterility led Pechstein to the *Brücke*. Kirchner and Pechstein
went to Gollverode to work together. The exhibition of the *Brücke*
with its new members took place in the Salon Richter, Dresden. This
exhibition greatly impressed the young artists of Dresden. Heckel and
Kirchner wanted to relate the exhibition space to the new painting.
Kirchner decorated the rooms with murals and batiks on which Heckel
had also worked. In 1907 Nolde left the *Brücke*. Heckel and Kirchner
went to the Moritzburg lakes in order to study the nude in the open
air. In Dangast Schmidt-Rottluff worked to complete his color rhythm.
Heckel went to Italy and brought back the stimulus of Etruscan art.
With a commission to paint decorations Pechstein went to Berlin.
He attempted to bring the new painting into the Secession.† In Dres-
den Kirchner discovered how to print lithographs by hand. Bleyl, who
had become a teacher, left the *Brücke* in 1909. Pechstein joined Heckel
in Dangast. In the same year both men joined Kirchner at Moritzburg
in order to paint nudes at the sea shore. In 1910 the New Secession
was formed after younger German painters were rejected by the old
Secession. In order to support Pechstein's position in the New Seces-
sion, Heckel, Kirchner, and Schmidt-Rottluff also became members.

* The date should be 1906.
† The Secession (Berlin) was organized by German Impressionists (after a con-
troversy involving Munch's art in 1892) in order to protest the conservative policies
of academic artists. After a decade it too became somewhat reactionary.

In the first exhibition of the New Secession they got to know Müller.*
In his studio they saw Cranach's Venus, which they themselves had
always admired. The sensuous harmony of his life and work made
Müller a natural member of the *Brücke*. We were fascinated by his
distemper technique. In order to keep *Brücke* efforts pure the mem-
bers of the *Brücke* left the New Secession. They promised each other
that they would only have joint exhibits in the Secession. Following
this there was an exhibit of *Brücke* work which filled the whole Gurlitt
gallery, Berlin. Pechstein betrayed the group by becoming a member
of the Secession, and he was expelled. The *Sonderbund* invited the
Brücke to its Cologne exhibit in 1912 and commissioned Heckel and
Kirchner to decorate the chapel there. The majority of the members
of the *Brücke* is now in Berlin. Here also the *Brücke* preserved its
intrinsic character. Inwardly unified, the group radiates its new crea-
tive values out over all modern art work in Germany. Uninfluenced
by contemporary movements, cubism, futurism, etc., it fights for a
humane culture which is the basis of true art. The *Brücke* owes its
present-day position in art to these efforts.

Three Letters

Jena, Sept. 21, 1916

Dear Botho,†

As you know, I was born in Aschaffenburg. As a child I was always
at the window drawing what I saw, women with baby carriages, trees,
trains, etc., etc. Later we moved to Frankfurt and I added the huge
railroad station which was then under construction as well as the ani-
mals and people on the street and in the zoo. I was also impressed by
the art in the Frankfurt museum, the pictures of Grünewald's school.
Old sculptures and foreigners in the zoo. From Frankfurt we moved
to Switzerland with its huge mountains, its cows and pastures and
stony paths. And from there to Chemnitz, where my artistic develop-
ment was interrupted. It was not resumed until the last year of secon-
dary school, when I decided to be a painter. I went to Dresden and

* Otto Müller (1874–1930) joined the *Brücke* in 1911 and was one of its most
active members. After service in the army he became a teacher at the Breslau
Academy.

† Botho Graef, an archaeologist and art historian at the University of Jena.

there I discovered parallels to my own work in rafters from Palau and in Negro sculpture and in the ornament of the feathered cloaks of the South Seas. Went then to Munich and there, as at Dresden, I pretended to study architecture since my parents did not want me to be a painter. Thanks to a friend I made innumerable anatomical studies and drew many nudes, both in my studio and during the evening in night school. I worked with Debschitz and someone else whose name I've forgotten. There Dürer, Rembrandt, and the Dutch were influential, particularly on my drawing. I also made my first woodcuts and etchings here. Then, back to Dresden. There by chance I discovered Senefelder's book on lithography and successfully made my first lithos on stone all by myself. Years went by as I continued my studio study, mostly drawing on the streets, in city squares and in cafes. I attempted to translate these drawings into pictures. Technically, I first used thick oil colors, then in order to cover larger surfaces I applied the colors more thinly with a painting knife, and then I used benzine (my secret for the mat finish) with a wax additive. Every day I studied the nude, and movement in the streets and in the shops. Out of the naturalistic surface with all its variations I wanted to derive the pictorially determined surface. This is why I rejected academically correct drawing. Old masters like Cranach and Beham supported me in this effort. When the simple two-dimensional surface was purified I began shading the surface in order to enrich the composition, first with black and white, nowadays with other colors. At the same time I gained a deeper understanding of human psychology by getting to know my subjects better as human beings. I never had real models in the academic sense. Of course, you have quite a bit of private information about all this. Then, with insight into the limits of human interaction, I undertook the withdrawal of the self from itself and its dissolution within the other person's psyche for the sake of a more intense expression. The less I was physically involved, something which quickly occurred as a result of my mood, the more easily and completely I entered into and depicted my subject. My technique kept pace with this inner development until my induction into the army made me afraid of people and revealed new things to me in landscape. Today I can't think of anything more to tell you. Besides, you know quite a bit from talks we've had and also from the notes I made on those photos which I left with you in Halle. In addition I'm sending you more photos.

Perhaps I will be able to see you in Halle day after tomorrow. In a couple days I'm going to Berlin. All my best.

Your faithful friend E. L. KIRCHNER

Kreuzlingen, December 1, 1917.

Very Honored Herr Doctor,*

Many thanks for your friendly letter. I have already written off Herr von Sydow.† He lectures about "Expressionism" and false catchwords like these irritate me. What you write about art, and creation in general, is easy for me to understand. I also understand what you mean about the artist and philosopher creating their own world. Actually, such a world is only a means of making contact with others in the great mystery which surrounds all of us. This great mystery which stands behind all events and things (sometimes like a phantom) can be seen or felt when we talk to a person or stand in a landscape or when flowers or objects suddenly speak to us. We can never represent it directly, we can only symbolize it in forms and words. Think of it, a person sits across from us and we talk, and suddenly there arises this intangible something which one could call mystery. It gives to his features his innate personality and yet at the same time it lifts those features beyond the personal. If I am able to join him in such a moment, I might almost call it ecstasy, I can paint his portrait. And yet this portrait, as close as it is to his real self, is a paraphrase of the great mystery and, in the last analysis, it does not represent a single personality but a part of that spirituality or feeling which pervades the whole world.

I don't know whether I can express myself intelligibly. I can only give you an example of what I understand by passivity. It is the ability of so loosing one's own individuality that one can make this contact with others. It takes immense effort to achieve this, yet it is achieved without willing it, to some extent unconsciously without one's having anything to do with it. To create at this stage with whatever means—words or colors or notes—is art. Frequently this relationship is reached only as an after-effect, sometimes after weeks and months.

* Eberhard Grisebach, philosopher and art lover. Besides Kirchner, he corresponded with such artists as Hodler, Munch, and Schlemmer.

† Professor Eckart von Sydow, philosopher and art historian. He was best known for *Die deutsche expressionistische Kultur und Malerei* (1919) and several important books on primitive art.

And then the most powerful things are produced here because feeling is released from specific material limitations.

I really don't believe that I can put these notions into words. Please write and tell me whether any of this makes sense to you. After all, pictures are the true expression for this. Certainly we can try to explain it but in spite of all explanation whatever it gives us, or should give us, it remains inexplicable. I am very happy to talk to you about all this and to hear frankly what you yourself think about these things. Please greet your wife and Schaxels and Herr Dr. Dexel and accept my thanks and best greetings.

Your E. L. KIRCHNER

[No date; written summer 1919]

Dear Miss Nele,

Papa has just left, much to my sorrow.* Now I had better write a few quick words to you.

While looking through old drawings we came across a number of copies of Indian murals. Papa suggested that you should look at the book by John Griffith, *Paintings in the Indian Cave Temples of Candia Haber.* They would give you ideas! Unfortunately I don't have the book but in order to give you some idea of the work I'll send you my very poor copies tomorrow. Also, a few sketches after some other exotic things.† Such works have encouraged me for many years. The originals are so strong and elegant that they just knock the brush right out of your hands. Perhaps you will feel the same thing and your figures will be filled with their spirit. I hope so. Papa calls it *"du corps."* Perhaps you could also say *"sensibilité."* It takes real effort for us Europeans to acquire this quality, at least as a transitional stage since it nourishes us in the realization of our dreams. These orientals have it in their blood, perhaps it's because they live out in the sun. We miserable Europeans have to sacrifice life and soul just to get a shadow of it. Take my sketches in exchange for those you made

* "Papa" refers to Miss Nele's father, Henri van de Velde, the distinguished Belgian architect and designer.

† In another letter to Miss Nele (Jan. 20, 1919) he wrote about these drawings of African and Oceanic wood sculptures: "I find this art much purer, nobler, and truer than the highly praised antique which has diluted all European art with its insipid aestheticism."

in the Ethnographical Museum, Basle. These made me very happy last winter. If you want to get any benefit from such study you must examine and draw other works of art as if they were nature herself, that is to say, something where you capture feeling in only one of its thousand different aspects and by means of such study absorb life itself. The subject isn't important. At best the attempt to reproduce it is a good exercise for the fingers and for your powers of comprehension and therefore very useful. Remember Van Gogh who had his brother send him reproductions of drawings in order to copy them? Or Rembrandt, the way he copied the Indians and Italians? Certainly neither lacked material. They copied only to acquire *"du corps."* To that end you have to draw constantly everything that impresses you: pictures, statues, objects, people, animals, nature, everything, everything because developing a calligraphic style is just as difficult as learning to walk. It is easy to see how this happens to others, but you have to do it for yourself.

While developing artistically one will discover among the infinite riches of the world's art feelings and points of view paralleling one's own (the discovery is made intuitively). To penetrate these by means of drawing helps one to understand oneself and ripens one for further growth. The Japanese attracted you although you wanted much more than that and your small lithos are much freer and warmer. Their dream-shape with its thinness is not true form. Oh, you will love the Indians. The pure Arian Indians and not what you see in Berlin where Chinese influence has made their forms frozen and sterile. I'm really sorry that all I can send you are these clumsy sketches and they do give you only my feelings about the works. In the final analysis the Indian works will speak differently to you. They are completely flat and yet absolutely corporeal and in this way they have completely solved the secret of painting. And yet they are inimitable. Even their direct followers couldn't make simple copies. They tried to. Through their influence the European is encouraged to become a sculptor, a temptation which one avoids by carving works out of wood. Also, if one works in three dimensions one moves almost as a matter of course in the direction of two-dimensional curves in handling the filling of surfaces. If one traces these curves in the human body one is led to the origin, to the spiritual energy which generated these forms and folds. Then the great struggle begins with oneself to express this formally and that is the beginning of the real job.

Well, that is a little too much theory, so please forgive all these lines. I'm afraid my explanations have been rather clumsy.

I'll send you the drawings by the same post. It would be wonderful to be able to talk to you and how marvelous if you and your father could both visit me in the summer! I need a little good conversation here. And when a person is inhibited as I am, good talk is a necessary release even though what is essential is always my work.

All my best to you,

E. L. KIRCHNER

"Drawings by E. L. Kirchner"

If Kirchner's unique mode of representation, his forms and his pictorial structure, are to be understood, one should study his drawings. However, all aesthetic approaches have to be avoided. If the drawings are read the way one reads a precious letter or a favorite book, then human feeling will naturally provide the key to their hieroglyphic script. Kirchner draws the way other people write. His habit of sketching year after year everything he saw and experienced made it easy for him to represent in lines and forms everything which appeared before his physical or spiritual eyes. He used the whole surface of any given sheet to do this. Not only the lines and the forms defined by them but all the empty areas were part of the picture.

The forms do not so much represent specific objects per se. They receive their specific meaning from their position, their size, and their relationship to each other on the page's surface.

They are hieroglyphs in the sense that they change nature's forms into simpler two-dimensional shapes and suggest their meaning to the observer much as the written word "horse" places the image of horse before everyone's eyes. They are not hieroglyphs in the customary sense of always using a specific shape for the same object or idea.

Among all Kirchner's drawings from cartoons three feet square to small sketches there is neither a detailed study nor a working drawing of the kind generally found among older as well as younger painters. This is explained by Kirchner's creative process. He proceeds from the large to the small, making each single form dependent upon the whole. Single forms are evolved from the whole and thus there cannot be a detail as such. For example, the shape of a hand or a tree is de-

termined by the total composition, by the whole surface. Separate studies would be of no help to Kirchner in the realization of his picture. Forms develop and change as a result of working in terms of the entire surface. This also explains the so-called distortion of single forms; the small must accommodate itself to the large. In art one can intensify or omit.

In the above landscape drawing* one sees how a sunny river landscape is made out of a few lines and planes defined by lines following along a horizontal format. Houses can be seen between the trees along the river. A path cuts across a meadow to the houses. Behind them is a hill with its outline echoed by the foliage of the tree on the right. The zigzag horizontals of the branches close off the picture while at the same time defining the shape of the tree. In this way pictorial necessity was responsible for the hieroglyph "tree." The left side, which also evolved out of the whole, developed an equally clear formulation of "tree" in terms of a construction of three compartments. . . .

As in letters written by sensitive people, where the script expresses the spiritual condition of the writer, these drawings reveal through line the inner life of what is represented, something like the marks made by a manometer. Feeling is always creating new hieroglyphs which, emerging from an almost chaotic tangle of line, become virtually geometric signs. The above drawing of a Chinese juggling dishes emphasizes the essentials of his activity, head and whirling plates, by means of a compartmentalized composition which ascends from the lower left. What appears is not a real or apparent description of reality, it is a new form deriving from personal phantasy, a nonobjective hieroglyph. And yet, this nonobjective hieroglyph has the power to make us see two Chinese on a brilliantly lit stage, one who juggles plates and one who assists. . . .

The most modern of the moderns claim that the old masters had exhausted all the possibilities of painting from objective reality long ago, from this deducing in part the necessity for their own abstract works. However, if one looks at the drawings shown here one can, on the contrary, claim that they do demonstrate new possibilities. Perhaps they can be interpreted as nonobjective since no object is shown in its real form or for its own sake. Nevertheless, it is the real world which guides creation even if it is pure phantasy. All art needs this visual

* All illustrations referred to in this and subsequent articles have been omitted in this anthology in order to save space.

world and will always need it, simply because it is accessible to all and thus provides the key for all others.

All art is derived from man. The art of these pages strives for clear concise signs, for hieroglyphs which are broad enough to include a wealth and variety of pictorial visions. Its forms are sensual and arise out of an intense love of life. And yet some people will see absolutely no art in them at all. Perhaps the general public will progressively develop to a point where, in addition to writing, they might use a calligraphic means of communication similar to these drawings. This would certainly be an enrichment. Words express so very little. And artists' drawings will never be superfluous since they have that which is the essence of art—beauty beyond purpose or morality.

If the smaller reproductions served to illustrate methods of representing and working, the following fourteen large reproductions demonstrate what is purely artistic—giving form to phantasy and different types of composition.

It is difficult to define Kirchner's style in terms of specific recurring forms. The draftsman unencumbered by much technical apparatus is able to develop his feeling for forms without any inhibitions. Drawing for him is assimilation and self-enrichment. His sensations are directly transcribed there and every expression of true life is beautiful to him. This art is many-sided and yet it is quiet and restrained; its impact is not immediate but requires affectionate study.

Kirchner's drawings perhaps are his purest and most beautiful work. They mirror the feelings of a man of our times, instinctively and without premeditation. Besides, they comprise the formal language of his prints and paintings, that other part of his work in which a conscious will operates. The vital power of this will, however, derives from drawing.

"Concerning Kirchner's Prints"

Perhaps what makes an artist a printmaker is, in part, the desire to define clearly and conclusively the singularly loose forms of drawing. On the other hand, the technical challenge of printmaking certainly releases powers in the artist which do not come into play in the much more easily managed techniques of drawing and painting. The me-

chanical process of printing unifies all the separate phases of the work of art. Yet creative work can be prolonged as long as one wishes without danger. It is extremely exciting to rework a picture again and again over a period of weeks or even months in order to achieve the ultimate in expression and form without any loss of freshness. The mysterious excitement which surrounded the invention of printing during the Middle Ages is still felt by anyone who seriously studies printmaking down to the last detail of craftsmanship. There is no greater joy than to watch the printing press roll over a completely cut woodblock or to etch a lithographic plate with nitric acid and gum arabic and observe whether the desired effect occurs or to test on trial proofs the maturing of the final version of a piece. How interesting it is to examine prints, right down to the smallest detail, page after page, without noticing the passing hours. Nowhere can one get to know an artist better than in his prints. . . .

He [Kirchner] made his technique, like his subject matter, serve his special needs. Thanks to patient experimentation, and in spite of many failures, he discovered methods in lithography that made this technique, which rightly or wrongly had been carelesssly handled in the past, equal to all the rest. His method of etching with turpentine produced tonal effects on the stone which had never been seen before. His lithos are all hand-printed. He works his stones until the preparatory drawing has been made completely graphic. That is, the drawn lines vanish and are formed anew by etching. Deep blacks alternate with silky grays which are produced by the grain of the stone. The soft tonality, resulting from the gray portions distributed by the grain of the stone, functions as color and gives warmth to the print. In this way Kirchner developed a personal lithographic technique which is much richer than the woodcut. He also invented a color process which enabled him to print color lithographs from a single stone with as many colors as he wished. He made very exciting color prints with this technique, which was analogous to painting. Each color is defined separately. The forms developed individually combine to full effect in the finished print where they appear one over the other.

Kirchner's lithos exist only in very small editions—five or seven to ten copies and a few trial proofs. He has never worked upon transfer paper. Unfortunately, most lithos these days are made with the help of transfer paper and are little more than reproductions of drawings.

Up to now Kirchner has made approximately 400 lithos in four different sizes, the largest being 50 by 60 cm. All lithos show the stone's edge. For his black prints the artist likes to use lemon-yellow paper.

These days Kirchner's favorite technique is etching. It allows him to carry plates about without difficulty and to make his first notes directly from nature. Thus his etchings, especially in their first trial proofs, have the most direct hieroglyphs. The etchings are like a painter's diary, rich with lively calligraphy and a wide variety of motifs. Figure studies, landscapes, phantasies occur in a lively series and in addition there are expressive portaits. The uninhibited capriciousness of this art is completely realized. Furthermore, there are plates which have been worked over repeatedly so that everything is highly finished and the smooth plate is transformed by repeated acid baths into a dramatic terrain of mountains and valleys. There are plates with etched lines 2 millimeters wide next to those with lines as fine as hair, plates with airily delicate aquatints and others with etched surfaces which look like cloisonné. Often engraving enlivens the etched surfaces. Sometimes Kirchner begins with etched surfaces, as in his early "Man and Woman." The second etching places lines upon the etched surfaces after which more deeply etched areas follow and so forth until the work is finished. This process creates very remarkable and unusual effects. Another etching, like the "Street Scene," consists only of clearly bitten lines. It gives great pleasure to follow forms stroke by stroke. The freedom and boldness with which figures, especially the small ones in the background, are sketched is really extraordinary. Indistinct forms (the curbstone in the above mentioned "Street Scene") are actually defined with apparent carelessness by long flowing and interlaced lines which expand the scene and make the figures appear larger.

Etching is a refined technique. Even the heaviest impression produces extremely delicate lines. They sit lightly raised upon the ground, which shimmers like velvet. The printed black is pressed into the paper and has a quality which is quite different from a litho or woodcut, where the black simply rests upon the surface. . . .

The woodcut is the most painterly of the printmaking techniques. It demands great skill and concentration, but Kirchner's technical ability made woodcutting easy for him. Thus, by means of the simplification natural to the technique he achieved without effort a clear representational style. We see the formal vocabulary of his pictures prefigured by the woodcuts which constantly accompany all his crea-

tive effort. . . . The liveliness of his vision saved him from the
schematization which makes the majority of woodcuts today so dis-
agreeable. Kirchner early attempted to use the woodcut for illustra-
tions. He was the first to print picture and text simultaneously (in the
periodical *Sturm,* Vols. 9–10), thereby unintentionally provoking the
current flood of books illustrated with woodcuts. Up to now he has
been unable to find a publisher for his own projects. In these he tries
to cut text and picture together in order to compose the entire page
as an entity. The title vignettes for Georg Heym's "Umbra Vitae" are
just such works. Besides small things Kirchner also cut posters. In
addition to simple work in black he made a whole series of colored
woodcuts. After many attempts he developed a new way of working
using from two to ten plates without an outline plate. . . . The color
plates always cover the whole surface. Kirchner would never cut another
plate just for the sake of another spot of color. For example, "Man
and Girl" is printed in three colors: blue-green, orange and yellow,
one over the other. Such color prints are really color compositions
and should not be confused with a colored black-and-white print.
There are trial proofs of works in many colors in which the sequence
of colors has been changed. Sometimes plates are omitted and other
times the trial proof has more colors than the published edition. This
indicates how the artist experiments with his colors. A color print is
made like a painting. When printing, Kirchner is eager to exploit the
elasticity of the wood and in this way make blended passages.

Karl Schmidt-Rottluff

Born at Rottluff, Germany 1884. Studied architecture in Dresden, where he met Kirchner. Co-founder of *Brücke* 1905. Settled in Berlin 1911. Served in the army 1915–18. Joined Workers Council for Art 1919. Member of the Prussian Academy of Fine Arts 1931. Forced to resign by Nazis 1933. Forbidden to paint 1941. Since 1947 a teacher at the Berlin Academy of Art.

Schmidt-Rottluff was psychologically and artistically the least complex of all the *Brücke* painters. His stylistic development closely paralleled Kirchner's but from the very beginning his work was simpler and coarser, and his rare, always short statements about art were as blunt and direct as his paintings and woodcuts.

"The New Program" was written by Schmidt-Rottluff in response to a questionnaire sent out by an influential art periodical in 1914. Other Expressionists were quizzed, including Beckmann, Macke, Meidner, and Heckel.* The answers given by Schmidt-Rottluff and Heckel were the shortest of all. Heckel refused to say anything except that "the unconscious and the accidental" were the only sources of artistic power. Schmidt-Rottluff said little more. He emphasized that he was after something which "neither intellect nor words" could grasp. Such reticence may seem surprising for Expressionists. However, their emphasis upon the irrational factor in art is not. As a matter of fact, none of the *Brücke* members indulged in the metaphysical and aesthetic theorizing which was so characteristic of *Blaue Reiter* painters like Kandinsky, Marc, and Klee.

"The New Program"

I haven't heard about a "New Art Program." I can't even imagine what it would be. If there is anything at all to say about something

* In this anthology see, for Beckmann's answer, Part Three, pp. 106–7; for Macke's answer, Part Two, pp. 75–77; and for Meidner's answer, Part Three, pp. 111–15. The originals first appeared in "Das Neue Program," *Kunst and Künstler,* XII. (1914), 299ff.

like an "Art Program," in my opinion it would always be the same thing and it would be as old as the hills. Except, of course, for the fact that the forms of art change along with the artists. But the essence of art can never change. As for me, I know that I don't have any program, only an inexplicable yearning to lay hold of what I see and feel and then to find the most direct expression possible for such experience. I only know that there are things which neither the intellect nor words can grasp. Actually, if you want my honest opinion, I'm convinced you can't talk about art. At best, all you will have is a translation, a poetic paraphrase, and as for that, I'll leave that to the poets.

Emil Nolde

Born Emil Hansen in 1867 at Nolde-Schleswig, Germany. Died at Seebüll, Germany in 1956. Studied at Flensburg, Karlsruhe, Dachau, and Paris between 1884 and 1900. Settled in Berlin 1906. Member of *Brücke* 1906–1907. Expelled from Berlin Sezession 1911. Traveled through Russia, the Far East, and the South Seas 1913–14. After the war lived in Seebüll and Berlin. Appointed member of the Prussian Academy of Fine Arts 1931. Expelled in 1937 and denounced as a degenerate artist by Nazis. Forbidden to paint 1941.

Nolde was a member of the *Brücke* for little more than a year. Thus, it would be a mistake to identify either his style or his views with the rest of the movement. However, his highly emotional interpretations of landscapes and religious scenes, as well as his expressive use of color had much in common with *Brücke* styles. But unlike *Brücke* artists and most other Expressionist painters, Nolde was deeply impressed by *"Blut und Boden"* ("blood-and-soil") ideals, or by what the historian George Mosse has called "Volkish thought." * This thought can be defined as the belief that a race and its landscape exist in a reciprocal and mystical relationship which embodies divine truths and gives meaning to individual existence as well as to the history of nations. At their best, such ideas were an expression of affection for one's own culture. At their worst, they became a high-flown excuse for the persecution of other races. Nolde, as millions of other Germans, was unfortunately seduced by "Volkish thought" into supporting the Nazis. He even joined the Nazi party. Nevertheless, the Nazis condemned him with the rest of the avant-garde as degenerate. Nolde even attempted to reason with the Nazis (see his letter to the Minister of Information and Propaganda, 1938, pp. 209–10), but to no avail, and in 1941, he was forbidden to paint. The artist, on the other hand, never changed his style in the slightest and he continued to work in secret making a series of small watercolors which rank among his greatest works.

* See George Mosse, *The Crisis of German Ideology* (New York, 1964).

Nolde's writings testify to his mystical and pious outlook; they reveal the intensity of his feelings, feelings which mixed art, religion, and love of Germany into a confused but passionate expression. That Nolde, however, was no racist but sincerely respected the work of other cultures is also revealed in his written work. He was especially enthusiastic about primitive art and, although he never imitated any specific primitive styles, he successfully emulated in his own terms the simplicity and power of primitive art.

The extracts selected for this section are taken from *Years of Struggle*, the second volume of Nolde's four-volume autobiography.*

Work in Nine Parts (*January, 1911*)

We were back in Berlin again.

However, my Ada† soon left for Copenhagen in order to visit her relatives and also to realize her ambition to study singing with a particular teacher, a person in whom she had great confidence.

I've always liked her voice, which was halfway between rust red and dark lilac. . . .

While she was gone I kept the apartment door bolted. I painted and painted, day and night and nights more than days, sometimes until the next morning. I did "People at the Village Inn," "Man and Woman," "Blacksmith and Clergyman." And then I painted "Holy Night" with the star shining in the evening sky and the ecstatically happy Maria holding her divine son, the child Jesus in her outstretched arms. I painted the "Resurrection" in lilac morning air, and then my large picture of the "Crucifixion" where the savior with deeply furrowed face suffers his human redeemer's death.

It must have been painful to be on the cross, but it must also have been an inexpressible joy to die in absolute certainty as son of God and son of man in order to save mankind from everlasting torment. I can't imagine a grander or more glorious death. Don't people and

* *Jahre der Kämpfe, 1902–14* (Berlin, 1934), pp. 169–75, 176–81, 186–237. The selections date from the period 1911–12. Translated for this volume by the editor with permission of Dr. Urban, director of Stiftung Seebüll Ada und Emil Nolde.
† Nolde's wife.

priests reveal how small their own souls are when they weep and wail over Christ's death? Isn't the death of every ordinary person, in pain and misery, in sickness or war, or in the fulfillment of his own destiny, a much harder death? I couldn't help thinking about this. The spirit of the age has changed, kings and popes are just people, like you and me, bound by their duties but having additional honors.

Thoughts like these fly to the ends of the earth while I paint. They buzz about my finished works, helping or destroying them.

Thoughts are unique in their swiftness. In comparison lightwaves move at a snail's pace.

Following the large "Crucifixion" I painted three more pictures so that these along with the three I had painted the previous summer added up to a large work of nine parts.

The "Magi," painted the previous summer, displeased me at the time. I immediately turned its face to the wall and there it remained without my looking at it until fall. But at the time I was still at work on the flickering light of the torches in the Garden of Gethsemane, Christ and Judas and the soldiers of the pharisees; also on the twelve-year-old Christ with the scribes in the temple.

When I looked at the picture of the "Magi" again, its natural, involuntary style pleased me. Thus, just as I once ran through the entire spectrum from the most intense color to the most delicate gray I now changed from form which was almost completely dissolved, as in the "Gethsemane," to form which was tight and compact. I was no longer attracted by superficial and obvious excitement, by aesthetic play. I wanted a tighter, more solid structure with larger and simpler surfaces which could express a greater spiritual depth and sincerity—like what I had been trying to express in the "Last Supper" and "Pentecost."

Perhaps it was only an accident that the "Magi" stood right next to the other Biblical paintings. At any rate I then decided to add a fourth picture, and then a large central scene and then, on the other side, four more pictures. The first four were to show events prior to the other four, events subsequent to the crucifixion. And that is what happened. The pictures reinforced each other artistically; it was my intention that they give a single monumental and powerful pictorial effect imbued with religious feeling and spirituality: the "Life of Christ." . . .

When my large work left the studio for exhibitions it was called an "altar." This was not my intention at all. Just as in the case of my

triptychs "Maria Aegyptiaca" and "Martyrium." They all are works of art in the service of art.

My nine-part work was first exhibited at the Folkwangmuseum in Hagen. Frau Osthaus* wanted to keep it, only this was not possible. It was sent to the World's Fair in Brussels. I didn't want to show it to the world so soon, but Osthaus had agreed to supervise the religious pavilion at the World's Fair on the condition that my work be given the place of honor there. However, things did not turn out as we expected. The Catholic Church protested. The work was ordered removed. Consequently, when the king came to the pavilion on opening day Osthaus had already locked it up and left. "If Nolde's work can't be exhibited," he said, "the whole exhibition no longer interests me." . . .

At that time I didn't know that Protestants as well as Catholics did not like and did not want my pictures. They had kept silent. Naturally I had not asked anyone how religious pictures should look. I created them instinctively, painting the figures as Jewish types, Christ and the apostles too, Jews as they really were, the apostles as simple Jewish peasants and fishermen.

I painted them as powerful Jewish types, since the weaklings were certainly not the ones who followed the revolutionary teachings of Christ.

How marvelous it must have been—Christ as man and leader wandering and preaching from village to village, with him and around him, twelve simple human beings, Jewish publicans and fishermen.

The fact that during the Renaissance the apostles and Christ were represented as Aryans, as Italian or German scholars, must have convinced the Church that this practice should continue forever, that this artistic deception—to be quite frank—justified further deception.

It was a remarkable experience to be threatened and attacked for decades simultaneously from two opposing sides. It takes nerves of steel to keep calm when a painter is persecuted on one hand by Jews because he paints them as Jews and attacked on the other hand by Christians because they want Christ and the apostles to look like Aryans. Where will all this lead? If we demand that Biblical figures

* The wife of industrialist Karl Osthaus, one of Germany's most important collectors of modern art. He was a patron of Nolde and other Expressionists and his museum, Folkwang at Hagen, became a kind of shrine of avant-garde art in Germany.

be painted as Aryans, then can't Chinese Christians represent Biblical heroes as Chinese and the Negroes represent theirs as blacks? . . .

Art is exalted above religions and races.

Not a single solitary soul these days believes in the religions of the Assyrians, the Egyptians, and the Greeks. And their races are exhausted, crossbred, and spoiled. Only their art, whenever it was beautiful, stands proud and exalted, rising above all time.

Ancient artists often did not receive the respect which they deserved. Hardly any of their names are recorded even though they did more for the happiness of their people and of mankind in general than the pharaohs, generals, and world rulers whose pride and actions filled the world with sorrow and required the sacrifice of thousands upon thousands of human lives; and what remained for future generations?

Art elevates itself to the loftiest heights.

Primitive Art

I kept myself busy writing a book, the *Artistic Expression of Primitive Peoples*.

1. "The Greeks had the most perfect art. In painting, Raphael is the greatest of all masters." Only twenty or thirty years ago every art teacher taught this.

2. Much has changed since then. We cannot stand Raphael and we are indifferent to the statues of the so-called Greek Golden Age. Our ideals are no longer those of our predecessors. The works under which great names have been placed for centuries have lost their appeal. Worldly-wise artists, driven by their age, created art for popes and palaces. We love and respect those modest people who worked in their shops, whose lives are almost completely unknown to us, whose names are unrecorded but who made the simple and grand sculptures of the cathedrals of Naumburg, Magdeburg, and Bamberg.

3. Our museums are growing rapidly, they are becoming gigantic and filled with works of art. But I'm no friend of those collections which suffocate inspiration through sheer size. There will soon be a reaction against all this accumulation.

4. Just a short time ago only a few periods were suitable for museums. But then Coptic, Early Christian, Greek terracottas and vases, Persian and Islamic art were added. Why, however, is Indian, Chinese, and

Japanese art still classified under science and ethnology? And why is primitive art ignored altogther?

5. Why are we artists so eager to look at primitive art?

6. Our age has seen to it that a design on paper has to precede every clay pot, ornament, useful object, or piece of clothing. The products of primitive people are created with actual material in their hands, between their fingers. Their motivation is their pleasure and love of creating. The primeval vitality, the intensive, often grotesque expression of energy and life in its most elemental form—that, perhaps, is what makes these native works so enjoyable.

These sentences pertain to today's situation and perhaps to the future as well.

The elemental feeling, the sheer enjoyment of color, the ornamentation and carving which "savages" give to the designs of their weapons and ceremonial and utilitarian objects are as a rule more beautiful than the mawkish and precious objects which we have in the glass cases of our drawing rooms and our museums of decorative arts.

There are enough overrefined, pallid, decadent works of art and perhaps that is why artists who are vital and developing seek guidance from vigorous primitives.

We "cultured" people haven't been as splendid as some claim. Our achievements cut both ways. For centuries we Europeans have acted toward primitive peoples with inexcusably barbaric greed, destroying entire peoples and races and always under cover of the most noble intentions. Beasts of prey have no mercy and we white people often have even less. . . .

Every powerful artist, no matter where he works, gives his art the impress of his personality and of his race. What a talented Japanese paints becomes Japanese art, what a German artist of strong character makes becomes German art irrespective of whether he is in his very own homeland or at the farthest corner of the earth. What weaklings make, wavering as they do back and forth, is always an insipid mishmash.

Later, when I traveled in other countries and visited the South Seas I particularly wanted to get to know places and people which had never been touched by civilization.* Exotic arts—just like the earliest

* Nolde is referring to his trip to the Far East in 1913–1914. The artist and his wife traveled through Siberia, Manchuria, Korea, Japan, China, the Palau Islands, New Guinea, and the Admiralty Islands.

primitive European folk art, masks, and ornaments—all of it seemed very close to me. It is marvelous that folk art appears so early in the history of every race, long before many other things—sophistication, vulgar taste, and cheap elegance.

And the primeval power of all primitive people is germinal, is capable of future evolution. Only insipid decadence is perishable.

Everything which is primeval and elemental captures my imagination. The vast raging ocean is still in its elemental state, the wind and the sun, yes the starry sky are more or less what they were 50,000 years ago.

ALSEN—BERLIN

. . . I said what I could say in painting. Only in a very general way perhaps can I add a little verbally. Dualism is particularly important in both my paintings and my graphics. With or against each other: man and woman, joy and sorrow, God and the devil. Colors were also used in opposition to each other: cold and warm, light and dark, weak and strong. However, usually after a single color or a color chord has been put down, as if self-evidently, one color determines the other intuitively and without conscious effort. In a state of pure sensuous abandon and creative joy one can range through the whole glorious array of colors on one's palette. The general composition was almost always determined by a few structural lines, the colors then completed the picture, shaping themselves with absolute certainty into expressive forms.

Colors, the raw material of the painter: colors in their own individual life, weeping and laughing, dream and happiness, hot and holy, like love songs and lovemaking, like tunes and like magnificent chorals.

Vibrating colors like tinkling silver bells or pealing bronze bells announcing joy, passion, love, soul, blood, and death.

I frequently find it very difficult—after reaching the high point of a picture, something which often happens quite early while painting —to preserve the tension until the work is completely finished. When the pure sensuous power of vision relaxes a rational coldness is all too eager to continue the work, to weaken it, and sometimes to destroy it.

Man's reason insists upon outwitting his artistic instinct: "Obviously I alone know best; the artist, that simpleton doesn't know anything."

The artist need not know very much; best of all let him work instinctively and paint as naturally as he breathes or walks.

For the creative person intellect is antiartistic; intelligence can be a false friend. Good taste is that great pleasure which satisfies intellectuals. Intellectual art experts called me an Expressionist and I detested this limitation. Later when Futurists and Constructivists claimed this label I felt free again. . . .

All of the phantastic pictures which I painted at this time and afterward developed without any plan or model or even without any particular idea in mind. I could imagine pictures down to the last detail, quite easily of course, but they were far more beautiful than when actually painted—I had become a mere copier of my preconceptions. Therefore, I eagerly avoided any planning and was satisfied with only vague ideas generated by emotion or color. The work then evolved in the very process of painting.

Complete composure is extremely difficult under such conditions.

I wanted to be true to myself and do something that was not only effective on the picture's surface but something that would create an aura of spiritual beauty which would extend beyond the limits of the frame and fill an entire room.

Pictures are spiritual beings. The soul of the painter lives in them. The best command our highest respect. . . .

Out of intense desire and yearning for what has never been done, never seen, for the intangible—that is how pictures of enduring value are made. Out of a yearning for impossible joys, a yearning for life beyond measure, for a beauty vital and flourishing, for everything grand and glorious—that is how works are made which transcend the banality of everyday life. This is true for the visual arts and for all the fine arts.

Pleading in difficult times, stretching my arms upward desperately praying for help, filled with intense yearning, or my hands spread out wide holding a most holy joy—that is how my pictures "Maria Aegyptiaca" and "Holy Night" were made. And in both of these women, who were filled with divinity, I experienced my inmost being. But how could this happen to a virile man? There is a lot that I don't understand—but I don't need to understand it. . . .

I used somber, black wooden frames for all my pictures, or almost all. They could stand it, and it made the strongest possible contrast

with the playful, gilded plaster French rococo frames which were
fashionable. The public didn't like it, they wanted gold, plaster cov-
ered with gold! But I didn't give it to them. . . .

While I was working on my religious pictures I was excited not
only by art but by religious problems. I couldn't stop thinking, strug-
gling, and contradicting; I spared nothing from myself and my sharp
criticism. From out of these many struggles with myself I will mention
only one instance, a Bible passage which then, and even earlier, tor-
mented me: "Many are called but few are chosen." To me, these words
in their cold brutality sounded like the decree of a Babylonian tyrant.
I could not conceive that a merciful and almighty God would be less
kind to weak men than men frequently were to each other or to small
and helpless animals.

And what is good, what is bad? What is sin?—the sin which has
corrupted mankind from the very beginning? Whom can we blame?
Was it necessary to offer mankind an opportunity for sin?—Who is
really guilty, the tempter or the tempted?

No God could want evil, no God could be mean. I lived in humility,
I struggled with my God for profound, heartfelt wisdom and truth.

THE NEW SECESSION* (1912)

The New Secession was founded. At first I remained aloof. Then I
took part in its exhibition on Rankestrasse.

At its next exhibition in the upper story of an office building on
Potsdamerstrasse every young artist sent five or six of his best pictures:
Heckel, Kirchner, Schmidt-Rottluff, also the Munich people—Marc,
Kandinsky, Jawlensky, and a few others. . . . I stood quietly in front
of their work, but inside I was white hot with excitement over the
expressive power of our young new generation. Marc's large animals
were there, Kirchner's circus pictures, Schmidt-Rottluff's landscapes,
my "Holy Night" and many others. . . .

The young painter Freundlich arrived from France and told us in a
lecture that artists in Paris had begun to construct or partition all

* The New Secession (*Neue Sezession*) was founded in Berlin in 1910 as a reac-
tion to the policies of the Berlin Secession (see note on p. 16). Members of both
the *Brücke* and the *Blaue Reiter* supported the New Secession.

objects, even the human body, in terms of cubes and prisms. He men-
tioned Picasso's name. We listened and then we discussed this news.
Thanks to the Italian Futurists we had some orientation. Some others
had also informed us about these developments. It seemed to me that
we should praise France for everything that was developed there—
impressionism, cubism, abstractionism or what have you—but that we
should also insist upon acknowledging what we ourselves have done.
Each person should only make that which no one but that person
alone can make. For those who have no ideas of their own there is
always plenty of room for foreign ideas.

A few years ago pleinairism and impressionism flooded Germany
and all of Europe; I lived through all of this myself. Both movements
left behind nothing but fashionable mishmash everywhere, with the
exception of France and a few artists who ignored fashion. Now cub-
ism has arrived as an anarchistic destruction of all form and solidity,
Picasso as leader. A year or two has passed and among young German
painters its influence is evident in the representation of objects, land-
scapes, and architecture. Among my friends I was the only one who
opposed this new style. I did not change. Was this weakness? Did I
lack the power to assimilate these new developments? I saw the crystal
clouds, the surfaces of structural color, the cubist city scenes—they
excited me and yet in front of my own canvases my will and my feel-
ing rejected all of it. I could not work and deny nature. I could be
true to myself only when I was in contact with nature, profoundly
and positively. Franz Marc had painted his simple groups of deer and
other animals without a touch of affectation. Now, practically over-
night, he became a constructivist, a cubist to a point where his animals
became unrecognizable. Had a new age dawned? These large and
powerful rays, curves, lines, and these prismatic colors? I followed
everything with intense interest. At times I felt clumsy, backward,
outdated, and angry—with twilight in my heart. For me the highest
value, the form of visible life, was always inward and spiritual and
incomprehensible. If I had to be that way was it different for others?
I thought about it, I questioned and analyzed. To what extent are
modern ideas experienced firsthand, to what extent do they develop
of their own accord? To what extent are they introduced from with-
out? In front of my friend's pictures how I wanted to sweep away
everything that was foreign to me in order to see reality stripped of

all sham—but surely only my primitive narrowness demanded such clarity. It was something which I seemed to owe myself. I was also disturbed because I didn't know whether Jews had originated cubism or constructivism. I wasn't interested in a value judgment, I wanted an unprejudiced understanding, yes or no. Were we standing before a truly Jewish art, a real cultural event? It would clear things up splendidly, since up to now Jews have painted either in a French or a German manner or in some combination of the two—as if they were trying to deny their own racial characteristics. I was busy with question after question. In cubist-constructivist art I thought I could detect great technical facility and a strong emphasis upon tasteful effects. It seemed to me that after Manet's time, with the decomposition of impressionism, a process of dissolving form began which climaxed in cubism and abstraction. I stood still and examined the situation. Finally I buried myself in my own work. I never got around to discussing these matters with other artists. But soon I, a man from the country, recovered all my lost powers. My love for my native landscape, for the sea, for flowers, for animals and for people was stronger than ever before. Instead of dissolution I strove for fusion, instead of destroying I wanted to unify form, instead of good taste and cleverness I worked for a more profound expression, broad and simple surfaces and strong, healthy colors. . . .

FRIENDS OF ART AND COLLECTORS

We young artists instinctively wanted to give back to German art the Germanic character which it had lost 250 years ago, but in a newly-born form and in full color. I served this cause, barely aware of what I was doing, as if out of an innate sense of duty. And I passionately loved the old, pure German art for its austere, stubborn, spiritually perfect beauty, for its phantasy which is so deeply rooted in nature and in the ineffable. A truly inward, heartfelt art once existed and still exists in Germanic areas, in Germany; and practically all non-Germans with their love for sweet, round forms stand speechless and uncomprehending before it.

My joy and my love were reserved for medieval sculpture, Dürer's linear phantasy, the passion and grandeur of Grünewald, the childlike beauty of Cranach, Hans Holbein's great technical ability, Rembrandt's

divine humanity, and the work of many more artists, all of them shining like rare and wonderful stars.

Oh Germany, in passion and in travail, dreamland in music, in poetry, in color. And your youth, they are your best and most beautiful hope for the future.

PART TWO

Der Blaue Reiter

Der Blaue Reiter ("The Blue Rider"), a second group of German Expressionists, was founded in Munich in 1911 by Wassily Kandinsky and Franz Marc. The name which attracted much attention was invented, according to Kandinsky, because both he and Marc liked blue and Marc liked horses while Kandinsky admired riders. Its membership was international: German, Austrian, Italian, Russian—even American artists—belonged. And not only painters and sculptors but musicians, poets, dancers, and art historians were attracted to the group. In addition to Kandinsky and Marc, members included Paul Klee, August Macke, Alfred Kubin, Heinrich Campendonk, Gabriele Münter, Robert Delaunay, and Arnold Schönberg.

One of the best statements of the group's aims appeared in the introduction to its first exhibition in 1911:

> In this little exhibit we are not interested in propagandizing a *single* precise or particular form. On the contrary, we wish to demonstrate by means of a *variety* of forms that the *inner wish* of the artist can be structured in many different ways.

There was consequently no *Blaue Reiter* style. Nevertheless, the leading artists had certain traits and attitudes in common. Most of them agreed that art should ignore outward appearances in order to express spiritual truth, and in general their paintings were more mystically oriented, more abstract, and in a sense more intellectual than works by *Brücke* artists. All *Blaue Reiter* members were inspired by current artistic developments from Monet to Picasso, as were members of the *Brücke*. However, if the tormented imagery of Van Gogh and

Munch was central to the latter group, the lyrical abstraction
of Robert Delaunay was of major importance to the *Blaue
Reiter*.* Five of his works were exhibited in their first show;
Marc, Macke, and Klee all went to Paris to see him; and Klee
translated Delaunay's article *On Light* for *Der Sturm*. What
captivated them was Delaunay's color, which seemed to have
a life of its own and simultaneously symbolize spiritual mys-
teries.

The organization's point of view was nowhere more effec-
tively presented than in their "almanac" *Der Blaue Reiter*.†
The book contained important articles on contemporary de-
velopments in the visual arts, music, and theater. Its illustra-
tions, which were of equal importance, embraced modern art
(Cézanne, Van Gogh, Picasso, Matisse, Rousseau, Kokoschka,
Nolde, Kirchner, Klee, Marc, Kandinsky, et al.) as well as
medieval, Oriental, peasant, African, and children's art.‡
Musical scores by Schönberg, Webern, and Berg were also
included. By juxtaposing different art forms, art from differ-
ent cultures, and modern, ancient, and children's art, the
Blaue Reiter demonstrated their conviction that all true art
shared a similar "inner life." Significantly, no examples of
classical or Renaissance art were reproduced. The major con-
tributors to the "Almanac" were Marc and Kandinsky and
their most important pieces for this important book have
been translated for this anthology.

* After manifesting cubist influence the French painter Delaunay developed a
very personal style based upon the interplay of color. The poet Apollinaire called
his work "Orphic Cubism."

† *Der Blaue Reiter,* ed. Kandinsky and Marc (München, 1912). Additional vol-
umes were planned but none ever came about. A new edition of the original work
in abridged paperback form was published in 1965 by the original publisher,
R. Piper.

‡ This is one of the first instances of children's art published for *artistic* reasons.

Wassily Kandinsky

Born 1866 in Moscow. Died at Neuilly-sur-Seine, France 1944.
Studied law 1886–92. Offered professorship in law. Refused and
moved to Munich to study art 1896. Founded Phalanx group
1901. Traveled extensively: Russia, Holland, Italy, Tunisia, and
France 1903–1908. From 1908 on Munich and Murnau. Finished
On the Spiritual in Art 1910. Met Marc 1910. Co-founder of
Blaue Reiter 1911. Returned to Russia because of the war 1914.
After Revolution taught at government-sponsored workshops
and schools. Returned to Germany 1921. Taught at Bauhaus
1922–33. Emigrated to France 1933.

Kandinsky, although he was born in Russia and died in
France, lived in Germany during the key years of his own
as well as Germany's artistic development. In addition, his
thinking was rooted in German philosophy and aesthetics.
This is not to say, of course, that Kandinsky should be called
a "German"— He may have been a leader of the German avant-
garde, but he maintained his contacts with Russia. He also
established contacts with France at the very beginning of his
career, exhibiting at the Salon d'Automne from 1905–1910 and
with the Fauves at the Indépendants in 1907.

Between 1910 and 1912 Kandinsky painted some of the first
significant abstractions in history. Motivated primarily by the
conviction that reality is essentially spiritual, he sought to
express this spirituality by using form and color in a com-
pletely symbolic, nonimitative way. To prevent misunder-
standing and to satisfy his own need for order, Kandinsky
wrote numerous essays and books attempting not only to ex-
plain his art but to give it a theoretical justification. His books
Concerning the Spiritual in Art and *Point and Line to Plane*
were, in fact, as influential as his art.* Just as important was
his essay "The Problem of Form," which appears in this sec-
tion of the anthology.† The essay, which was the major state-

* *Über das Geistige in der Kunst* (München, 1912 [written 1910]); and *Punkt
und Linie zu Fläche* (München, 1926). Both have been translated into English.
† Über die Formfrage," in *Der Blaue Reiter* (München: R. Piper & Co., Verlag,
1912, 1965). Copyright © 1965 by R. Piper and Co. Verlag. Translated for this
volume by the editor by arrangement with The Viking Press, Inc., and Thames

ment of theory in the *Blaue Reiter* "Almanac," is significant
as a further development of ideas presented earlier in *Concerning the Spiritual in Art.*

Kandinsky's ideas remained influential for decades, even
though styles changed and new organizations appeared which
violently attacked his mystical ideals. As for Kandinsky's own
style, his freely painted and spontaneously generated pictures
were supplanted after 1918 by stricter, more geometrical ones;
yet his mystical standpoint was never modified.

"The Problem of Form"

What is destined ripens at its appointed time, i.e., the Creative
Spirit (which can be called the "Abstract Spirit") first inspires a single
soul, later other souls, and causes widespread yearning or spiritual
desire.

When the necessary conditions for the ripening of a particular form
have been fulfilled, this yearning or spiritual desire is granted the
power to create a new value in the human soul, a new value which
then consciously or unconsciously begins to live in people.

From that moment people, consciously or unconsciously, attempt to
give material form to that inner spiritual form.

It is Spirit striving for material realization. Matter here is simply
a kind of pantry from which the Spirit, like a cook, takes necessary
ingredients.

It is the Positive, the Creative. It is the Good. *The inspiring White
Beam.*

This White Beam leads to evolution, to elevation. Thus, the Creative Spirit is hidden behind matter and in matter.

The Spirit frequently is so well-hidden by matter that few people
are able to detect it. In fact, there are many people who cannot rec-

and Hudson Ltd., who are publishing a new translation of the entire book in
their forthcoming series *The Documents of 20th Century Art.* There were two
other pieces by Kandinsky in the "Almanac": "Über Bühnenkomposition ("Concerning the Art of the Theater"), and "Der Gelbe Klang." The latter ("The Yellow Sound") an experimental work for the theater, can be found in Part Four,
"Drama and Poetry by Expressionist Artists," pp. 138–45.

ognize the Spirit in a spiritual form. Right now many cannot recognize the Spirit in religion and art. Whole epochs deny the Spirit because they are unable to see it. This happened in the nineteenth century and, generally speaking, nothing has changed in our own day.

People are blind.

A Black Hand covers their eyes, and this Black Hand belongs to the Hater! The Hater tries to retard evolution and elevation in every way possible.

It is the Negative, the Destructive. It is Evil. *The Black Hand bringing death.*

Evolution, movement upward and forward, is possible only when the road is clear, i.e., when no barriers are in the way. That is the external condition.

The power which moves the human spirit forward and upward on the open road is the Abstract Spirit. Of course it must ring out and be heard. The possibility for it to call out must exist. That is the inner condition.

The Black Hand attempts to destroy both conditions in order to prevent evolution.

Its weapons are: fear of the open road, of freedom (philistinism), and a refusal to listen to the Spirit (vulgar materialism).

That is why every new value antagonizes people and provokes scorn and slander. The person who introduces a new value is attacked as a fool and a fraud while the new value is criticized and ridiculed.

That is the horror of life.

But the joy of life is the steady and inevitable victory of new values.

It is a slow victory. A new value conquers only very gradually, but when it once becomes established beyond question, though it was absolutely necessary at the time, it becomes nothing less than a wall against the future.

The transformation of new value (the fruit of freedom) into stone (a wall against freedom) is the work of the Black Hand.

Thus, all of evolution, i.e., internal growth and external culture, becomes a matter of breaking down barriers.

Barriers destroy freedom and prevent new revelations of the spirit.

Barriers are constantly being built up out of the new values which have overthrown the old.

Thus, one realizes that basically it is not the new value which is all-important but the Spirit which reveals itself in this value and, furthermore, the freedom which is necessary for revelation.

Thus, one realizes that the Absolute is not to be found in form (materialism).

Form is always transient, i.e., relative, since it is nothing more than the necessary medium through which today's revelation can be heard.

The Sound is therefore the soul of form. Coming from within, it alone activates form.

Form is the outer expression of inner content.

Therefore, one should not deify form. And one should fight for a form only so long as it serves as an expression of the inner sound. Therefore one should not seek salvation in any one form.

This statement has to be correctly understood. The expressive means (form) of each artist (truly creative artist and not mere imitator) are perfect since they embody best what he is duty-bound to reveal. From this fact people often falsely deduce that one artist's form is or should be the best for others.

Since form is only an expression of content and content varies from artist to artist it is clear that *there can be at one and the same time many different forms, all of them good.*

Necessity creates form. Fishes living in lightless depths have no eyes. The elephant has a trunk. The chameleon changes his color, etc., etc.

Form reflects the spirit of each artist. Form bears the imprint of *personality*.

Of course, personality does not exist outside time and space. It is determined to a degree by time (historical period) and space (race).

Just as every artist has his message, so has every race, and this includes the race to which a particular artist belongs. This relationship is reflected in form and is called *nationality*.

And finally, every age has its assigned task—the revelation which is possible through it and it alone. The reflection of this temporal aspect is called *style*.

These three elements of a work's personality are all absolutely inevitable. Not only is it unnecessary to worry about them, but it is harmful since great effort in this area will produce nothing but a passing delusion.

In addition, it is obviously unnecessary and harmful to favor one element more than another. Just as many today trouble themselves about nationality and others about style, a short time ago everyone payed homage to the personality cult (the individual).

As was said at the beginning of this article, the Abstract Spirit influences first a single human spirit and then a constantly growing number of people. At that moment individual artists become subordinated to the spirit of the age and are compelled, though using individual forms, to work in terms of forms that are closely interrelated and outwardly similar.

This moment is called a *movement*.

A movement is quite justified (just as individual form expresses an individual artist) and indispensable for a group of artists.

However, if one cannot expect salvation from the individual form of a particular artist neither can one from the collective form of a group of artists. Every group's form is the best since it best embodies that which it is duty-bound to reveal. But one must not conclude that this form is or should be the best for everyone. Here also there should be complete freedom and one should consider every form valid, correct (artistic) which is the outer expression of inner content. If one does not, one serves the stone wall (Black Hand) and not the Free Spirit (the White Beam).

Thus, just as above, not form (matter) but content (spirit) is usually most important.

Thus form can be pleasant or unpleasant, beautiful or ugly, harmonious or inharmonious, skillful or clumsy, delicate or coarse, etc., etc., but it cannot be accepted or rejected on any of those bases. All of these ideas are quite relative as a quick glance over the endlessly different forms of past art will prove.

Form itself is just as relative and should be understood and judged accordingly.

One has to experience a work so that its form affects the soul. Past the form through to the content (Spirit, inner sound). Otherwise one elevates the relative to an absolute.

In everyday life it is highly unusual for someone going to Berlin to get off the train at Regensburg. However, in spiritual life getting off at Regensburg is customary. In fact, sometimes the engineer himself refuses to go farther and then all the passangers have to get off at Regensburg. How many seeking God got no further than a wooden

statue? How many seeking art got no further than a particular form used by a particular artist: Giotto, Raphael, Dürer, or Van Gogh?

And in conclusion, it must be emphasized that what is most important is not whether a form is personal or national, or whether it has style or whether it corresponds to a major contemporary movement, or whether it is related to many or a few other forms, or whether it stands alone, etc., etc.; *what is most important is whether or not a form results from inner necessity.**

The appearance of forms in time and space can also be explained as resulting from the inner necessity of a period and place.

Therefore, in the final analysis it will be possible to uncover and represent schematically the characteristics of an age and of a race.

And the greater an epoch is, i.e., the greater (quantitatively and qualitatively) the effort to achieve the spiritual, the larger will be the number of forms and collective efforts (movements). This is obvious.

The marks of a great spiritual epoch (which was prophesied and today is revealed in its early stages) are seen in contemporary art. That is to say:

1. a great *freedom,* which appears limitless to some and which

2. makes the *Spirit* audible, which

3. we see revealing itself with especially powerful *energy* in objects which

4. will gradually use and have already used all *spiritual spheres* whereby

5. a *means of expression* (forms) will be created for individuals and groups in every spiritual sphere, the visual arts (especially painting) included, and

6. for which today all the items in the pantry are being prepared, i.e., where *every material* is used as an element of form, from the most complex to those used only for two-dimensional (abstract) works.

P.S.

1. Concerning freedom: it is manifested in the effort made to free oneself from those forms which have already achieved their purpose, i.e., old forms; in the effort made to create new endlessly diverse forms.

* [Kandinsky's note:] I.e., form should not become a uniform. Works of art are not soldiers. A particular form for a particular artist might be excellent on one occasion and completely inappropriate on another. In the first instance the form was dictated by inner necessity, in the second by external necessity: pride and greed.

2. The instinctive search for the ultimate limits of our epoch's expressive means (personality, race, and period) is actually a check upon the seemingly unbridled freedom, a check defined by the spirit of the age and a definition of the direction which any search must take. The beetle which runs about in all directions under a glass dome believes he sees before him freedom without limit. But at a certain point he hits the glass; he can see farther but he cannot go any farther. If the glass is moved in a certain direction, the beetle can run farther, but only in that direction. The beetle's main movement then is determined by the hand guiding the glass—in the same way, our epoch, which considers itself totally free, will encounter limits which will disappear "tomorrow."

3. This apparently unlimited freedom and the intervention of the Spirit originate in the fact that we are beginning to experience the Spirit, the *inner sound* in everything. At the same time this growing sensitivity is the ripening fruit of apparently limitless freedom and intervening Spirit.

4. We cannot define here the effects of the above-mentioned upon all other spiritual spheres. However, it should be obvious to everyone that the collaboration of freedom and the Spirit will sooner or later affect everything everywhere.*

5. Today we encounter in the visual arts (especially painting) a remarkable variety of forms which reflect in part individual personalities and in part whole groups. All these forms are swept into a single, huge, well-defined forward-sweeping current.

 In spite of the variety of these forms, their common purpose is easily recognized. It is precisely in this collective movement that the all encompassing spirit of form can be recognized. Therefore, one can say: *everything is permitted*. What is permitted today cannot be overstepped and what is forbidden today remains absolutely forbidden.

No limits need be set for oneself since they are set all the same, and this applies to the sender (artist) as well as to the receiver (viewer). He can and must follow the artist and he should not worry about being led astray. It is physically impossible for man to move in an absolutely straight line (notice the paths in fields and meadows!), still less for him to move so spiritually. And it is precisely in spiritual mat-

* [K's note:] I have examined this matter in somewhat more detail in my book *Concerning the Spiritual in Art* [Munich: R. Piper Co., 1912; New York: George Wittenborn, Inc., 1947].

ters that the straight road turns out to be the long and false, while
the crooked road is the right road.

"Feeling," if permitted its voice, will sooner or later point the artist
as well as the observer in the right direction. An anxiety-ridden de-
pendence upon any *particular* form inevitably leads to a dead end.
Sincere feeling leads to freedom. The first is materialism. The second
—spirituality because the Spirit creates a form only in order to pro-
ceed beyond it in order to create another.

> 6. The eye which focuses upon a single point (whether it is form or
> content) is unable to see the broad vista. The careless eye which
> hastily scans surfaces can see the vista but is easily distracted and con-
> fused by superficials. This confusion arises from the great variety
> of materials and techniques which today's Spirit takes with apparent
> randomness from its pantry. Many call the present situation in art
> "anarchy." Here and there the same word is used for today's music.
> In this way people wrongly envision a purposeless subversion and
> chaos. But anarchism actually signifies planning and order, though
> not by external force or coercion but by an intuition of the *Good*.
> Here too there are limits, but these must be defined as *inner* limits
> which replace external ones. And these limits are steadily being
> extended. In this way freedom grows and creates that open road
> which leads to the Spirit.
>
> Contemporary art, which can be called anarchistic in the above
> sense, not only reflects the present spiritual level of the world but it
> embodies as a creative energy that next spiritual level which is ripe
> for revelation.

The forms for this embodiment which are taken by the Spirit from
the pantry of matter can be located easily between two extremes.

These two extremes are:

1. The great abstraction.

2. The great realism.

These two extremes open *two roads* which ultimately lead to a
single goal.

Between these two extremes are many combinations of abstraction
and realism.

These two were always present but were thought of as the "purely
artistic" and the "representational." The first expressed itself through
the second while the second supposedly served the first. It was a matter
of balancing different elements in order to achieve a perfect equi-
librium which would result in that perfection called the "ideal."

Der Blaue Reiter

Now it appears that this ideal no longer commands anyone's allegiance, that the two sides of the balance scale have split apart and rather than working together lead separate lives. Anarchism has been blamed for this destruction and it would appear that art is now through with nicely supplementing abstraction with representation and vice versa.

On the one hand abstraction has lost the diverting assistance of representation and the spectator feels the ground cut out from under him. He claims that art no longer has any foundation. On the other hand representation has lost the diverting idealization of abstraction (the "artistic" element) and the spectator feels as if he has been nailed to the floor. He claims that art has lost the ideal.

These criticisms result from underdeveloped feeling. The habit of concentrating upon form and the consequent practice of spectators demanding the accustomed form of harmonious balance have blinded people and prevented feeling from functioning freely.

The previously mentioned great realism which is now developing tries to purge the picture of everything artistic. It wants to manifest content by means of the simple ("inartistic") representation of simple, tough objects. The outer husk of the object so conceived and defined in the picture and at the same time the suppression of conventional beauty most certainly reveals the inner sound of the object. It is precisely through this husk that the soul of the object sounds strongest, since the "artistic" has been reduced to a minimum and superficial prettiness has been stripped away.*

And that is only possible because more and more we want to hear the world, not as a beautiful tune but as it really is.

Reduced to a minimum the "artistic" becomes comparable in effectiveness to the most intense abstraction.†

* [K's note:] The Spirit has already absorbed the content of conventional beauty and finds no new nourishment in it. The form of conventional beauty gives the lazy physical eye only conventional pleasures. The effect of the work remains merely corporeal. Spiritual experience becomes impossible and this kind of beauty frequently leads people away from, not to, the Spirit.

† [K's note:] *The quantitative reduction of the abstract is related to its qualitative intensification.* Here we touch one of the most essential laws: enlarging expression *outwardly* in certain cases results in a loss of inner vitality. Here $2 + 1$ is less than $2 - 1$. Naturally this law applies to even the smallest expressive forms: a spot of color often loses intensity and consequently effectiveness by being made larger and more striking. Color can be made exceptionally vivid and active through restraint; sweet color can produce painful sounds, etc. All of this is an expression

The great abstraction is the great antithesis to this realism. It results from an apparent determination to eliminate completely the representational (reality) and to embody content in "incorporeal" forms. The inner sound of a picture is revealed most effectively by abstract life conceived and established as a reduction of representational forms to a bare minimum and therefore as a preponderance of abstract entities. Just as the cancellation of abstraction intensified the inner sound in realistic art so the inner sound is intensified in abstract art by cancelling out realism. In the former, conventional prettiness muted the inner sound; in the latter it was the usual appearance of things.

In order to "understand" this kind of picture the same liberation as in realism is necessary, i.e., here too one must learn to hear the whole world exactly as it is without any representational interpretation. And in such work abstract forms (lines, planes, spots, etc.) are not important as such, but only as inner sound, as life. Just as in realism, neither the object itself nor its outer husk but its inner sound, its life is important.

*Reduced to a minimum the "representational" becomes comparable in effectiveness to the most intense realism.**

Thus, in conclusion: we see that in the great realism the real appears strikingly prominent and the abstract strikingly small and in the great abstraction the relationship is reversed. Thus, in the final analysis (goals) these two extremes meet. An image can be placed somewhere between these two antipodes:

Realism = Abstraction
Abstraction = Realism

The greatest external difference becomes inwardly complete identity.

A few concrete examples should make these ideas more meaningful. If the reader studies any particular letter in these lines naively, i.e.,

of the law of antithesis in its wider application. Briefly: *true form is the combination of feeling and science.* Here I have to refer to cooking again! Good food is produced by a good recipe (where everything is carefully measured in pounds and grams) and by feeling. An important characteristic of our age is the expansion of science and the scientific study of art develops accordingly. This is the "thorough bass" which of course will change and develop endlessly.

* [K's note:] Thus, at the other extreme we also encounter that law where quantitative reduction is related to qualitative intensification.

not as a sign for part of a word but as an *object,* he will appreciate that the letter, aside from being an arbitrary abstract shape functioning as conventional notation for a particular sound, is a physical entity which makes a specific external and internal impression in a completely independent way, i.e., independent of its above-mentioned function. In this sense a letter is made up out of:

1. A general shape = an overall configuration, which, to put it very crudely, appears "happy," "sad," "aspiring," "declining," "defiant," "proud," etc., etc.
2. Parts, lines which bend this way or that, lines which in each instance make a specific impression, i.e., also "happy," "sad," etc.

If the reader has reacted to these two aspects of a letter he has experienced the feeling which a letter produces as an independent entity with its own inner life. One should not reply that a particular letter will affect one person one way and another person another way. That is obvious and beside the point. In general, everything affects different people in different ways. The point is that a letter consists of two elements which combine to give forth a *single* sound. The separate lines of the second element can be "happy" and yet the overall effect (element 1) "sad." The separate movements of the second element are organic parts of the first. The same kind of construction and the same kind of subordination of separate elements to a *single* sound can be found in every song, every piano piece, and every symphony. And a drawing, a sketch or a painting functions exactly the same way. Here are revealed the laws of construction. But for us only one thing is important right now: letters function. And to repeat, they function on two levels.

1. A letter functions as a utilitarian sign.
2. A letter functions, first as form and then as the inner sound of that form, in an independent and completely autonomous way.

It is important to note that these two functions do not necessarily depend upon each other; the first function is purely external while the second is a matter of inner significance.

From this we may conclude that *external effects can differ from inner ones* which are determined by the *inner sound,* something that

is *one of the most powerful* and most profound *means of expression* in all compositions.*

Let us give another example. In this same book we can find a dash. This dash, if it is used conventionally—as I have done here—is a line with a practical function and meaning. Suppose we make the line longer but do not move it? Its meaning is not changed but the dash is given an indefinable quality because such elongation is very unusual. The reader may ask why the dash is so long and whether this length serves any useful purpose. Now let us put the dash in an incorrect spot (as—I do here). Its proper function disappears and at this point the question becomes much more serious. Perhaps there has been a misprint? i.e., a conventional and practical sign has simply been misplaced? This is a kind of negative reaction. Now put the same line, perhaps lengthened and curved, on an empty page. In this, as in the previous case, one expects a conventional and practical explanation (as long as there is any prospect of an explanation). Then (when no explanation can be found) the reaction is negative.

As long as this or that line is in a book one cannot completely exclude this conventional and practical interpretation.

But suppose we put a similar line in a context which is remote from conventional and practical concerns, e.g., on a canvas. As long as the observer (he is no longer a reader) interprets the line on the canvas as a means for defining an object he is still limiting himself to a conventional and practical interpretation of line. But the moment he appreciates that objects in a picture are usually incidental, not essential, and that sometimes line can have a purely artistic function,† at that moment the observer's soul is prepared to hear the *pure inner sound* of that line.

Are objects, things, therefore banished from the picture?

No. The line, as was mentioned previously, is a thing which is as much of a practical entity as a chair, a well, a knife, a book, etc. In the last example this thing, the line, was used in a purely artistic way, stripped of its other uses and therefore exists as pure inner sound. Thus, in a picture when a line no longer describes a thing but func-

* [K's note:] I can only touch upon these problems in passing. But if the reader delves more deeply, the power, the mystery, and the endless fascination—e.g., of the conclusion cited above—will become self-evident.

† [K's note:] Van Gogh, without wanting to dramatize the object in any way, used line as such with extraordinary energy.

tions as a thing itself, its inner sound is not muffled by other considerations. Its inner power is fully released.

Thus we may conclude that pure abstraction can serve things in all their corporeality as effectively as pure realism. Once again the greatest negation of objects and their greatest affirmation become identical. And this identity is the result of identical goals: the expression of the same inner sound.

Here we see that in principle *it makes no difference whether a realistic or an abstract form is used by an artist.*

Since both forms are inwardly identical. To the artist, the person who knows best, must be left the choice of which form most clearly materializes the content of his art.

Formulated as a general principle: *there is no problem of form.*

And even if there were, in principle, a problem of form there would also be a solution to this problem. And anyone with the solution would be able to create a work of art. I.e., at that moment art would no longer exist. Put in practical terms: the problem of form is changed into the problem of which form I should use in a particular instance so that my inner experience is most effectively expressed. In this case the answer will be absolute and scientifically precise, but for other cases, relative. I.e., a form which is best in one case can be the worst in another: everything depends upon inner necessity which alone can determine form. A particular form takes on a wider relevance only if the spirit of an age and the nature of a place permit. But this changes nothing as far as the relative nature of a form is concerned, since the right form in one instance still could be false in many others.

All the rules which have already been discovered in earlier art and which will be discovered in later art and which art historians take too seriously are not general rules: they do not create art. If I know the rules of cabinetmaking I can always make a cabinet. But if one knows the presumed rules of painting there is no guarantee that a work of art will be created.

These presumed rules, which will soon lead to a "ground bass" in painting are only the recognition of the inner effectiveness of expressive means, singly and in combination. But there will never be rules which will determine the right form for a specific case.

The practical result: *one should never believe a theoretician (art*

historian, critic, etc.) when he claims that he has discovered a specific objective error in a work of art.

And: *the only thing* which a theoretician can rightly claim is that up to now he had not seen such and such a form. And: the theoreticians who criticize or praise works from a point of view based upon previous works do nothing but dangerously mislead naive people and cut them off from art.

In light of the above, *art criticism is the worst enemy of art.*

The ideal art critic thus would not be someone who sought to discover "errors," * "aberrations," "ignorance," "borrowings," etc., etc., but rather someone who tries to determine how this or that form works inwardly, and then tries to effectively communicate his whole experience to the public.

Naturally such a critic would need the soul of a poet. A poet must feel objectively in order to embody his emotion subjectively. I.e., the critic would have to have creative power. However, in actuality critics are often unsuccessful artists who, frustrated in their own creativity, feel obliged to tell others how to create.

Furthermore, discussion about form frequently harms art because untalented people (i.e., people for whom art is not a matter of *internal* necessity) simply borrow forms from others and in this way counterfeit art and cause nothing but confusion.

I want to be precise here. Critics, the public, and frequently artists believe that it is a crime or a fraud to borrow forms. But actually this is true only when the "artist" uses forms without inner necessity and thereby creates nothing but a lifeless deception. However, if an artist uses a particular borrowed form because he is convinced that it is true for him and because it honestly expresses his inner excitement and experience, then he is exercising his right to use any form which *inner necessity* dictates—be it a utilitarian object, a heavenly body, or an artistic form ready made by someone else.

For quite some time now the whole question of "imitation" † has

* [K's note:] E.g., "anatomical errors," "distortions," etc., and later offenses against the approaching "thorough bass."

† [K's note:] Every artist knows how fantastic critics have been in this respect. Critics know that they can make the most absurd statements with impunity. E.g., a short time ago a Negress by Eugene Kahler, a good naturalistic studio piece, was compared to . . . Gauguin! The only possible explanation for this comparison must have been the model's brown skin (see *Münchner Neueste Nachrichten*, XII, 1911), etc., etc.

been taken too seriously by the critics.* The living remains. The dead vanishes.

As a matter of fact, counterfeits and frauds become fewer and fewer the farther back we go in history. They seem to disappear mysteriously while true art survives; i.e., those works which have a soul (content) in their body (form).

Let the reader examine any object on his table (even a cigar butt) and he will notice these two levels of expression. It does not matter where or when (in the street, church, heaven, water, barn, or forest) the two levels of expression reveal themselves everywhere and everywhere the inner sound is independent from conventional or external meaning.

The whole world rings out. It is a cosmos of spiritually expressive beings. Even dead matter is actually living spirit.

At this point, if we draw the necessary conclusions from the independence of the inner sound, we shall appreciate that the inner sound is intensified when it is separated from conventional practical meanings. That is why children's drawings have such a powerful effect upon independent-thinking, unprejudiced observers. Children are not worried about conventional and practical meanings, since they look at the world with unspoiled eyes and are able to experience things as they are, effortlessly. Conventional and practical meanings are slowly learned later, after many and often unhappy experiences. Thus, without exception, every child's drawing reveals the inner sound of objects. But adults and especially teachers make every effort to instill in children conventional and practical meanings. They criticize the child's drawings specifically from this superficial point of view: "Your man cannot walk because he has only one leg," or "no one can sit on your chair because it is crooked," etc.† The child laughs at all this. But he should cry.

Now the gifted child not only ignores externals but has the power to express the internal so directly that it is revealed with exceptional force (as they say, "so that it speaks!").

Every form has many aspects and in a form one constantly can discover new and wonderful qualities. However, at this point I only

* [K's note:] Thanks to the prevailing overestimation of this question, the artist is insulted with impunity.

† [K's note:] As is so often the case: those who are taught should teach. And later people wonder why gifted children do not amount to anything.

wish to emphasize one important aspect of childrens' drawings: composition. Here we are impressed by the unconscious, almost automatic use of both qualities of the letter which were previously discussed, i.e., (1) the *overall appearance,* which very often is quite precise and sometimes even schematic, and (2) *separate parts,* the *forms* which build the great form but nevertheless possess an independent life of their own (e.g., the "Arabians" by Lydia Wieber) [illustrations omitted here]. There is an enormous and unconscious power in children which makes their work as great (and often greater) than that of adults.*

Every flame dies down, every early bud is menaced by frost and every young talent by academies. These are not tragic words but a tragic fact. Academic training is guaranteed to ruin a child's creative power. Even very great and very strong talents are retarded by the academy. Weaker talents are destroyed by the hundreds. An academician of mediocre talent succeeds by demonstrating that he has mastered conventional and practical meanings and lost the ability to hear his own inner sound. Such a person makes "correct" but dead drawings.

An empty illusion is never produced when someone without any formal training or technical knowledge paints something. And this demonstrates the force of an inner power which is scarcely influenced by conventional and practical meanings.

The inner sound is intensified in this kind of painting because such meanings as well as external details are more or less ignored (less so than in children's works, but significantly so all the same). Nothing dead is produced. Only living works!

Christ said: "Let the little children come unto me for of such is the Kingdom of Heaven."

The artist, whose life is comparable to a child's in many respects, frequently can reach the inner sound more easily than anyone else. In this respect it is especially interesting to see how the composer Arnold Schönberg paints—simply and confidently. As a rule he is interested only in the inner sound. He omits, without regard, all embellishments and refinements and the "poorest" form in his hands becomes the richest (his self-portrait, for example).

Here lies the root of the new Great Realism. The object is separated from conventional and practical meanings by a complete but

* [K's note:] "Folk art" also has this amazing formal power. (E.g., see the votive picture of the plague from the church at Murnau [omitted here].)

absolutely simple representation of its outer husk which permits the inner sound to be heard, clearly and easily. Henri Rousseau, who is the father of this type of realism, indicated the way with simple and convincing work (look at his portraits and other pictures).

Henri Rousseau revealed the new possibilities of simplicity. And at the present moment this is the most important aspect of his many-sided genius.

Objects, or the object (i.e., it and its component parts), must be in some sort of relationship. This relationship can be shockingly harmonious or shockingly dissonant. Clearcut or extremely subtle rhythms can be used.

What impels artists of all types toward a common goal today is their irresistible determination to clarify form and to reveal the future laws of our great epoch.

Naturally, in such cases people tend to use the most regular and most abstract shapes possible. Thus we see that the triangle was used as a basis of composition in various periods in the history of art. The triangle was often equilateral and in this way number became important, i.e., the completely abstract aspect of the triangle. In today's search after abstract relationships, numbers play an especially important role. Every numerical formula is cool like an icy mountain peak and, in its conformity to rule, solid like a marble block—cold and solid like every necessity. Cubism, so-called, originated in the desire to compose according to specific rules. "Mathematical" construction sometimes culminates in the complete destruction of an object's conventional physical unity and leads to extremely important results (e.g., Picasso).

The ultimate goal of this approach is to construct a picture which, through its own pictorial means, will assume an independent and vital existence. If this approach can be criticized at all in a general way it would be on the grounds that its use of number is *still* too limited. Everything can be signified by a mathematical formula or merely by numbers. However, there are many different numbers: 1 and 0.333 . . . both are good numbers, both are living beings with an inner sound. Why should anyone be satisfied with number 1. Why exclude 0.333? Apropos of this: why limit expression to the *exclusive* use of triangles and similar geometric shapes? However, to repeat: "Cubism" is a part of a necessary endeavor to create pure, painterly entities, entities which on one hand are linked to objects and speak

through objects and which, on the other hand, by means of various combinations with more or less expressive objects are finally transformed into pure abstraction.

Between pure abstraction and pure realism lie all the possibilities for combining elements in paintings. The reproductions in this book [omitted here] demonstrate how large and varied the possibilities for combination are, how life can pulsate in every one of these pictures and how uninhibited one can be in regard to the problem of form.

Various combinations of abstraction and realism, choices among an infinite number of abstract or representational forms, i.e., the choice of separate means in both areas, are and remain dependent upon the artist's inner wish. Forms, proscribed or despised, forms which appear to be apart from the mainstream of artistic development, these forms merely wait for the right master. This form is not dead, it has only sunk into a kind of lethargy. When the content, the Spirit which only manifests itself through this apparently dead form becomes ripe, when the hour is ready for its materialization, the Spirit will enter into this form and speak through it.

Moreover, the layman especially should never approach a work with the question: "What did the artist *fail* to do?" Or put another way: "How did the artist neglect *my* wishes?" He should rather ask himself: "What did the artist do?" Or, "What inner wish did the artist express here?" I also believe that the time will come when critics will see their task not as a search for negative qualities and defects but as a search for and communication of positive qualities and valid insights. One of today's "important" critical issues is the problem of how to distinguish the false from the valid in abstract art, i.e., how to ferret out negative qualities.

Our approach to art should be different from buying a horse. One major flaw can make a horse worthless; with art the reverse is true and one important positive quality can overcome all flaws and make a work valuable.

If this simple principle were respected, the main problems of form in an absolute sense would instantly disappear; of course, the problem of form in its relative sense would remain. However, the artist would now have, among other things, the right to choose his own forms according to their relative importance for him and for the particular work he is making.

To conclude these unfortunately hasty observations on the prob-
lem of form I would like to refer to the compositions of several works
reproduced in this book [omitted here]. I.e., I am forced to concen-
trate here upon only one vital aspect and to ignore all the others
which characterize a particular work and the spirit of its creator.

The two pictures by Matisse demonstrate how "rhythmical" com-
position ("The Dance") has an interior life as well as a sound which
differs from a composition where the parts seem to have been assem-
bled in an unrhythmical fashion ("Music"). This comparison is also
an excellent proof that harmony can be found not only in clearcut
patterns but also in rhythmical structures.

Objects do not necessarily have to be destroyed in order that their
abstract sound be heard. The picture by Marc ("The Bull") proves
that there are also no general rules in this matter. Thus, objects can
keep both their inner and outer sounds, and their separate parts
can be transformed into independently sounding abstract forms and
in this way produce an overall major abstract sound.

The still life by Münter shows that dissimilar and uneven treat-
ment of objects is not harmful, but when properly done actually
produces a powerful and complex inner sound. The external sound
which seems dissonant is, in this case, the origin of the harmonious
inner effect.

Le Fauconnier's two pictures are strong and very instructive exam-
ples; similar "relief" forms achieve two absolutely different effects
through a different division of "weights." The *"Abondance"* rings
out with an almost tragic weightiness while *"Paysage lacustre"* re-
minds one of a simple lyrical poem.

If the reader is able to free himself for a while from his own wishes,
his own thoughts, his own feelings and skims through this book, going
from a votive picture to Delaunay, from a Cézanne to a Russian folk
print, from a mask to Picasso, from a glass painting to Kubin, etc.,
etc., then his soul will experience many vibrations and he will enter
into the world of art. Here he will not be bothered by outrageous de-
fects or aggravating errors. Instead he will experience a spiritual plus
instead of a minus.

Later the reader can examine works of art objectively and analyti-
cally. He will then find that all the examples cited obey a common

inner call—composition, that they all have a common base—structure.

The inner content of a work can belong to either one or the other of two types. Today these two types (only today? or only obvious today?) embrace all secondary movements.

These two types are:

1. The disintegration of the souless, materialistic life of the nineteenth century, i.e., the destruction of the very basis of matter, its fragmentation into parts and then the dissolution of those parts.

2. The creation of the spiritual and intellectual life of the twentieth century, our era, which already is manifested and embodied in strong, expressive and well-defined forms.

These two types are the two aspects of the "modern movement."

To define what has already been achieved or even to define the final goal would be a presumption which would be punished by a frightful loss of freedom.

As has been often observed, we should strive for more freedom, not greater restriction. One should reject nothing without making *every effort* to uncover its vital, living qualities. It is preferable to mistake a dead for a living thing than ever, even once, to mistake something living for something dead. *New growth* needs free and open ground and the free person is inspired by every experience, affected by every aspect of life, even if it is only a burnt match.

That which is coming can be taken up only by free people.

One cannot stand aside like the barren tree in the Bible, the tree which Christ saw as ready and waiting for the ax.

Franz Marc

Born 1880 in Munich. Killed 1916 at Verdun. First studied phi-
losophy and theology; then art at the Munich Academy 1900–
1903. Trip to Italy 1902. In Paris 1903 and 1907. Settled in
Sindelsdorf, Bavaria 1910. Met Macke 1909. Met Kandinsky
1910. Co-founder of *Blaue Reiter* 1911. Went to Paris with
Macke and met Delaunay 1912. Settled in Ried, Bavaria and
then entered army 1914.

Marc was as devoted as Kandinsky to developing the spirit-
ual powers of color and form. His early work was conventional
but in his desire to convey deeper meanings he evolved dur-
ing the years 1907–1912 an almost abstract style based upon
brilliantly colored transparent planes and animal forms. Marc
believed that animal existence was purer and closer to the
secret forces of the universe and therefore he used animal
forms as a means to express his intuitions about those forces.
By 1914 he felt that even this animal symbolism had to be
suppressed for the sake of "the inner truth of things."

Although Marc never published as much as Kandinsky,
he was as interested as the Russian master in coordinating
his work into a *"Weltanschauung"* or philosophical system.
It is probable that only his untimely death prevented him
from a systematic presentation of his theories. As it was, his
correspondence and aphorisms fill several volumes, and they
reveal not only a sensitive but a critical intelligence fully the
equal of Kandinsky's. The letters to his wife and to his friend
August Macke are especially revealing. One of the most in-
teresting of these has been included in this section.* In this
letter to Macke, Marc touches on topics ranging from primitive
art to modern music. Of special note is Marc's comparison
between Schönberg's atonality and Kandinsky's use of color.

The essays by Marc which have been translated for this
section, "Germany's 'Savages,' " and "Two Pictures"—were

* *August Macke, Franz Marc, Briefwechsel* (Cologne: Verlag M. DuMont Shau-
berg, 1964), pp. 39–42. Letter dated January 14, 1911. Translated for this volume
by the editor with permission of Verlag M. DuMont Schauberg.

part of his contribution as co-founder and co-editor to the *Blaue Reiter* "Almanac," and since they were lead articles they can be read as a virtual manifesto of the movement.*

Marc, only thirty-six when he was killed in battle, was perhaps just beginning his real development as an artist. In any case, his experience in war, although it suggested to him that he should re-evaluate his ideas about art, merely strengthened his conviction that material reality was an illusion and that true reality was spiritual.†

Letter to August Macke

Sindelsdorf, January 14, 1911

Dear August,

I'm back from Berlin safe and sound; Maria‡ isn't doing so well; her appendix was infected but luckily it was caught in time and she didn't need an operation; bed rest and a strict diet cured her. To make her happy, her parents had insisted that I visit them and they were so pleasant and friendly that I had quite a jolly time. I visited Nauen,§ who showed me a number of his things (at his place and at H. Talbot's). His Kalkreuth period repels me (like my own earlier things but with this difference, I cut up as many of mine as I could). But what he did this past year was superb. With such work he'll end up in the arms of the *Vereinigung*‖ (he doesn't seem to realize this himself; I believe he actually resists the idea; but it won't help him any!). He is seriously thinking about coming to Munich and this would really please me.

Naturally I also went to see Koehler¶; quite innocently I asked

* "Die 'Wilden' Deutschlands," and "Zwei Bilder," *Der Blaue Reiter* (München: R. Piper & Co. Verlag, 1912, 1965). Translated for this volume by the editor by arrangement with The Viking Press, Inc., and Thames and Hudson Ltd.

† For Marc's interpretation of the war, see *In War's Purifying Fire* in Part Five of this anthology.

‡ Franz Marc's wife.

§ Heinrich Nauen (1880–1940), sometimes classified as a "Rhenish Expressionist."

‖ *Neue Künstlervereinigung* ("New Artists' Federation"), Munich; sometimes called simply NKV. It was founded in 1909 under the leadership of Kandinsky and Jawlensky. Franz Marc joined in February 1911. This association can be considered the immediate predecessor of the *Blaue Reiter*.

¶ Bernhard Koehler (d. 1964), a Berlin collector and special patron of the *Blaue Reiter*.

him about that bronze head which you were supposed to have sent him this past summer. He didn't know anything about it so I immediately said that I probably had misunderstood you—damn it! But you told us that you modeled a head, had it cast and sent it to him, or did I dream this whole thing up? Koehler's coming to Munich soon.

I spent a lot of time in the Museum of Ethnology in order to study the art of the "primitives" (a word Koehler and most other critics like to use when they talk about our work). Well, in the end I was held spellbound by woodcarvings from the Cameroons; perhaps only the sublime work of the Incas is better. It seems obvious to me that we should look for rebirth in the cold dawn of that kind of artistic intelligence and not in cultures like the Japanese or the Italian Renaissance which have already passed through a thousand years of development. In one short winter I've become a completely different person. I believe I am really coming to understand, little by little, what it means to be an artist; we will have to become ascetics—don't get excited; I'm only talking about intellectual matters. We will have to renounce absolutely almost everything which was precious and indispensable to us as good Central Europeans; our ideas and ideals will have to wear hairshirts; we will have to feed them grasshoppers and wild honey, not history—we must, in order for all of us to escape our tired European lack of taste. Well, smile at my comical sermon; I delivered it, not to *you* but to *myself.*

Some music I heard in Munich gave me a real jolt; chamber music by Arnold Schönberg (Vienna).* Two quartets, piano pieces, and songs. It was the only concert I attended this winter—I knew something was up and I got the *Vereinigung* to come along; besides, they also must have had their suspicions. The audience behaved like rabble, like

* The piano work by Schönberg (1874–1951) which Marc heard was "Three Piano Pieces" (Opus 11, 1908), pieces which decisively broke with traditional harmonics and heralded a musical revolution. Marc sent the score for these works to his wife Maria, who was in Berlin at the time. Her response was enthusiastic and she suggested that the music was comparable to the pictures of the *Vereinigung.* In another letter to Macke (Feb. 14, 1911) Marc wrote: "Recently I had a long discussion with Kandinsky about Schönberg and told him about Maria's conclusion, which was for me rather surprising (she claims that he works with completely unresolvable mixed tones, without any tonal color, only *expression*). Kandinsky enthusiastically agreed! He said that that was his own goal; "beautiful color," the merging of his colors into a single grand harmony was a *faute de mieux* in his work which he still had to overcome."

silly children; they snuffled and coughed, giggled and squirmed so
that it was difficult for us to follow the music. Can you imagine music
in which tonality (that is, the retention of any key) is completely
abandoned? Listening to that music, I kept thinking of Kandinsky's
large composition, which hasn't any tonality either (*in contrast* to
Bechtejeff and Erbslöh* and also of Kandinsky's "jumping spots."
In the music each tone stands by itself—like *white canvas* between
color spots! Schönberg works on the principle that consonance and
dissonance don't exist at all. So-called dissonance is only a conso-
nance which has been stretched. I'm really preoccupied with this idea
in painting and I use it like this: complementary colors don't have to
be near each other as in a prism, separate them as far as you want.
The partial dissonances which arise are resolved in the overall appear-
ance of the painting, they become consonant (harmonious) insofar as
they are complementary in their extension (size) and their intensity.
For example, when I paint the interior of a forest, instead of doing
the trees in complementaries keyed to the requirements of light and
shade as well as setting, I paint one pure blue, the next pure yellow,
green, red, violet, etc. (as many colors as I see in nature, although in
nature they are blended and intermixed). In the same way I separate
the color of the terrain and foliage into distinct, pure colors which I
distribute over the entire painting, not with any exact idea about
the juxtaposition of complementaries but with artistic sensitivity and
instinct. Whether or not I have used colors in proper relationships
will be determined by the prism; if I have, it will mirror a pure pic-
ture. From my own experience the prism definitely does not demand
that complementaries be *juxtaposed* in any picture.

Naturally, what "is most fervently desired" is to achieve something
like that without any theoretical formulation, by working like the
primitives purely in terms of a healthy color instinct. Our superiority,
our "Europeanness" resides in the fact that we want to make "pic-
tures" in those terms and not just brightly colored pillars and capitals,
straw hats and pots.

Like the *Vereinigung*, Schönberg seems convinced of the inevitable
dissolution of the laws of European art and harmony. He uses the
musical devices of the Orient, which up to now have remained primi-

* Vladimir von Bechtejeff (b. 1878) and Adolf Erbslöh (1881–1947) were members
of the *Vereinigung*.

tive. Unfortunately I don't know enough about music to tell you anything more but possibly people in your circle know something about it; (but hardly where Beethoven is always being played; how does he impress you?). After the concert we drank several bottles of wine in the Ratskeller with Kandinsky, Jawlensky, Münter, and Werefkin. Werefkin ordered an artichoke. Helmuth, who wasn't familiar with this vegetable, asked in all innocence whether it was a lotus flower—what a scene!!! *

I discussed the musical problems quite a bit with Maria and also showed her your letter; she can't get anywhere with the analogies you draw between color and musical tones; she has quite different ideas about these matters and in her present hermit's life she is trying to define and organize them. At first she explored the idea of comparing keys (and their combinations) to tones but, nothing *practical* resulted, and that was the purpose of the study. But she made many very good comparisons between minor and major keys and pictures, minor–warm and major–cold, with less reference to separate colors than to the quality of an entire picture; Kandinsky is major, Bechtejeff minor (in his "Battle of the Amazons" and in the "Hesperides") with several chords in a major key produced not by color but by form (the sharp angles and the "cold line" in the "Hesperides"). Jawlensky's "White Feather" is minor but most of his other things are major; Erbslöh is pure minor. On the other hand, there is a nude by Erbslöh which isn't very successful and at first it's impossible to say why. According to Maria it's been painted in a major key instead of minor *as it should have been*. You can test this with music where such falsely conceived works do exist.

If we ever get to Bonn we'll make the test together.

Did you know that Cassirer suddenly refused to exhibit the collection after he had it sent by express from Hagen under a signed contract for a January show? † The reason: they were not, as the contract had stipulated, "works by Munich artists"!! Erbslöh natu-

* Alexeij Jawlensky (1864–1941), Marianne von Werefkin (1860–1938), Gabriele Münter (1877–1962), and Helmuth Macke (1891–1936, August Macke's cousin) were all artist friends of Marc and Kandinsky and members of the *Vereinigung*.

† Paul Cassirer (1871–1926). The most influential dealer and supporter of modern art in Berlin. He was particularly close to Impressionists Max Liebermann (1847–1935) and Lovis Corinth (1858–1925) but he was also a patron of Expressionists such as Beckmann, Kokoschka, Meidner, and Barlach.

rally sued. I'm very curious how it will turn out. No doubt about it, Liebermann and Corinth are behind the whole affair and have a knife at Cassirer's throat.

At any rate, apparently there is a new art dealer* in Berlin; the enterprise already seems financially secure; quod dii bene vertant.

Your surprise at this long letter will serve you right. You are being punished for your own laziness as a letter writer. The good Helmuth is quite angry that you didn't write a word about his Watteau; you could at least bawl him out (it would do him good), but to write absolutely nothing, that's too little—understand?

What are you up to? What about the studio? Are you even painting? Or are you listening to all kinds of Beethoven in order to prepare yourself for that asceticism that I've been writing about—it wouldn't be a bad idea.

Well adio; friendliest greetings to your wife and write again, even if it's just a little fart of a note. Your FRZ. MARC

"Germany's 'Savages' " †

In this epoch's great battle for a new art, we fight as disorganized "Savages" against an old, well-organized power. The battle seems unequal; but in spiritual matters victory is never determined by number but by strength of ideas.

New thoughts are the dreaded weapons of the "Savages"; they kill better than steel and they destroy the indestructible.

Who are these "Savages" in Germany?

Many of them are well-known and much-ballyhooed: the Dresden *"Brücke,"* the Berlin *"Neue Sezession,"* the Munich *"Neue Vereinigung."*

The oldest of the three is the *"Brücke."* From the very start it was in dead earnest, but Dresden was unreceptive and the rest of Germany was not yet ready for their ideas. Not until several years later did the exhibitions of the two other groups bring a new and a dangerous vitality to the nation.

* Herwarth Walden: see footnote, p. 4.
† *"Die 'Wilden' Deutschlands"* in the original German. As Marc uses it, the word *"Wilden"* might appropriately be translated *"Fauves,"* in reference to French developments of the time.

At first the *"Neue Sezession"* was recruited partially from among the membership of the *"Brücke."* However, it was actually formed by dissatisfied members from the old *Sezession* who felt that things were moving too slowly. They boldly climbed that dark wall behind which the old Secessionists had entrenched themselves, and stood suddenly, as if blinded, before the infinite freedom of art. They have no program and are restrained by nothing; they only want to move forward no matter what the cost like a large river that sweeps everything along, the possible and the impossible, trusting only in its purifying power.

We are so close to events that we cannot separate the noble from the weak. Moreover, criticism would touch only what was insignificant and would be embarrassed and helpless before the defiant freedom of this movement which we of Munich greet with tremendous joy.

The origin of the *"Neue Vereinigung"* is subtler and more complicated.

The first and only serious exponents of the new ideas in Munich were two Russians who worked here quietly until several Germans joined them. With the formation of this group there began those rare and beautiful exhibitions which became the despair of the critics.

Characteristic of the artists in this group was their strong emphasis upon a *program;* they learned from each other; it was a mutual competition to see who best understood the theories involved. Of course, the word "synthesis" was sometimes heard much too often.

The young French and Russian artists who exhibited with them as guests had a liberating effect. They made one think. One came to understand that art was concerned with the deepest things, that a true revival could not be a matter of form but had to be a spiritual rebirth.

Mysticism awoke in their souls and with it the primeval elements of art.

The recent works of these "Savages" simply cannot be explained as a logical development and transformation of Impressionism (e.g., B. W. Niemeyer in *Denkschrift des Düsseldorfer Sonderbundes*). For these "Savages" beautiful prismatic colors as well as famed Cubism become unimportant.

They have a different goal: to create *symbols* for their age, symbols for the altars of a new spiritual religion. The artist as technician will simply vanish behind such works.

Ridicule and lack of understanding will be like so many roses scattered along their path.

Not every member of the "Savages" inside or outside Germany has this kind of art and this high goal in mind.

So much the worse for them. After a few quick victories their superficiality will destroy them along with their programs, cubistic and what have you.

On the other hand, we believe—or at least hope we can believe—that in addition to these groups of "Savages" in the forefront, others in Germany strive for the same goals with quiet power, and that somewhere ideas are maturing peacefully unknown to the leaders in today's battles.

We give them, whoever they may be in the darkness, our hand.

"Two Pictures"

Wisdom must be vindicated by its children. If we are wise enough to teach our contemporaries, our works will have to demonstrate our wisdom and prove it indisputable.

We are not afraid of a test by fire. We are willing to make it as difficult as possible by placing our works, which point to the future and are still unproved, beside works of old time-tested cultures.* We do this because there is no better way to illustrate our ideas than through such comparisons; no matter how different in expression, one honest work can always stand comparison to another. Furthermore, the hour is right for such a confrontation since we believe that we are now at the juncture of two long ages; such presentiment is not new; the call was even louder a hundred years ago. Back then people thought the new age was close at hand, much closer than we think it is today. An entire century passed, during which time a lengthy evolution occurred at a furious pace. Humanity raced through the last stage of that thousand-year period which had begun after the collapse of the great, ancient world. At that time the "primitives" laid the foundation for a long, new artistic development, and the first martyrs died for the new Christian ideal.

This long development in art and religion has now run its course.

* The reference here is to the illustrations for the *Blaue Reiter* "Almanac."

But everywhere ruins remain, old ideas and old forms which refuse to vanish even though they now belong to the past. These old concepts and creations linger on like ghosts; and a Herculean task faces us—how can we dispel them and make room for the new which is already waiting? There is no one to advise us.

Science works negatively, *au détriment de la religion*—what a dreadful confession for all intellectuals.

Indeed, a new religion has made its presence felt throughout the nation, still without a spokesman and identified by no one.

Religions die slowly.

But style, the inalienable possession of an earlier age, collapsed catastrophically in the middle of the nineteenth century. There has been no style since then; as if swept away by an epidemic it is perishing all over the world. Since then, what serious art there is, has been made by individuals;* these have nothing to do with "style," since they are unrelated to the style and the needs of the masses. On the contrary, these works were made in defiance of their times. They are stubborn, fiery signs of a new age and they are appearing everywhere. This book† shall be their focus until the dawn comes and removes that unreal quality which they seem to have for our period. What looks unreal today will be natural tomorrow.

Where are these signs and these works? How can we recognize what is honest?

As with every honest thing—the inner life guarantees its truth. In art anything created by a truth-loving spirit without any regard for conventional external effects will be honest for all times.

We placed two small examples [illustrations, omitted here] at the beginning of this article in order to demonstrate the point: on the right a popular illustration from *Grimms' Fairytales* from the year 1832, on the left a picture by Kandinsky, 1910. The first is honest and completely sincere like a folksong and was loved and understood in its day simply as a matter of course. In 1832 journeymen and princes had the same feeling for art and such feeling produced this picture. Everything honest created at that time had this pure and untroubled relation to the public.

* [Marc's note:] In France, e.g., Cézanne and Gauguin to Picasso; in Germany, Marées and Hodler to Kandinsky; no evaluation of these artists is intended, merely a suggestion of the development of expression in France and Germany.

† I.e., the *Blaue Reiter* "Almanac."

Now we believe that anyone who appreciates the warmth and artistry of the old fairytale picture will experience in Kandinsky's work, its modern counterpart, a comparable warmth of expression even though he cannot enjoy it with the same directness as the good Biedermeier of 1832 enjoyed his fairytale picture. But for such a natural relationship the prerequisite and basic condition is that the "nation" have style.

Since this is not the case today, a chasm *must of necessity* separate honest art from the public.

It cannot be otherwise because the artistically gifted no longer have a nation's artistic instinct to support them. This instinct has vanished.

But perhaps this very situation will encourage serious reflection. Perhaps the viewer will nevertheless begin to dream before a new picture until it creates a new vibration in his soul?

Today's isolation of the unusual, honest artist is, at the moment, absolutely unavoidable.

This sentence is quite clear; only the cause has not been identified.

Concerning this we believe the following: since nothing happens accidentally or without an organic basis, and the loss of an instinct for style during the nineteenth century was no exception, this fact too has helped convince us that we are at the juncture of two long ages just like people 1500 years ago who were living during a transitional period which had neither art nor religion, when what was great and old died while the new and the unforeseen took its place. Nations would not have wantonly slain nature except for religious and artistic ideals. And we also live in the conviction that we are now able to proclaim the first signs of a new age.

The first works of a new age are exceedingly difficult to define—who can say what their goal really is or what their consequences will be? But the fact alone that *they do exist* and that they are the products of numerous independent factors and that they are profoundly honest makes us positive that they are the first signs of the dawn of new epochs—beacons for pathfinders.

This moment is unique—are we being rash in calling attention to the small and unique signs of a new age?

August Macke

Born 1887 in Meschede, Germany. Killed 1914 in Champagne, France. Studied at the Düsseldorf Academy 1904–1906. Travelled extensively: Italy, Holland, Belgium, France. Met Marc 1909. Joined *Blaue Reiter* 1911. With Marc met Delaunay 1912. With Klee and Moillet went to Tunisia 1914. Entered army 1914.

Macke was deeply impressed by Delaunay's fusion of cubist forms and rich color. His enthusiastic response to this development doubtlessly influenced both Marc and Klee. However, of all these artists (including Delaunay), Macke's modernism was the least metaphysical. Indeed, the simple gaiety and the gentle lyricism of his oils and watercolors were in striking contrast to the works of almost all the other Expressionists. Moreover, Macke disliked theorizing about either art or life and his published statements were relatively few. The two most important were "Masks," which appeared in the *Blaue Reiter* "Almanac" and "The New Program." * In both the artist preferred to talk about "vivacity" rather than "spiritual values." And what he said about European aesthetic theory in "Masks" could have been directed as much against the *Blaue Reiter* love of theory as against the Academy: "Forms, as if scorning European aesthetic theories, speak out in an exalted language no matter where we find them—in children's games, in a coquette's hat, or in the joys of a sunny day."

"The New Program"

The tension between things in nature excites us. We react to this tension as we attempt to give it form.

Life is indivisible. Pictorial life is indivisible. Pictorial life is generated by a simultaneous tension between different parts.

* August Macke, "Das neue Programm," *Kunst und Künstler*, XII (Berlin, 1914), 299ff. In addition to Macke, other Expressionists were asked about their "new program." In this anthology see, for Schmidt-Rottluff, Part One, pp. 28–29; for Beckmann, Part Three, pp. 106–7; and for Meidner, Part Three, pp. 111–15.

This vital tension is dissipated as parts and groups of a whole become more and more uniform. Dripping or rushing water. A completely painted canvas.

Vital tension grows as parts and groups become more diverse. A Mozart sonata. A still-life by Renoir or Cézanne.

In details from old pictures the transitions are usually gentle. Individual tensions usually combine with the tension of the whole in terms of a quiet contrast. (There are exceptions of course, e.g., El Greco). Delacroix and the Impressionists, it seems to me, were the first to appreciate fully the importance of space creating contrasts of color (as opposed to chiaroscuro) for the vitality of a picture. From then on people have been trying to use these means in order to give a unified structure to pictorial space.

For example, units made up of contrasting colors are present in Pissarro's and Signac's work. However, these are so uniform, so closely lined up next to each other, like letters on a printed page, that they produce an almost overall gray quality. In Cézanne's work these units are welded into an absolute whole so that the impression approximates the closed unity of a single letter.

What is unique about the "new" pictures is that in every detail they have units of contrast, either colored, a shocking red-green-yellow combination for example, or more formal, a series of colliding planes and edges. Most new pictures, in my opinion, seem to be constructed so that a maximum overall contrast is built up out of contrasting parts, unlike earlier pictures with their gently fused and subtly contrasting elements.

In spite of their differences I believe that most of the "new" painters have in common the desire to intensify through contrast the vitality of their pictures. Picasso abandoned the old masterly calm of his early pictures in order to strive for a dynamic tension, which he generated by means of planes which were, however, closely related in color. Movement in his pictures is created by a simultaneous clash of antagonistic planes. Matisse, in his own way, developed impressionistic devices into a structure which was freely and boldly expressive of his experience of nature. But he is not always able to give his color depth; it usually remains two-dimensional. Delaunay, without using chiaroscuro, combines contrasting colors (or perhaps better put, he divides them but, nonetheless, creates a unified effect) so that a powerful motion back and forth in depth results, a motion which he structures not

only in quite realistic pictures but also in works where motion is an end in itself. He actually creates motion, the Futurists only illustrate it (much as the Japanese illustrate the motion of rain, the cavemen a running herd of reindeer, or Wilhelm Busch draws old drunken Meyer). As soon as a Futurist has motion in his picture he is satisfied.

Similarly, in many old pictures, as soon as the painter becomes too interested in illustration, one is inclined to criticize everything pious, pathetic, feudal, or cheerily anecdotal as superfluous and harmful to the direct structuring of life. There are parts of some fifteenth-, six-teenth- and seventeenth-century pictures which are false ·and super-ficial—a good peasant dance but a bad glaze. Modern sensibilities have changed in regards to all art. And very rapidly too. When did we be-gin to admire as truly great artists the Egyptians, the early Greeks, the early Christian and Romanesque painters, the Chinese, and the primitives? A short time ago we excused them because they were un-able to do any better. However, just so that people do not attack me for my enjoyment of exotic art I want to acknowledge how much I love Giotto, the Sienese, the Cologne Masters, the early Flemings, the School of Ferrara, many Dutch still-life painters, Manet, Renoir, and much else which reveals a true sensitivity to "vivacity." Vivacity does not always have to be realized in terms of imitating nature. I doubt whether many "art lovers" would agree with Herr Privy Councillor Bode who, in an attack upon the "new art" a short time ago, defined art as the imitation of nature. It was the desire for living, vital ex-pression, without benefit of an art critic's permission, which built the Gothic cathedrals, which created Mozart sonatas and Negro masks and dances. And I believe that it is going to stay that way for a long time to come.

Paul Klee

Born 1879 at München-Buchsee near Berne, Switzerland. Died 1940 at Muralto near Locarno. Studied art in Munich 1898–1901. Italy 1901. Berne 1902–1906. Moved to Munich 1906. Met *Blaue Reiter* group. Met Delaunay in Paris 1912. Went to Tunisia with Macke and Moillet. Served in the German army 1916–18. Taught at Bauhaus 1920–31. Professor at the Düsseldorf Academy 1931–33. Moved to Switzerland 1933.

Although Klee did not reach artistic maturity until after the *Blaue Reiter* had disbanded, his association with the group was anything but superficial. The broad interests and aims of this movement were crucial to Klee, who was a talented violinist, wrote poetry, loved theatrical productions, and could philosophize with an almost Nietzschean keenness, and yet lacked confidence in himself.* Personal contacts with Marc, Macke, and Kandinsky gave him much-needed encouragement for both art and life.

Klee's mordently witty drawings and prints brought him his first recognition. His painting developed more slowly and it was not until he was thirty-five (1914), after studying Delaunay's and Marc's work and after a remarkable trip to Tunisia with Macke and Moillet that Klee felt he was a painter. It was there, in Kairouan, that he wrote the famous passage which concluded: "Color possesses me. I don't have to pursue it. It will possess me always. I know it. That is the meaning of this happy hour: color and I are one. I am a painter."

In following years his work revealed a remarkable variety; sometimes it was nonobjective, sometimes representational, sometimes geometric and tightly structured, and sometimes organic and free. As a rule, his paintings were small in size and delicate in appearance, but after 1930 they became not only larger but more powerful. Throughout his career, however, his artistic intention remained basically the same: to discover "a kind of formula for man, animal, plant, earth, fire, water, air, and all the circling forces at once."

* For some examples of Klee's poetry, see Part Four of this anthology, pp. 149–50.

Klee's writings about art—which include diary entries, notes, essays and the renowned *Pedagogical Sketchbook*—are comparable to Kandinsky's in quantity and, more important, in quality.* The diary entries selected for the anthology were written during a period of great crisis for Klee, 1914–1916; in other words, after the trip to Tunisia, which marked a turning point in his art, and during the war while he was serving in the German army.† After the war, between 1918 and 1920, Klee finally reached artistic maturity and in these very years he wrote the definitive statement of his views on art: the "Creative Credo." The "Credo," which was printed in 1920, took an additional importance because it was a part of a publishing project of the expressionist Kasimir Edschmid, a project which attempted, in typically expressionistic fashion, to define a modern world view by presenting the ideas of creators from every field of endeavor. Twenty-nine little volumes were published in the series, which was given the collective title of *Tribüne der Kunst und Zeit* ("A Platform for Art and Current Issues"). Edschmid referred to it as a "little encyclopedia of contemporary cultural energies" and was proud of the fact that here art was inextricably mixed in with politics and religion. Klee's "Credo" appeared in the same volume, as did statements by Beckmann, Marc, Pechstein, Schönberg and such Expressionist authors as Fritz von Unruh and Ernst Toller.‡

* *The Diaries of Paul Klee, 1898–1918*, ed., Felix Klee (Berkeley: University of California Press, 1964), entries 934, 951, 952, 958, and 1008. Reprinted by permission of the publisher. See also *The Thinking Eye, The Notebooks of Paul Klee*, ed. Jürg Spiller (New York, 1964); and *The Pedagogical Sketchbook* (New York, 1953), first published as *Pädagogisches Skizzenbuch* in 1925.

† All items were taken from the English translation of the diaries, *op. cit.* They have, however, been changed in some respect. For the reaction of other Expressionists to World War I, see Part Five.

‡ Paul Klee, "Creative Credo," from Kasimir Edschmid, ed., *Schöpferische Konfession*, Vol. XIII, *Tribüne der Kunst und Zeit* (Berlin, 1920), in Jürg Spiller, ed., *The Thinking Eye* (New York: George Wittenborn, Inc., 1964), pp. 76–80. Used by the editor in translating "Creative Credo" for this volume by permission of the publisher. For Beckmann's "Credo," see Part Three of this anthology; for Pechstein's contribution, see Part Five.

Extracts from The Diaries

934 [1914]*

Misery.
Land without ties, new land,
Without a breath of memory,
With the smoke of a strange hearth.
No restraints!
Where no mother's womb ever bore me.

951 (1915)

One deserts the realm of the here and now in order to be active in the
great beyond where total affirmation is possible.
Abstraction.
The cool Romanticism of this style without pathos is unprecedented.
The more horrible this world (as today, for instance), the more ab-
stract our art, whereas a happy world brings forth an art of the
here and now.
Today is a transition from yesterday. In the great pit of forms lie
broken fragments to some of which we still cling. They provide
abstraction with its material. A junkyard of unauthentic elements
for the creation of impure crystals.
That is how it is today.
But then the whole crystal cluster once bled. I thought I was dying,
war, and death. But can I really die, I crystal? I crystal.

952 (1915)

I have had this war inside me for a long time. That is why, inwardly,
it means nothing to me.
And to work my way out of my ruins, I had to fly. And I flew.
I remain in this ruined world only in memory, as one does occasionally
in retrospection.
Thus, I am "abstract with memories."

* After this entry, which is not dated, Klee noted that the war broke out. All
of Klee's entries were numbered, but not all were given exact dates. Number 934,
a little poem, seems to have been written upon the artist's return from Africa and
it can be interpreted as referring either to his mood in Tunisia or to his reaction
to Europe *after* his Tunisian experience.

958 (1915) *

The outward existence of an artist may reveal a number of things about the nature of his work.

My childhood friend Haller loves life with such passion that he practically hunts for shattering emotional experiences, lest he miss something. This worldly drive was only useful to his art for a short time, until his imitative type of statuette, which has its great charm, had been created. But then?

How is he to achieve an active spiritual development now, when in addition a way of life weighs on him that in itself requires a giant's constitution? I once led a restless mode of life, until I acquired a natural base that enabled me to abandon that mode. (One disclaims "the stomach" by granting it neither too little nor too much, for both excite.)

Both of us married; he needed to put the emphasis on "beauty" and thereby overlooked other, more important matters. In consequence his marriage began to founder. Nor did he want to give up the hunt for shattering emotional experiences. The effects on his artistic activity could only be negative.

Then his body aged prematurely, and this jarred with his primitive mentality. It would have been better if he had aged mentally and remained young physically!

In contrast to him, I thus had become a kind of monk, a monk with a broad natural basis where all the natural functions found a place. I regarded marriage as a sexual cure. I fed my romantic tendencies with the sexual mystery. I found that mystery tied up with monogamy, and that was enough.

Here too I struggled away from memories, down toward the essence, and to a considerable depth at that.

Kubin is a third case. He fled from the world because he could no longer stand it physically. He remained stuck halfway, yearned for the crystalline, but could not tear himself out of the sticky mud of the world of appearances. His art interprets the world as poison, as break-

* Hermann Haller was a minor artist whose personality (and weakness) as sketched by Klee seems not only "romantic" but "expressionistic." Alfred Kubin was a respected member of the *Blaue Reiter*. Kubin's and Klee's early drawings had much in common. There may also have been an affinity of temperament. However, in the above entry Klee with remarkable insight and an almost disturbing coolness reveals his determination to permit nothing to interfere with his artistic quest for the essence of reality.

down. He has advanced further than Haller, who is a quarter alive; he is half alive, living in a destructive element.

1008 (1916) *

While I was standing guard over the munitions depot in Fröttman-ing, on one of several occasions, a great many thoughts about Marc and his art came to me. Walking in circles around a couple of am-munition storehouses was just the kind of thing to get one lost in thought. During the day magnificent flora made things unusually colorful, and late at night and before dawn, a firmament unfolded before me that lured my soul into vast expanses.

When I tell what kind of person Franz Marc is, I must at once confess that I shall also be telling what kind of person I am, for much that I participated in belonged also to him.

He is more human, he loves more warmly, is more demonstrative. He responds to animals as if they were human. He raises them to his level. He does not begin by dissolving himself, becoming merely a part in the whole, so as to place himself on the same level with plants and stones and animals. In Marc, the bond with the earth takes pre-cedence over the bond with the universe (I am not saying that he might not have developed in the direction of the latter, and yet: Why in that case, did he die?).

The Faustian element in him, the unredeemed. Forever questioning. Is it true? Using the word "heresy." But lacking the calm assurance of faith. Often, toward the end, I was afraid that he might be a com-pletely different man some day.

The changing times oppressed him, he wanted men to change with them. But he himself was still a human being and there was a rem-nant of inner conflict that bound him. The bourgeois empire, which was the last instance of the good being still a common good, seemed worthy of envy to him.

I only try to relate myself to God, and if I am in harmony with God, I don't fancy that my brothers are not also in harmony with me; but that is their business.

One of Marc's traits was a feminine urge to give everyone some of his treasure. The fact that not everyone followed him filled him with misgivings about his path. I often anxiously surmised that he would

* Klee was drafted March 11, 1916, seven days after Marc's death. Entry 1008 was probably written in July or August of that year.

return to earthly simplicity, once the ferment was over, that he would not come back in order to rouse the world to some grand vision, but entirely from a human impulse.

My fire is more like that of the dead or the unborn. No wonder that he found more love. His noble sensuousness with its warmth attracted many people to him. He was still a real member of the human race, not a neutral creature. I recall his smile when my eye overlooked some elements of earth.

Art is like Creation: it holds good on the last day as on the first.

What my art probably lacks is a kind of passionate humanity. I don't love animals and every sort of creature with an earthly warmth. I don't descend to them or raise them to myself. I tend rather to dissolve into the whole of creation and am then on a footing of brotherliness to my neighbor, to all things earthly. I possess. The earth-idea gives way to the world-idea. My love is distant and religious.

Everything Faustian is alien to me. I place myself at a remote starting point of creation, whence I state a priori formulas for men, beasts, plants, stones, and the elements, and for all the whirling forces. A thousand questions subside as if they had been solved. Neither orthodoxies nor heresies exist there. The possibilities are too endless, and the belief in them is all that lives creatively in me.

Do I radiate warmth? Coolness?? There is no talk of such things when you have got beyond white heat. And since not too many people reach that state, few will be touched by me. There is no sensuous relationship, not even the noblest, between myself and the many. In my work I do not belong to the species, but I am a cosmic point of reference. My earthly eye is too farsighted and sees through and beyond the most beautiful things. "Why, he doesn't even see the most beautiful things," people then say about me.

Art imitates creation. And neither did God especially bother about nonessentials.

"Creative Credo"

I

Art does not reproduce what is visible, instead, it makes visible. The nature of graphic art easily and quite rightly encourages one to abstract. The schematic and fairytale quality of imaginary forms is

not only inherent in it but can be expressed with great precision. The purer graphic work is—which is to say, the more emphasis it places on its own formal means—the less successful it will be imitating visible things. The formal elements of graphic art are: points and lines, planar and spatial energies. For example, the unmodulated energy produced by the mark of a wide crayon is a planar element which is not built out of smaller units. On the other hand, a cloudy, vaporous spot made with a loaded brush and uneven in value is an example of a spatial element.

II

We will develop this idea by making a topographical plan and taking a little journey into the land of better understanding. Our first action (line) takes us away from the dead point. After a little while, a pause, to catch our breath (an interrupted line or, after several stops an articulated line). A look back to see how far we have come (countermovement). We consider our route; which direction? this way or that? (a cluster of lines). A river crosses our path (wavy motion). Farther upstream, could that have been a bridge (a series of arches)?

On the other side we meet someone who also wants to go where better understanding can be found. At first, united in joy (convergence), gradually differences arise (two lines moving independently). A little agitation on both sides (line—expressive, dynamic and psychic).

We cut across a ploughed-up field (a plane laced by lines), then a dense forest. He gets lost, searches around, and once even imitates the classic movement of a running dog. By now I'm not exactly calm either: another river and fog (the spatial element). But it soon begins to clear up. Basket weavers are returning home with their carts (the wheel). In their midst, a child with magnificent curls (spiral movement). Later things become sultry and dark (spatial element). Lightning on the horizon (zigzag line). Yet stars are still above us (a field of points).

We soon reach our first night's lodging. Before falling asleep—many memories. A little trip like this produces quite an impression.

All kinds of lines, spots, dots, and planes. Planes smooth, dotted and streaked. Wavy motion. Restrained and articulated motion. Countermotion. Netted, woven, bricked, scaled. One voiced and many voiced. Lines disappearing and appearing (dynamism).

The happy tranquility of the first few miles, then the uncertainty,

nerves! The gentle stirring, the caress of a promising little breeze. Before the storm an attack by horseflies! Fury and murder. A good cause as our guide, even in thickets and at sunset. Lightning, an ominous reminder of that fever curve. A sick child . . . long ago.

III

I have listed the elements of graphic representation which should be visible in a work. This does not mean that a work must consist solely of elements. The elements should produce forms but without sacrificing their own identity; by preserving it instead.

In order to create form or objects or things of a secondary type a number of elements usually have to be combined. Planes out of related lines (e.g., the way rough watercourses look) or spatial structures out of energies related to the third dimension (swarming fishes).

The possibilities for variety and therefore the potentialities for expression become infinite by enriching in this way the symphony of form.

In the beginning was the deed, of course, but above the deed is the idea. And since infinity has no precise beginning, but is like a circle, the idea may be regarded as primary. In the beginning was the Word, according to Luther's translation.*

IV

Motion is the basis of all becoming. In Lessing's *Laokoon,* on which much mental effort was wasted in younger days, a great deal was made of the essential difference between temporal and spatial arts.† And yet upon closer examination the distinction turns out to be foolish. For space is also a temporal concept.

When a point is set into motion and becomes line, this takes time. Likewise when a line changes into a plane. And similarly when planes move to become spaces.

Can a work of art be made instantaneously? No, it is constructed piece-by-piece like a house.

* The reference here is to the first verse of the Gospel according to St. John. Goethe in his drama *Faust* had Faust rewrite it so that *Logos,* "the Word," was changed to "the Deed." Klee, on the other hand, although he agrees with Faust, insists that nevertheless the Word, or the Idea, is primary.

† Gotthold Ephraim Lessing 1729–1781), German critic and dramatist. His *Laokoon* (1766) is a classic study of the distinctions between, and the limits of, painting and poetry.

And the viewer, does he finish with a work instantaneously? (Yes, often. Unfortunately.)

Didn't Feuerbach say that you need a chair to understand a picture? Why the chair?

So the legs, when they get tired, don't distract the mind. If you stand too long your legs get tired. Thus, the space in which we move: time.

Character: motion. Only the dead point is timeless. Motion is also the basis of the universe. When nothing moves on earth this is due to an accidental restriction of matter. It is a mistake to interpret this restriction as essential.

Biblical "Genesis" is a very good allegory for motion. A work of art is also first and foremost genesis, it is never experienced as a mere product.

A kind of fire appears, it flares up, moves through the hand, flows on to a sheet, and from this sheet, closing the circuit, it leaps as a spark back to where it started back into the eye and beyond.

Essentially, the viewer's activity is also temporal. He takes a scene, part by part, into his vision's cave; before he can move to a new unit he has to leave the old one.

When he is finished he gets up and leaves, like the artist. If he thinks it worthwhile he returns, just like the artist.

For the viewer's eye, which wanders about like a grazing animal, paths are laid out in the picture. (In music, as everyone knows, there are channels for the ear; drama has both kinds.)

Visual art originated in motion, it is itself frozen motion and it is experienced in terms of motion (eye muscles).

V

In earlier days people represented things which they saw on earth, or liked to see, or would have liked to see. Now that the relativity of visible things is becoming evident the conviction is strengthened that in relation to the whole universe visual truth is only one of many and that other truths exist in potentially vaster numbers. Objects appear in so many expanded and varied ways that they seem to contradict the rational experience of yesterday. People are trying to give essential form to what is accidental.

The inclusion of concepts of good and evil creates an ethical sphere. Evil should not be an enemy which conquers or shames but a force

which cooperates with the whole. A factor of conception and development. Ethical stability requires the simultaneity of the primordial masculine (evil, aggressive, passionate) and the primordial feminine (good, fertile, tranquil).

To this corresponds the simultaneity of merged forms, movements and countermovements, or more naively put, of objective contrasts (Delaunay's use of analytical color contrasts). Every energy needs its complement in order to achieve a self-sufficient balance which will raise it above a mere play of forces. Out of abstractions or out of abstract things like numbers and letters to the ultimate construction of a cosmos of forms which is so similar to the Creation that only the slightest breath is needed to transform religious feeling, religion into fact.

VI

A few examples:

A man in ancient times, a sailor in a boat; quite happy and enjoying the ingenious comfort of his little craft.

And now: the experience of modern man as he paces the deck of a steamer.

(1) His own motion; (2) the ship's motion, which may oppose his; (3) the direction and the speed of the current; (4) the rotation of the earth; (5) its orbit; (6) the orbits of moons and planets around it.

Result: an interaction of motions throughout the universe, and as center, the "I" on the steamer.

An apple tree in blossom, its roots, the rising sap, its seeds, the cross-section of its trunk with annual rings, its sexual functions, the fruit, the core with its kernels.

An interaction of states of growth.

A sleeping man, the circulation of his blood, his measured breathing, the delicate function of his kidneys, in his head a world of dreams, all linked to the power of fate.

An interaction of functions united in sleep.

VII

Art is related to Creation symbolically. It is always an allegory, similar to the way the earth is a cosmic allegory. Liberating the elements, subdividing them, simultaneously and on all sides tearing them down and building them up, a pictorial polyphony, peace achieved

by harmonizing motions: all these are very important formal issues, crucial to wisdom about form, but not art in the highest sense. In the highest sense an ultimate mystery hides behind all this complexity and in its presence the light of intellect sputters and goes out.

Of course, one can still talk rationally about the effects of art, even about its redemptive power: of imagination activated by instinct conjuring up visions which are somehow more lively and exciting than earthly or supernatural scenes.

Of symbols which console the spirit, so that it recognizes that something exists beyond earthly things and their possible intensification. Of high ethical seriousness which coexists with the impish ridicule of scholars and priests. Even an intensified reality is unsatisfying in the long run.

Art plays an ignorant game with ultimate things and yet manages to reach them.

Get up, man! Appreciate this little holiday; to change a point of view with a change of scene and to be in a world transformed; it will give you strength for the inevitable return to the gray of working days.

And more, it will get you out of your shell and even help you for a moment to imagine that you are God. Here you can always look forward to holidays when the soul will sit down to feed its hungry nerves and fill its tired veins with new sap.

Let broad rivers and delightful brooks, like the aphoristic but many-branched graphic arts, carry you into this life-giving ocean.

Independent Expressionists

It would be a mistake to think that there was a type of Expressionist, called an "Independent," distinct from, and possibly opposed to, an organizational type. For one thing, organizations like the *Brücke* and the *Blaue Reiter* were not in the least dogmatic or coercive. Furthermore, most "Independents" at one time or another were connected with some kind of association. Actually, the term "Independent Expressionist" merely signifies that a particular Expressionist was never a member of one of the major Expressionist groups. Outstanding "Independents" in this sense were Käthe Kollwitz, Lyonel Feininger, Ernst Barlach, Oskar Kokoschka, Max Beckmann, and Ludwig Meidner. One thing all these artists had in common, with the important exception of Feininger, was their intense dislike for the abstractionism of the *Blaue Reiter* in general and of Kandinsky in particular. Feininger, on the contrary, was always friendly with the *Blaue Reiter* and was instrumental in the unsuccessful attempt to revive it as the *Blaue Vier* ("Blue Four") in 1924.*

* The members were Feininger, Kandinsky, Klee, and Jawlensky. Unfortunately, permission to publish any of Feininger's writing on art could not be secured. Feininger (1871–1956) was born in New York and came to Germany when he was 16. He did not return to the United States until forced to by Nazi oppression in 1937. His role in German art was an active one and it included participation in Walden's *Sturm* group and teaching at the Bauhaus. Feininger was very skeptical about artists' writing about art, but on occasion succumbed to the temptation. His "Conversation with Adolf Knoblauch" which appeared in *Der Sturm* (1917) is of particular interest. It begins: "Like a bad swimmer I am easily drowned by swirling currents of feeling. So great is my need to share feeling that I cannot even express myself in words. I often seat myself at the organ to seek release in the powerful tones of Bach." In spite of this initial stress upon feeling, however, it is significant that he concludes this article by insisting that the "strictest discipline" and "tight organization" are absolutely necessary to great art.

Ernst Barlach

Born 1870 in Wedel, North Germany and died 1938 in Rostock. Studied in Hamburg, Dresden, and Paris 1888–97. Traveled in Russia 1906. Visited Florence 1909. After living in Berlin withdrew to the village of Güstrow near Lübeck 1910. Served in army 1915–16. Became a member of the Prussian Academy of Arts 1919. Defamed by Nazis and forced to resign from the Academy 1937.

Ernst Barlach was one of Germany's leading sculptors. His style, which had little in common with classically inspired conventional sculpture, was based upon peasant art, German medieval woodcarving, and the work of (then) modern painters like Van Gogh. Barlach was also important as a graphic artist and dramatist. But no matter what his medium, all his work was characterized by religiously motivated feeling, ranging from grotesque humor to mystical reverence.

His writings comprise more than three volumes of letters, journals, poetry, stories, and dramas. From this wealth of material only two short but important items have been chosen for this section of the anthology. The first, simply called "From a Notebook, 1906," is a brief summary of Barlach's ideas about sculpture.* Written in the same year, 1906, as his crucial trip to Russia, it is his definitive statement on his art. The second, a letter to the famous Munich publisher Reinhard Piper, further explains Barlach's ideas about art and also reveals a skepticism about abstractionism which was typical of a number of Expressionists—Kokoschka, Beckmann, and Kollwitz, for example.†

*Ernst Barlach, "Aus Einem Taschenbuch, 1906," in Elmar Jansen, ed., *Prosa aus vier Jahrzehnten* (Berlin, 1963), p. 323ff. Translated for this volume by the editor with permission of R. Piper & Co Verlag.

† Ernst Barlach, Brief an R. Piper, in *Die Briefe, 1888–1924,* Vol. I (München: R. Piper & Co Verlag, 1968). Copyright © 1968 R. Piper & Co Verlag. Translated for this volume by the editor with permission of the publisher. The most ambitious, though still incomplete, collection of Barlach's literary work is Ernst Barlach, *Das Dichterische Werk,* ed. Friedrich Dross (München: R. Piper & Co Verlag, 1956), in three volumes. See Part Four of this anthology for an excerpt from Barlach's drama *The Dead Day* (1912).

"From a Notebook, 1906"

The world of sculptural ideas is tied to clearly defined concepts of material, of stone, of metal, of wood, of solid substances. Mountains and trees contain those worlds of feeling which the sculptor reveals. It is feeling which is absolutely concrete, completely circumscribed, a heaven-shaking mood but calm and majestic, the boldness of the titans, a rugged and lonely, profoundly intimate, cosmic feeling. No cloud, no wind, no light, no darkness nourishes it. It permits no vagueness, no play of color, no vibration and no anxious yearning. It simply wills! In sculpture the human soul finds expression for its primeval form—what mountains reveal to thinking people. The possibility of making manifest the ultimate. To proclaim an exalted conviction, to reveal the consciousness of absolute age.

A sculptor's forms derive from the character of stone, of bronze. Concepts of material become perceptual norms; the visual world is measured according to the nature of bronze and stone, is tested against the nature of bronze and stone. The sculptor's vision, like a storm, strips from the skeleton of the world all sensuous frills and casual superficialities, all excess and ornamentation.

It is not easy to see a sculptor's vision as a happy one. It disenchants most people and I believe that those are the very people who admire not what is genuine but what is spurious in sculpture. These do not thrill to the profound severity of stone and bronze, which is like a cool, clear, comforting revelation, like a calming absolute.

The sculptor discovers in nature simultaneously time and eternity; in earth he sees the skeleton of the world rather than the many little hairs which cover its skin and hide its clarity; in air he sees the breath of a great space and only later, if at all, he notices the play of a thousand colors and tones; in trees and bushes he sees individual forms which are children of the soil, instead of registering like a camera a thousand details, things which exist, of course, but like so much froth on the waves of the sea.

Just like a sculptor with his fist, we with feeling cleanse life of pretentious nonsense, we creatively transform life in order to see the world not as it appears but as it really is—for now let our hands, which though fumbling never stop groping after the skeleton and

muscles of reality, scatter the feathers of the birds of appearance that is, until we understand their structure and can measure their flight. After that, their plumage can gleam magnificently in the sunshine and fill the sky with the lively play of exquisite effects, effects as pleasing as the delicate chasing of surfaces in bronze sculpture or the dull glow of a marble surface.

Just like a dramatist who feels the need for an absolute standard and then with the consciousness of this standard within him forms and elevates, simplifies, and clarifies, so too there lives in the sculptor's soul something which compels him to imbue his intention with a heroic boldness and with a joy in achieving monumental effects, in overcoming triviality and in transforming the unnatural into the natural. The rules which he obeys are no longer the petty ones of common sense but the great ones of a free intelligence.

I know a sculptor who is inspired not by the model, not by the life of the people but by nature; his ideas soar far beyond what everyday life can provide. A mythic vision. He is compelled to create figures which correspond to a roaring storm, to the building up and breaking up of waves.

People have suppressed visions in favor of merely looking at things. Creating visions is a god-like act, art in a higher and therefore better sense than just realistic imitation which involves mere technical know-how. Shouldn't this "feast of vision" be a higher sacrament than the others? Are visions unreal? Actually, they are the basis for such ideas as "self-evident," "correct," as much as they are for physical objectivity.

The most conscientious studies can be experienced as false just like the most audacious vision can be experienced as true.

Merely to demonstrate how mystical everything is is futile since it only reminds the public that it must continue living in this gloomy world. But when the artist gives sensuous form to the mystical in such a way that it becomes intimately familiar he has elevated the observer above what is conventional and has placed him in the realm of the infinite. And he has revealed: see, the whole world is grand, everywhere, since the commonplace, everywhere, has mystical significance.

What is to be understood as a mythic point of view is naturally no theogony but rather the process which would lead to a theogony. No Wagnerian nonsense. No poetizing and no romanticizing which seeks to enliven a landscape with forms. Rather it is forming as such in the sense of that process which long ago led to the creation of myths.

Every object can be seen as mythic; one can also describe the matter differently: the revelation of the living (that which has personality) features of eternity, features which speak to man's soul. Something which does not mean: it could be this way, but rather—this is the way we know it to be, in this way we once more recognize each other.

The human soul needs the aesthetic only as a decoration, but its other requirements: exaltation to an awareness of the world as a totality; the awareness of God; the miracle of immediacy (to which not only the miracle of light belongs); the memory of the first, fundamental eruption of sight; all of these came out of nature—or rather, let's just say they were placed inside nature, but like living seeds placed in earth which are not earth but apparently derive completely from earth.

Still more types of mythic creation in art: visualizing the architectonic, the form of the earth which rears, undulates, and races along with the quality of a tremendous activity which has become form, the end result of endless attempts, experiments and tragedies, the unchanging language of thousands of millennia, whose words one is constantly trying to hear, always a little clearer. Consequently one tries to free her from such disguises as weather changes. One tears the veil from the face of a mysterious person.

All in all the architectonic is the expression of the striving for truth, that which one can really know, and if I exaggerate I'm not being capricious but expressing my personal search for absolute certainty.

Making something simple, making something monumental gives me a conception of eternal ideas. Part of nature's face is stripped of its wrinkles and little hairs and I try to show myself how it really looks. This process signifies an exaltation of my individuality to a status equal to nature, person to person.

Letter to Reinhard Piper

Güstrow, 12. 28. 1911

Dear Herr Piper, your books arrived safely, but when I tell you that Klaus* received as his main Christmas presents a shadow theater and a "huge" wooden train you won't be surprised that he hasn't been interested, up to now, in your things. However, as author, di-

* Nikolaus Barlach, the artist's son, who was born in 1906.

rector and speaker of the shadow theater I have some time, once in a
while, for better things. (Although I am surprised what a little imagi-
nation can accomplish with only a couple of pitiful things.)

I haven't been able to really read your book* and I suspect that I
won't in the near future. Not that I could or would want to condemn
the author's intense spirituality. On the contrary, from the little I've
glanced at, the book does not appear at all to be what one would call
"well-intentioned." Therefore, my lock snaps shut all the more sharply,
meaning: I absolutely refuse to go along with the business—out of
instinct I'm sure. A bottomless pit opens up before me. Lately I have
felt that I had to insist in a number of places that I was a barbarian.
Thus, as a barbarian, I will believe this honest man when he claims
that for him, points, spots, lines, and dabs (as on pages 43 and 88 of
his book) create profound spiritual shocks, i.e., they have effects that
are more than ornamental. Yes, I will believe, and then—good bye!
We could discuss matters for a thousand years without coming to any
understanding. You know I am not exactly inexperienced, I have had
times myself when I sat and sat and "made" lines. These were the
intervals, the pauses during which mind and hand were certainly
willing, while everything else seemed paralyzed. Here I would like
to put in a word which will not be without some meaning to a Scho-
penhauerian like yourself: sympathy. I must be able to sympathize—
even where sympathy is forbidden—with myself, that I am so lowly,
so far from those who could have sympathy with me. Sympathy does
not have to involve misery and sorrow. I can enter fully into the joy
of heroism and humor. I could say suffering by proxy or joy by proxy.
A participation which goes so deeply into one's consciousness that it
takes the place of the events which have been visualized in the work
of art. Could you sympathize with the formal events on page 98 or
could you enter into the forms of page 88. It is a question without a
question mark. Naturally, I could use my imagination and make some-
thing out of these spots. Actually, I believe that most things and the
best things originate in a situation where accidental effects or ordered
chaos arouses the desire, by means of art, to take from what is un-
touched, vague, indescribable its virginity in order to make everything
fertile—spiritually meaningful and consciously vital. However, that
reverses matters.

* He is referring to Wassily Kandinsky's *Concerning the Spiritual in Art,* which
had just been published by Piper.

The newest music appears equally Expressionistic. But neither you nor anyone else whom I have asked has ever told me anything positive or convincing about all this.

Yet we must agree on a language in order to know anything at all: someone could say the most beautiful, most marvelous things in Chinese and I wouldn't pay attention. Therefore, if I want to share someone's spiritual experiences that person must speak a language in which I can experience the deepest and most secret things. My mother tongue is the most appropriate and my artistic mother tongue is the human figure or the environment, the objects, through which or in which man lives, suffers, enjoys himself, feels and thinks. I will never feel otherwise. And I will never have anything to do with an Esperanto art either. It is precisely the vulgar, the universally human, primeval racial feelings that are great and timeless. I am interested in what man has suffered and can suffer, his greatness, his adventures (including myths and utopian dreams), but my special little emotion or my most personal sensation is of no consequence, is only a caprice once I step out of the circle of humanity. Man as ego must be interested in his egoism, noble or base it doesn't matter. But page 88 or page 98 does not touch my egoism in the least. If there is anything figurative it is so disguised that I am mystified, beyond that I feel nothing. I also do not believe that one can logically construct a new style, as Herr Kandinsky thinks—except as literature, as a purely theoretical construction. However, my criticism is worthless since I am not the kind of man Kandinsky is. I imagine he would be unmoved by events and facts which would shock me to my very being. He could say to me: "You are not an artist but an actor! You behave 'as if' the emotions were there—on the other hand, I generate images and emotions, moods, sensations like a wireless message—without any medium, by means of direct transmission." That would be good if feelings could be created by general agreement. Blue means this, yellow that—easy enough to say, but it is questionable whether this assertion has the divine power to change a "should" into a "must." * But when colors

* Barlach is referring to passages where Kandinsky says: "Yellow is the typical earthly color. . . . Blue is the typical heavenly color. . . . The way to the supernatural lies through the natural. And we mortals passing from earthly yellow to the heavenly blue must pass through green (i.e., the mixture of yellow and blue)." However, Barlach is being unfair when he implies that Kandinsky is laying down rules of some kind. In that very book Kandinsky stressed that there was "no must in art." Barlach also misunderstands the Russian in that he seems to think that

and lines exist by means of human forms or vice versa, they possess real power because it is derived from the human spirit. Doesn't it often happen that colors and shapes on walls or furniture suddenly become pictures thanks to the imagination which animates them— thus, these images are drawn into my human ego, previously the experience was external to me—at the most it excited the ever-hungry optical nerves because it was less boring, more gay-colored, more exciting than other things. That the human ego can show a completely nonartistic interest in things is another matter. And whether you agree with this or even find it clear, that too is another matter.

This afternoon Klaus and I were in the woods, we returned when it was dark. Previously at the station we had looked at Grünewald's Christmas painting in the *Woche*. Would you believe it, as I spoke about it, a movement seized him which he tried to hide behind my back. Naturally, I pretended not to notice anything.

You say you want to show me your boy one of these days?! Please greet your wife for me.

<div align="right">Respectfully yours,
E. BARLACH</div>

P.S. I have made a flying figure (as a relief). I wish I could show it to you. Naturally, I hope you like it. Happy New Year!

representational art is being criticized. What Kandinsky emphasized in both *Concerning the Spiritual in Art* and his essay "The Problem of Form" (see this volume pp. 46–64) was the necessity for communicating the "inner sound," or what Barlach called "the living features of eternity." If Kandinsky suggests that colors, lines, and abstract shapes can convey the "inner sound," he makes abundantly clear that this is *only* true for that artist who finds representational forms superfluous. Kandinsky would probably be the first to agree that in Barlach's work the human form is absolutely essential to the communication of the all-important "inner sound." Had Barlach read Kandinsky's book more sympathetically he might have discovered not an implicit attack upon his art but support for it.

Oskar Kokoschka

Born 1886 at Pöchlarn, Austria. Studied in Vienna 1905–1909. Lived in Vienna, Switzerland, Berlin. With Walden's *Sturm* group in Berlin 1910–11. Served in Austrian army 1915–16. Discharged after nearly fatal wounds. Moved to Dresden 1917. Professor at Dresden Academy 1919–24. Extensive travel through Europe and Africa 1924–31. Vienna 1931–34. Emigrated to Prague 1934. Fled from Nazis to London 1938. In Italy 1948–49. Settled in Switzerland.

Oskar Kokoschka was gifted as a painter and a playwright, and before he was twenty-five he had created significant work in both fields. As he was an Austrian, his art reflected the complexities and the tensions of the intellectually brilliant but socially decadent milieu of imperial Vienna. Responding with a unique intensity to this environment and to the influence of Van Gogh and Munch, he painted between 1907 and 1914 some of his greatest pictures, a series of portraits which as psychological studies are unsurpassed in the history of twentieth-century portraiture. During the same period he wrote some of his most powerful plays, including *Sphinx and Strawman* and *Murderer, the Hope of Woman*.* These dramas, written in 1907, were among the very first manifestations of Expressionism in the German theater. Also during this period he delivered the lecture "On the Nature of Visions," 1912, which was one of his earliest and most important statements on art.† To this day he accepts this statement as definitive and refuses to change a single word.

Kokoschka's style, however, did change. In 1919 he reacted to the use of color by Fauve and *Brücke* painters. Then by 1924 he seems to have been influenced by impressionist techniques. Although his art lost some of its intensity with these shifts of interest, the numerous panoramic landscapes and

* See Part Four for *Sphinx and Strawman*.

† The lecture was subsequently published in *Menschen, Zeitschrift für neue Kunst* (Dresden, January 25, 1921), and is reprinted here by permission of the author.

allegories painted by Kokoschka from the mid-'20s up to the present still testify to his great admiration for the expressive ideals of Van Gogh and Munch. It is worth noting that among Kokoschka's most important recent essays are tributes to both of these painters. The essay "Van Gogh's Influence on Modern Painting" is especially interesting not only because it is such a spontaneous and personal tribute but because it reveals the artist's passionate concern for contemporary life, or to use his words, "the deluge that is coming over the world." * The article was written in English by Kokoschka himself.

"On the Nature of Visions"

The consciousness of visions is not a mode of perceiving and understanding existing objects. It is a condition in which we experience the visions themselves.

In visions consciousness itself can never be grasped. It is a flux of impressions and images which once called forth give power to the mind.

But the consciousness of visions has a life of its own, accepting but also rejecting the images which appear to it.

This consciousness of visions has a life which derives power from itself. This power freely organizes visions whether complete or barely perceptible irrespective of how they relate to each other, and in complete independence of temporal or spatial logic. Thus this power seems to influence experience in everything which involves the arrangement and quality of its visible forms. This influence, coming after the vision's appearance in the soul, is actually closer to being the manifestation of an experience which was ready and waiting or an overflowing of the soul into the vision; thus the soul now begins to shape the vision into a living form. This state of alertness of the

* Oskar Kokoschka, "Van Gogh's Influence on Modern Painting," *Mededelingen van de Dienst veer Schone Kunsten der Gemeente 's-Gravenhage*, 's-Gravenhage (1953), Vol. VIII, Nos. 5–6, pp. 79–81. Reprinted by permission of the author and the publisher. Kokoschka's article on Munch has been published in English in *College Art Journal* (1953), Vol. XII, No. 4, pp. 312–20 and Vol. XIII, No. 1, pp. 15–18. Kokoschka's autobiography is also available in English: *A Sea Ringed with Visions* (London, 1962). For readers of German a convenient source book for Kokoschka's writings is *Oskar Kokoschka Schriften, 1907–1955* (München, 1956).

soul or consciousness, expectant and receptive, is like an unborn child whose own mother might not be aware of it and to whom nothing from the outside world slips through. And yet, whatever affects his mother, even her birthmark, becomes part of him; just as if he could use his mother's eyes, the unborn absorbs visions even though he himself is unseen.

The life of consciousness is limitless. It flows out into the world and merges with other visions. Thus it shares essential qualities with all of life. Just like the seed of a tree growing all alone in the wilderness, the seed which possesses the potency from whose roots all the forests of the earth might spring anew, so it happens that when we cease to be and cease being conscious, consciousness awakens of its own power in order to search for a new center. There is no place for death here because visions may disintegrate and scatter but only to form again in another mode.

Thus we have to listen with complete attention to our inner voice in order to get past the shadows of words to their very source. "The Word became flesh and dwelt among us." And then the inner source frees itself, sometimes vigorously, sometimes feebly, from the words within which it lives like a charm. "It happened according to the Word."

Now, once we give up our aggressive, closed personalities, we can experience this magical way of life, either in thought, intuition, or in relationships with others. Every day we see beings absorbed in one another, living and communicating with or without purpose. Also, everything created and communicated in the flux of this world is preserved in consciousness and in its own identity by an inherent power to maintain its own form. Like a rare species it is protected from extinction. One can call this being "I," one can call it "you," depending how one views its scale and infinity in relation to oneself and in relation to one's own being as a being lost within it. In addition, one should surrender to whatever there is within oneself that is looking for union. I also believe if one lifts oneself up, step-by-step always on the alert to experience all of nature as a perfectly free spirit, one's soul can become a reverberation of the entire universe, and in a similar way one can experience the Word: the experience of visions!

The consciousness of visions can never be fully described and its history never completely defined because vision is life itself. Essen-

tially it floods into us, it simply presents itself to us, it is a love which beds itself down in our consciousness. To be possessed in this way, whether we like it or not, happens spontaneously from the moment we are born. Suddenly an image will take shape for us, like the first look, like the first shriek of a child, newborn, coming from its mother's womb.

Whatever the decisive mark of life may be, essential to it is the awareness of visions; whether incorporeal or corporeal depends on the point of view, whether one sees the flow of energy as rising up or ebbing away.

These visions which are dynamic, which impress and make visible, which impart power and can be evoked at will do not, however, exhaust consciousness. Because consciousness selects some of the images which flow into it and rejects others.

The consciousness of images which I am describing is like viewing life from a high place, like a ship which first plunges in the waves and then rises winged in the air.

Consciousness is the source of all things and all ideas. It is a sea with visions as its only horizon.

Consciousness is a tomb for all things, where they cease to be, the hereafter in which they perish. And thus it would seem that things end up with no existence beyond my inner vision of them. Their spirit is sucked up by that vision as oil in a lamp is drawn up by the wick in order to nourish the flame.

In this fashion everything I experience releases its essence into the hereafter. I thereby have visions without needing dreams. "Wherever two or three are gathered together in my name there am I also." And as if it understood, my vision is sustained by people, as the lamp is by oil, nourished out of the superabundance of life. But now I suppose I am expected to explain all this in a simple, natural way. At this point the things themselves must intercede for me and bear witness on their own account; I have spoken for them by means of their semblance, by means of my visions. My spirit, it has spoken!

I search, guess and question: the lampwick drinking oil, what excites it so that the flame suddenly leaps up before me in ratio with the oil absorbed? Of course, I am perfectly aware that I am imagining what I see there as a flame. But if I was shocked by something in that flame which escapes you, then I would like to hear from those who see everything with perfect clarity. My vision is like this: unintentionally

I draw out of the world something that one could call a "thing."
But then I become nothing more than one of the world's imaginings.
Thus in all things, imagination is that which is perfectly natural.
Thus, imagination is nature, vision, life itself.

"Van Gogh's Influence on Modern Painting"

On the occasion of the commemoration of the centenary of Van
Gogh's birthday I have been asked for a statement on his influence on
modern painting. Though I am of the opinion that an art critic would
answer this question better, I may, so far as the limited space allows,
suggest one or two points possibly overlooked by experts who deal
with artistic style and content and psychological approach to art.

It has always been the practice of artists to build their edifice with
some bricks of the past. But Van Gogh's effect on contemporary art
I should like to compare to that of delayed action because modern
painters, under his influence, seem to feel that something is changing,
something new is coming, but they do not know how and why.

One may select any group of paintings of Fauves, Cubists, Sur-
realists, Nonobjective artists and include them in an exhibition of
famous Van Goghs. There will be for the visitors too many visible
references in order to ignore the disruption in the traditional approach
to art. General uneasiness on the point of the new society, how to
give a verdict on art, is adding its somber significance to all art, that
of the past and that which is to come.

However, as far as the objective content of Van Gogh's painting is
concerned, no new elements seem to justify the revolutionary change,
his subjects were not different from the flowers, still lives, portraits,
and landscapes chosen by the impressionists, from whom he had taken
over. The next thing the connoisseurs, picking busily around their
barn yard of traditional art, were to ask was, why, for instance, the art
of the impressionist was still impressively compact, whereas Van Gogh's
art does not give them this feeling of security any longer. The masterly
constructed painting of a Manet, Monet, Sisley, Pissarro, and Renoir
could be taken to pieces, studied in detail and analyzed in accordance
with patched-up art theories, drawn from classic art by experts of
varying merit and reputation. These experts had the advantage of
belonging to a world, whose general structure of mind depended on

the spiritual heritage of the eighteenth century, just like their fa-
vorite painters, whose work they classify according to their favorite
method. The eighteenth century was neoclassicist, even Goya, who
was after all the king's painter. The following century was too sophisti-
cated to be surprised by the social changes or even to notice them at
all. The social elite could afford by mere persistence a vision of
materialistic progress but of compact surfacial substance. Remember
Cézanne's pyramids, cubes, and cylinders.

Alas, such a world has become an alien one to us, the fact alone of
two world wars, with all their tragic implications for the common
man, like transfer and expropriation of whole nations, contains clear
indications, that no illusions are possible about the changed reality.
In a world full of impropriety, human nature has substantially al-
tered from progress to something close to regression. Millions of
slave workers still in camps!

As I said before, Van Gogh's originality must not be looked for in
the objective content of his painting, rather in his strange ability
to catch the passing thoughts of *malaise de la vie* of our time. The
sunflower, the basket of potatoes, the unavoidable self-portrait, un-
dulating cypresses, and distant views gained under his brush a ten-
sion and finality as if, with the upsurge of the mechanical age, the
last breath of everyday life would have come to its end. No more re-
finedness and easygoing leisure of human existence in a world per-
ceived as a still life or *nature morte*. Like the demonic world of
another Dutch painter, Hieronymus Bosch, whose work revealed the
hellish estrangement of man, so Van Gogh's world is no longer lulling
society into security.

As a reality this vision of Van Gogh strikes the average man of to-
day, who has risen to fear the deluge that is coming over the world.
It must be remembered that the painter started as a missionary in
one of the poorest mining districts. It is the fiery tongue of his magic
which dominates the subject. Life has to be experienced and not
dreamt! So long as the objective nature of reality is twisted, idealized
according to a canon of unreal beauty, none can be sure that some
Utopians are not dreaming of a metaphysic Arcady. Like Virgil's
islands of herdsmen and shepherdesses it never can be found on a
map but is preached from all the political soapboxes of today. Where
the esoteric artist has nothing to give to the ordinary man and wo-
man of his day, *malaise de la vie* becomes apparent, man finds him-

self estranged in his environment. When social problems were simple, artists could be pleasant and social conscience was dumb. On the other hand Van Gogh's reaction, the days of Impressionism past, has to be understood as a violent reaction of modern man's bad conscience, his "collective guilt" as it has been called, to his environment of highest technical progress, where he finds himself shanghaied, pressed into service of the mechanism of self-destruction at the end. Society is in danger of losing the control of the mind, aestheticism answers human despair with a chuckle.

There is no doubt that art mirrors society's mind. Whenever social revolution occurred it resulted in the handing over of the spiritual heritage of the older culture to a younger, barbarian civilisation. Drawn from a lower strata, renaissance in art is an organic growth, where it differs from Impressionism is that it puts the stress on tension and finds expression in a new magic of the form. It is the task of the phenomenalists to explain this process. Let us understand Expressionism as the living voice of man, who is to recreate his universe.

Certainly, the hellfire of burning towns today is reality to the common man as was the bestiarium of Hieronymus Bosch's imagination engendered in plague and pestilence, foulness and devilry of the wars fought for religious ideologies during the schism of Catholicism. Bosch's rival artists may have dreamt of celestial beauty of metaphysical life in Heaven. Likewise our time is wishfully thinking of the social justice on Earth to come. That trend of advanced and abstract art, at present internationally so domineering, which does away with the image of man and all manmade objects and human environment, is just in keeping with the unrealistic philosophy of our prophesied brave new world.

Now, why are then Van Gogh's critics making capital out of his mental illness, thus giving confidential asides to their public? Perhaps to shirk the point in helping thus to obscure the crucial problem of society in modern industrial civilisation.

I agree with those who believe that the cheap publicity associated with Van Gogh's illness, which offers material for entertaining biographical thrillers only, ought to give way to a new understanding of the work of this man of genius, which should be seen with new eyes at the occasion of the centenary of his birth. This artist did face the reality of existence, however disconcerting, rather than close his eyes before the tragic futility of inhuman life! I believe that he had

no illusions about the time to come; nor did he intend to carve a niche for himself in the cold halls of fame, where the laurels of those rivals in fashion, skill, and technique soon dry to dust. But most certainly he would have been the last to hope to leave the imprint of his mind on the abstract artists, since there seems not to be much point in their painting and sculpturing anything.

Nobody took any notice of him when he died. But the spell of this highly disturbing ghost, like that of the painters of great eminence of the past, will always linger on the artistic firmament.

Max Beckmann

Born 1884 in Leipzig and died 1950 in New York. Studied art
in Weimar 1900. Traveled in Italy and France 1903–1906. Berlin
1907–14. Joined the Berlin Secession but resigned in 1911. In
the army 1914–15. After a medical discharge settled in Frank-
furt. Taught at Frankfurt School of Art 1925–33. Dismissed by
Nazis. Moved to Berlin. Left Germany 1937. Paris 1937. Am-
sterdam 1938–47. Moved to the United States 1947.

Before World War I Beckmann painted in a relatively real-
istic and semi-impressionistic manner. Even though some of
his early work revealed an emotional intensity which could
be called "Expressionist," his outlook corresponded to the
conservative views of the Berlin Secession. In 1912 he even
published an attack upon Marc's (and the *Blaue Reiter*'s)
search for the "inner, spiritual side of nature." His essay of
1914, "The New Program," is just a restatement of this po-
sition but it has a special importance because it was written
for a general survey of young modern artists' opinions about
art which appeared in a leading German art periodical.* The
critical thrusts of this piece seem all the more vigorous
since they appeared alongside statements by Macke of the
Blaue Reiter and Schmidt-Rottluff of the *Brücke*.

However, Beckmann's experiences during the war—in his
words, "the injuries of the soul I suffered"—brought about
a significant change of attitude. After his discharge from the
army in 1915 he began to respond to those influences which
were so important to both *Brücke* and *Blaue Reiter* artists
—cubism and medieval art. Between 1916 and 1921 Beck-
mann worked in a style characterized by violent distortion,
mysterious symbolism and gruesome subject matter. His "Cre-
ative Credo" was written during this period and, while it does

* Max Beckmann, "Das neue Program," *Kunst und Künstler,* XII (Berlin, 1914),
299ff. Translated for this volume by the editor with the gracious permission of
Dr. Peter Beckmann. See Part One of this anthology for Schmidt-Rottluff's state-
ment and Part Two for Macke's contribution. Ludwig Meidner's essay "An Intro-
duction to Painting Big Cities," which was written for the same series, follows
this section on Beckmann in Part Three.

not represent a repudiation of his earlier ideas (he still affirms his love for the visible world as opposed to some mystical inner reality), the impassioned tone of the essay and his fantastic notion of a special building for his art where mankind could "shriek out its rage and despair" is quite Expressionist.*

Because Beckmann's forms had such physical presence he was hailed around the mid-twenties as a leader of the *Neue Sachlichkeit* ("New Objectivity"), an "antiExpressionist" movement which included George Grosz and Otto Dix among its masters. However, it could be argued that all three of these artists made such savagely emotional pictures that they created a new kind of Expressionism, an antispiritual or antitranscendental Expressionism.

Beckmann's subsequent artistic development was certainly not inimical to Expressionist ideas. After 1930 his paintings, using images from Norse and Greek mythology, assumed a mysterious and otherworldly impressiveness. For the rest of his life his major project became a series of triptychs of monumental proportions. Painted in rich color and heavy black line and filled with personal symbolism, these triptychs may well fullfill one Expressionist ideal: art as "something with which to adorn the altars of the spiritual religion to come." †

"The New Program"

In my opinion there are two tendencies in art. One, which at this moment is in the ascendency again, is a flat and stylized decorative art. The other is an art with deep spacial effects. It is Byzantine art and Giotto versus Rembrandt, Tintoretto, Goya, Courbet, and the early

* Beckmann's "Creative Credo," like Klee's and Pechstein's, was first published in Kasimir Edschmid, ed., *Schöpferische Konfession*, Vol. XIII, *Tribüne der Kunst und Zeit* (Berlin, 1920). Translated for this volume by the editor with the gracious permission of Dr. Peter Beckmann. Beckmann wrote the essay in 1918. For Klee's statement, see Part Two; for Pechstein's, Part Five.

† These words were the words of Beckmann's old adversary Franz Marc. However, Beckmann probably never changed his mind about what he identified as "Expressionism." In a letter to Reinhard Piper, in 1922, he emphasized how pleased he was that his work proved that "this Expressionist business . . . [had] nothing to do with vital feeling in art."

Cézanne. The former wants the whole effect on the surface and is consequently abstract and decorative while the latter wants to get as close to life as possible using spacial and sculptural qualities. Sculptural mass and deep space in painting need not by any means be naturalistic in effect. It depends upon the vigor of presentation and the personal style.

Rembrandt, Goya, and the young Cézanne strove for important sculputral effects without succumbing to the danger of naturalism in the least.

It makes me sad to have to emphasize this, but thanks to the current fad for flat paintings people have reached the point where they condemn a picture a priori as naturalistic simply because it is not flat, thin, and decorative. I certainly don't want to deprive decorative painting of its right to exist as art. That would be absurdly narrowminded. But I am of the opinion that not one of all the French followers of Cézanne has vindicated the principle of two-dimensionality which followed the inspired clumsiness of the late Cézanne, the holy simplicity of Giotto, and the religious folk cultures of Egypt and Byzantium. As for myself, I paint and try to develop my style exclusively in terms of deep space, something which in contrast to superficially decorative art penetrates as far as possible into the very core of nature and the spirit of things. I know full well that many of my feelings were already part of my makeup. But I also know that there is within me what I sense as new, new from this age and its spirit. This I will and cannot define. It is in my pictures.

"Creative Credo"

I paint and I'm satisfied to let it go at that since I'm by nature tongue-tied and only a terrific interest in something can squeeze a few words out of me.

Nowadays whenever I listen to painters who have a way with words, frequently with real astonishment, I become a little uneasy about whether I can find language beautiful and spirited enough to convey my enthusiasm and passion for the objects of the visible world. However, I've finally calmed myself about this. I'm now satisfied to tell myself: "You are a painter, do your job and let those who can, talk." I believe that essentially I love painting so much because it forces

me to be objective. There is nothing I hate more than sentimentality. The stronger my determination grows to grasp the unutterable things of this world, the deeper and more powerful the emotion burning inside me about our existence, the tighter I keep my mouth shut and the harder I try to capture the terrible, thrilling monster of life's vitality and to confine it, to beat it down and to strangle it with crystal-clear, razor-sharp lines and planes.

I don't cry. I hate tears, they are a sign of slavery. I keep my mind on my business—on a leg, on an arm, on the penetration of the surface thanks to the wonderful effects of foreshortening, on the partitioning of space, on the relationship of straight and curved lines, on the interesting placement of small, variously and curiously shaped round forms next to straight and flat surfaces, walls, tabletops, wooden crosses, or house facades. Most important for me is volume, trapped in height and width; volume on the plane, depth without losing the awareness of the plane, the architecture of the picture.

Piety? God? Oh beautiful, much misused words. I'm both when I have done my work in such a way that I can finally die. A painted or drawn hand, a grinning or weeping face, that is my confession of faith; if I have felt anything at all about life it can be found there.

The war has now dragged to a miserable end. But it hasn't changed my ideas about life in the least, it has only confirmed them. We are on our way to very difficult times. But right now, perhaps more than before the war, I need to be with people. In the city. That is just where we belong these days. We must be a part of all the misery which is coming. We have to surrender our heart and our nerves, we must abandon ourselves to the horrible cries of pain of a poor deluded people. Right now we have to get as close to the people as possible. It's the only course of action which might give some purpose to our superfluous and selfish existence—that we give people a picture of their fate. And we can only do that if we love humanity.

Actually it's stupid to love mankind, nothing but a heap of egoism (and we are a part of it too). But I love it anyway. I love its meanness, its banality, its dullness, its cheap contentment, and its oh-so-very-rare heroism. But in spite of this, every single person is a unique event, as if he had just fallen from a star. And isn't the city the best place to experience this? They say that the air in the country is cleaner and that there are fewer temptations. But I believe that dirt is the same wherever you are. Cleanliness is a matter of the will. Farmers and

landscapes are all very beautiful and occasionally even refreshing. But the great orchestra of humanity is still in the city.

What was really unhealthy and disgusting before the war was that business interests and a mania for success and influence had infected all of us in one form or another. Well, we have had four years of staring straight into the stupid face of horror. Perhaps a few people were really impressed. Assuming, of course, anyone had the slightest inclination to be impressed.

Complete withdrawal in order to achieve that famous purity people talk about as well as the loss of self in God, right now all that is too bloodless and also loveless for me. You don't dare do that kind of thing until your work is finished and our work is painting.

I certainly hope we are finished with much of the past. Finished with the mindless imitation of visible reality; finished with feeble, archaistic, and empty decoration, and finished with that false, sentimental, and swooning mysticism! I hope we will achieve a transcendental objectivity out of a deep love for nature and mankind. The sort of thing you can see in the art of Mälesskircher, Grünewald, Breughel, Cézanne, and Van Gogh.

Perhaps with the decline of business, perhaps (something I hardly dare hope) with the development of communism, the love of objects for their own sake will become stronger. I believe this is the only possibility open to us for achieving a great universal style.

That is my crazy hope which I can't give up, which in spite of everything is stronger in me than ever before. And someday I want to make buildings along with my pictures. To build a tower in which mankind can shriek out its rage and despair and all their poor hopes and joys and wild yearning. A new church. Perhaps this age may help me.

Ludwig Meidner

Born 1884 at Bernstadt, Germany and died 1966 at Marxheim,
Germany. Studied in Breslau 1903–1905, and in Paris 1906–1907.
Settled in Berlin 1907. Founded the *Pathetiker* ("The Pathetic
Ones") in 1912. Served in the army 1916–17. Member of the
November group 1918. Concentrated upon writing 1925–32. At-
tacked by Nazis as a degenerate and for being a Jew. Withdrew
to teach art at a Jewish school in Cologne 1935–39. Escaped to
London 1939. Returned to Germany 1953.

Ludwig Meidner was best known for self-portraits and land-
scapes of near-hysterical violence. Painted in the years just
preceding World War I, these pictures seemed to symbolize
the total collapse of European culture. Meidner in fact was
one of the most anxiety-ridden and high-strung of all the Ex-
pressionists. Nevertheless, in a way which reminds one a lit-
tle of Kirchner, Meidner demonstrates in his writing about
art how even the most agonizing and ecstatic feelings require
discipline and analysis in order to become artistically effective.
Meidner's "An Introduction to Painting Big Cities," for ex-
ample, reveals little about his extremely troubled inner life.*
On the contrary, the article is an imaginative response to big
city life which is specifically concerned about the techniques
and devices necessary for the artistic realization of that kind
of experience.

Meidner's career as a serious writer began during his serv-
ice in the army. Unable to paint, he composed prose pieces
which revealed, as his pictures had done previously, his sensi-
tive and highly emotional reactions to the life around him.
He subsequently published a number of volumes of essen-
tially autobiographical and expressionistic prose. One of
the best of these was *September Shriek (Septemberschrei)*.†

* This essay was yet another contribution to "Das neue Program," *Kunst und
Künstler*, Vol. XII (Berlin, 1914), 299ff. Translated for this volume by the editor
with permission of der Magistrat der Stadt Darmstadt, Herr Stadtrat H. W. Sabais.
See footnote, p. 28.

† See Part Five for extracts from Meidner's "Aschaffenburg Journal," which was
taken from *Septemberschrei*.

"An Introduction to Painting Big Cities"

The time has come at last to start painting our real homeland, the big city which we all love so much. Our feverish hands should race across countless canvases, let them be as large as frescoes, sketching the glorious and the fantastic, the monstrous and dramatic—streets, railroad stations, factories, and towers.

A few pictures of the '70s and '80s represented big-city streets. They were painted by Pissarro or Claude Monet, two lyricists who belonged out in the country with trees and bushes. The sweetness and fluffiness of these agrarian painters can also be seen in their cityscapes. But should you paint strange and grotesque structures as gently and transparently as you paint streams; boulevards like flower beds!?

We cannot solve our problems by using Impressionist techniques. We have to forget all earlier methods and devices and develop a completely new means of expression.

First: we must learn how to see so that we see more intensely and more honestly than our predecessors. We cannot use the vagueness and fuzziness of Impressionism. Traditional perspective inhibits our spontaneity and is meaningless for us. "Tonality," "colored light," "colored shadows," "the dissolving of contours," "complementary colors," and all the rest of it are now academic ideas. Second—and this is just as important: we must begin to create. We can't simply carry our easel into the middle of a furiously busy street in order to read off blinking "tonal values." A street isn't made out of tonal values but is a bombardment of whizzing rows of windows, of screeching lights between vehicles of all kinds and a thousand jumping spheres, scraps of human beings, advertizing signs, and shapeless colors.

Painting in the open air is all wrong. We can't record instantaneously all the accidental and disorganized aspects of our motif and still make a picture out of it. We must organize, courageously and deliberately, the optical impressions we have absorbed in the great world outside, organize them into compositions.

It is emphatically not a question of filling an area with decorative and ornamental designs à la Kandinsky or Matisse. It is a question of life in all its fullness: space, light and dark, heaviness and lightness, and the movement of things—in short, of a deeper insight into reality.

Above all, three things help us to structure a picture: light, point of view, and the use of the straight line.

Our next problem is how to use light—but not exclusively because we don't react to light as the Impressionists did. They saw light everywhere; they distributed brightness over the entire picture; even their shadows were bright and transparent. And Cézanne went even further. He created a hovering solidity which gave his pictures that Great Truth.

We don't perceive light everywhere in nature; we often see, close up, large planes which seem unlit and motionless; here and there we feel weight, darkness, and static matter. The light seems to flow. It shreds things to pieces. Quite clearly we experience light scraps, light streaks, and light beams. Whole groups undulate in light and appear to be transparent—yet in their midst, rigidity, opacity in broad masses. Between high rows of houses a tumult of light and dark blinds us. Simple planes of light rest on walls. Light explodes over a confused jumble of buildings. Between moving vehicles light flashes. The heavens break in upon us like a waterfall and its abundance of light showers over the world below. Sharp contours waver in the glare and multitudes of right angles retreat in whirling rhythms.

Light sets everything in space into motion. The towers, houses, lanterns appear suspended or swimming in air.

Light is white or silver or violet or blue as you wish. Yet, take a white, as pure as possible. Brush it on with a wide brush—put next to it a deep blue or ivory black. Fear nothing and cover the areas, crisscross, vigorously with white. Take blue—the bright warm Parisian blue, the cool, sonorous ultramarine—take umber, plenty of ocher, and sketch it in quickly, nervously. Be brutal and unashamed: your subject is also brutal and without shame. You have to have more than rhythm in your fingertips, you have to writhe with mirth and madness.

The focal point is vital for the composition. It is the most intense part of the picture and the climax of the design. It can be located anywhere, at the center, right or left from the center, but for compositional reasons one generally puts it a little below the center of the picture. You should also make certain that all things in the focal point are clear, sharp and unmystical. In the focal point we see those lines which are upright as vertical. The further these lines are from the focal point the more these lines become diagonal. For ex-

ample, if we stand looking straight ahead in the middle of the street the buildings at the end of the street all appear to be perpendicular with their windows corresponding to ordinary perspective. But the houses next to us—we see them with only half an eye—they seem to totter and collapse. Here lines, although actually parallel, shoot up steeply cutting across each other. Gables, smokestacks, windows are dark, chaotic masses, fantastically foreshortened and ambiguous.

In the focal point area use a small brush and paint short, violent lines. They must all hit the mark! Paint very nervously, but as you get closer to the edge of the picture paint in a more broad and general fashion.

Formerly people kept saying: there are no straight lines in nature, free nature is unmathematical. People had no use for the straight line and Whistler dissolved it into many small parts. Since the days of Ruisdael the straight line has been proscribed for landscapes and thus artists avoided the use of new buildings, new churches, and palaces in their landscapes. They preferred picturesque things because these were irregular and variously shaped: tumble-down houses, ruins and as many shade trees as possible.

But modern artists are the contemporaries of the engineer. We see beauty in straight lines and geometric forms. Incidentally, the modern movement of Cubism has a pronounced preference for geometric forms. In fact they consider these to be more important than we do.

Our straight lines—especially those used in prints—should not be confused with the lines which master masons make with T-squares on their plans. Don't be fooled. A straight line is not cold and static! You need only draw it with real feeling and observe closely its course. It can be first thin and then thicker and filled with a gentle, nervous quivering. Are not our big-city landscapes all battlefields filled with mathematical shapes. What triangles, quadrilaterals, polygons, and circles rush out at us in the streets. Straight lines rush past us on all sides. Many-pointed shapes stab at us. Even people and animals trotting about appear to us as so many geometric constructions. Take a big pencil and cover a sheet with vigorously drawn straight lines. This confusion, given a little artistic order, will be much more vital than the pretentious little brushings of our professors.

There isn't much that has to be said about color. Take all the colors of the palette—but when you paint Berlin use only white and black,

a little ultramarine and ochre, and a lot of umber. Don't bother about "cold" or "warm" tones, about "complementary colors" and such humbug—you aren't Divisionists—but let yourself go—free, uninhibited, and without a care in the world. What really matters is that tomorrow hundreds of young painters, full of enthusiasm, throw themselves into this new area of expression. I have offered only a few suggestions and ideas here. One could just as well do it in a different way, perhaps better and more convincingly. But the big city has to be painted!

The Futurists have already pointed this out in their manifestoes—not in their shabby goods*—and Robert Delaunay three years ago inaugurated our movement with his grand visions of the "Tour Eiffel." In the same year, in several experimental paintings and in a few more successful drawings, I put into practice what I advocate here in theory. And all the younger painters should get to work immediately and flood all our exhibitions with big-city pictures.

Unfortunately, all kinds of atavistic ideas confuse people these days. The stammerings of primitive races have impressed some of the young German painters and nothing seems more important to them than Bushman painting and Aztec sculpture. Some also echo the pompous speeches of sterile Frenchmen about "absolute painting," about "the picture," etc. But let's be honest! Let's admit that we are not Negroes or Christians of the early Middle Ages! That we are inhabitants of Berlin in the year 1913, that we sit in cafes and argue, we read a lot and we know quite a bit about art history; and we all have developed out of Impressionism! Why then imitate the mannerisms and points of view of past ages, why proclaim incapacity a virtue?! Are these crude and shabby figures which we now see in all the exhibits really an expression of the complicated spirit of modern times?! †

Let's paint what is close to us, our city world! the wild streets, the elegance of iron suspension bridges, gas tanks which hang in white-

* Meidner's article actually reads in parts very much like a Futurist manifesto. Futurism was an Italian movement founded by the poet Marinetti in 1909. His announcement that a speeding car was "more beautiful than the 'Victory of Samothrace'" sums up nicely the movement's emphasis upon the beauties of the modern age.

† Meidner here is in striking opposition to the *Brücke* and *Blaue Reiter,* who encouraged the emulation of primitive art. Actually, Meidner's attitude toward primitive art agreed with that of Kokoschka and Beckmann.

cloud mountains, the roaring colors of buses and express locomotives, the rushing telephone wires (aren't they like music?), the harlequinade of advertising pillars, and then night . . . big city night. . . .

Wouldn't the drama of a well-painted factory smokestack move us more deeply than all of Raphael's "Borgo Fires" and Battles of Constantine?

PART FOUR

Drama & Poetry
by Expressionist Artists

The literary efforts of Expressionist artists are important not only for the light they shed upon Expressionist painting and sculpture but for their intrinsic value as well. Kokoschka, Barlach, and Kandinsky wrote enough significant work for the theater so that they can properly be called playwrights. They, as well as Meidner, Klee, and Grosz also wrote poetry, although it would seem that only Kandinsky and Klee composed verse steadily throughout their careers. Barlach, Kokoschka, Meidner, and Kubin published novels and other prose pieces. Kubin's novel *The Other Side* (*Die Andere Seite,* 1909) deserves special mention.* It may have impressed Kafka; it certainly influenced German surrealists with its phantasmagoric account of the decay and destruction of an imaginary kingdom.

There is no doubt that Expressionist artists wrote because they simply had the talent for it. However, they were also impelled to go beyond painting and sculpture by certain assumptions they held about the function of art. Most of those classified as Expressionist agreed that their art should function primarily as a means and not an end in itself, a means for transmitting what Kandinsky called "the inner sound"; Kirchner, "inner vision"; Nolde, "deep spirituality"; and Beckmann, "deep secrets." With all due respect for the inherent differences between the arts, it is understandable that,

* Alfred Kubin (1877–1959), painter and illustrator. Member of the *Blaue Reiter.* See Klee's remarks about him, p. 81, *Diary* entry No. 958. The Journal as an art form should also be noted. Barlach, Klee, Beckmann, and Kollwitz, for example, have to their credit sensitively written journals which are artistically as well as historically important.

assuming the primacy of a message over its medium, Expressionists would feel not only encouraged but even obligated to move from one medium to another for the sake of the message. Therefore, Feininger composed fugues and Schönberg painted pictures. It might even be argued that no single medium could possibly be adequate for the communication of high truth and profound mystery. And, in fact, that was why Expressionists advocated *Gesamtkunstwerk* ("total art"). Of course, German Expressionists were not the only artists at this time who were unwilling to take a specialized approach to art. No group around 1910–12 was more flamboyant than the futurists, for example, in their rejection of the conventional limits put upon artistic creation. Actually, Expressionist willingness to work in a variety of media, their interest in what critics today call "inter-media creation," was not only a manifestation of individual genius and a particular philosophy of art, but also part of a continuing historical development which has reached a climax in today's "Happenings" and "Events."

Oskar Kokoschka

Oskar Kokoschka (b. 1886) has the distinction of writing two of the first German Expressionist dramas: *Sphinx and Strawman* and *Murderer, the Hope of Women,* both in 1907. These plays broke completely with the realism of conventional theater, with "good taste," "common sense," and "good craftsmanship." They outraged contemporary audiences, visually as well as verbally. But they exercised an influence upon young writers which extended as far afield as America. For example, Thornton Wilder, author of *Our Town* and other well-known plays, studied Kokoschka's works.

Sphinx and Strawman was first staged in 1907 by Kokoschka's fellow pupils at the Vienna School of Arts and Crafts.* Its most illustrious performance, however, occurred ten years later at a Dada soirée in Zürich when the leaders of literary Dada, Hugo Ball and Tristan Tzara, produced the play and acted in it. The theme is the relationship of the sexes, one which Kokoschka also treats in his painting. Unlike realistic drama, there are no real social or personal problems to be resolved by specific men and women. Rather, on stage is created a symbolic image for the moral chaos and dark mystery of all existence. The action which unfolds is a dream-like transformation of personal ideas and private spiritual states into public events.

Sphinx and Strawman, A Curiosity

THE CAST

MR. FIRDUSI,† *a gigantic, revolving straw head with arms*

* *Sphinx and Strawman (Sphinx und Strohmann)* was first published in Oskar Kokoschka, *Dramen und Bilder* (Leipzig, 1913). Translated for this volume by the editor with permission of the author. In 1917 the drama was rewritten, enlarged and republished under the new title *Job. Job* and *Murderer, the Hope of Women* appear in English translations in Walter Sokel, ed., *An Anthology of German Expressionist Drama* (New York, 1963).

† The name of a tenth-century Persian poet who wrote the national epic of Persia, and the title of a poem from Goethe's *West-östlicher Divan.*

and legs. He carries a pig's bladder on a string.
MR. RUBBERMAN, *an accomplished contortionist.*
FEMALE SOUL, *called "Anima."*
DEATH, *a normal, living person.*
PARROT

FIRDUSI: (*his gigantic head rocking back and forth on his legs; talks to the parrot*) Who are you? What is your name?

PARROT: The female soul, Anima, sweet Anima.

FIRDUSI: (*turns away*) I had a wife, I treated her like a goddess and she left my bed. She said to our sad little chambermaid, "help me on with my travelling cloak" and then disappeared with a healthy muscleman. I had created a human soul but the ground vanished from beneath its feet. Now my creation floats in the air like a pig's bladder—*Horror vacui!* What kind of God steals words out of my own mouth in order to make me believe that they are his words of wisdom? Just like a sponge drinks up vinegar only to give it all back without swallowing a drop.

PARROT: Anima, sweet Anima!

FIRDUSI: At first she was a woman. Then I found myself dining with a ghoul, in the ecstasies of love with a ghost and then I solved the mystery of certain vocal phenomena. A nightmare entered my skull, it strangled my consciousness. Vitality, essentiality, reality help! That poor Adonis! She will feed on his mind until he begins to speak with my voice. She is a woman who lost her virginity for a soul and now she wanders from one man into another, she spins and wraps herself into a cocoon, she devours men's brains and she only leaves their empty skulls, as a magnificent butterfly, in order to lay her egg. Anima, Anima, the nucleus from one, protoplasm from the other, and we all recognize ourselves in the result. Resurrection from life. I want to die.

(*Death, who looks like an ordinary person, appears in thunder and lightning. He gestures threateningly, but with a smile and then disappears without doing anything.*)

FIRDUSI: (*to the public*) When I grab my handkerchief you all start to cry, how touching. But why do you look at me now so coolly, one hundred indifferent people against a single desperate

person? Only a nuance separates the hero from the audience. Do you believe in a bluff?

I am only exploiting your intelligence and your nerves and our mutual romantic interest in ghosts.

RUBBERMAN: (*enters and touches Firdusi's leg*) Hey there, I'm a doctor. You say you want to die! Let's talk awhile, you know, to exchange impressions is not to explain insights but to interchange outlooks. You don't die as easily as you're born. However, I have something for you in case your last little hour should give you any trouble. I know a woman . . .

(*Anima peeks in the door.*)

who is slowly murdering her husband in such a way that no court in the world could prove a thing. "Fear of adultery" is a poison which works with absolute certainty. And how can I serve you?

FIRDUSI: Thanks—thanks.

(*lost in thought*)

I don't think—things have gone that far—yet— But you are a doctor, and you don't try to stop crime?

RUBBERMAN: Oh, I'm interested in experimentation. I'm no practicing doctor, just a modest priest of science.

ANIMA: (*half aloud*) A man, magnificence and modesty combined, anything spectacular like that fascinates me.

FIRDUSI: (*embarrassed, he puts a rubber figure on his finger and lets it nod back and forth*) May I introduce my child, Emanuel, my hope—Mr. Rubberman!

RUBBERMAN: Be a credit to your father Mr. Emanuel, my dear sir. (*to Firdusi*) But to be frank with you, if you want your offspring to be legitimate—legal—you have to declare at least who its most important producers were.

FIRDUSI: (*he becomes confused and pulls the figure from his finger*) Oh my dear sir don't talk so loosely, my child is still pure. But you're right, Emanuel's progress might be hurt by not having a mother.

PARROT: Anima, sweet Anima.

ANIMA: (*in a light blue conventional angel's costume, wings, hands folded, she approaches the men*) Oh Lord, if I could only save a man's soul! They say that men suffer so from the mysteries of

their delicate and cultivated eroticism. (*pointing to Rubberman*)
You must be worthy, you have powerful muscles.

(*Rubberman, pleased, shows off his thigh muscles. She looks
down at her own feet coquettishly, one placed a little ahead of
the other*)

Horrors! Don't you think that one of my footsies is shorter than
the other?

RUBBERMAN: (*gallantly*) Perspective is an optical swindle invented
by art experts.

ANIMA: (*acts reassured*) And that's why I'll have to limp for the
rest of my life!

(*she lifts her dress and gives Firdusi, who has not paid any at-
tention to her, a light kick in the pants with her graceful leg*)

FIRDUSI: (*grumbling*) Women should only be looked down upon.

(*he turns his head slowly without moving his body. Anima, mov-
ing step by step, keeps out of his line of sight until Firdusi's head
has turned completely round; in spite of great effort he is then
unable to get his head back where it belongs. Thus right to the
end Firdusi never sees Anima*)

FIRDUSI: (*whining*) If you are kind and considerate in love, those
raging Amazons feel themselves cheated, but if you are rough and
domineering your own sensibility is violated. (*backing up to the
door like a crab, he rings for the butler*)

Johann, bring a mirror, a red rose and the photograph, also the
cockatoo, bring them into the Rose room.

(*the servant brings the rose and the mirror. Firdusi, going back-
wards as before, storms to the armchair, sits down backwards. He
puts the rose first in his back, then on his necktie, puts the mir-
ror to his rump and then to his face*)

ANIMA: (*in new, exquisitely luxurious clothes, singing with a book
in her hand*) Oh, where is the man who is worthy of me, the man
I dreamed of as a girl? Oh, no man like that proved himself
worthy of me! I took a feature from one man, another from the
next, to my lover I offered resigned lips, to my husband scorn
and melancholy. I am forced to wander and wander, eternally,
from one to the other. (*to Firdusi*) Hello handsome!

FIRDUSI: (*without being able to see her*) Who are you? What's your
name? Angel.

ANIMA: The female soul, Anima, sweet Anima.

PARROT: (*repetitiously*) Anima, sweet Anima.

FIRDUSI: (*pulls a larva out, like a dentist*) I've been through all this once already. Women have an earthly body but an immortal soul.

ANIMA: (*pointing to his figure*) You have an interesting view.
(*Firdusi, thinking that she is referring to what he has said, proudly puffs his chest out*)

ANIMA: Oh, I believe that I only love you.

FIRDUSI: (*smiling pathetically*) If I could only respond out of my loneliness to your secret confessions, oh, to be able to place a rainbow of reconciliation over shocked sexes, (*becoming hysterical*) my feelings are like so many falling stars, stars falling into the narrow fields of my soul to be extinguished—but the Word which reaches out far beyond me like a huge gesture means nothing to you.

ANIMA: Oh, but I do so love grand gestures! My dear, sweet big head. My light, my wisdom. (*shrieking she jumps on top of him*) My master, dear sweet Mr. Firdusi.

FIRDUSI: My self-respect grows by leaps and bounds.
(*Rubberman, panting; Anima pulls his leg up to his nose and he trembles gently*)

ANIMA: (*quietly*) Oh, Rubberman, I think I'm in love but I'm not sure. Do you gentlemen know each other—Mr. Rubberman.

FIRDUSI: (*involuntarily*) Fir–du–si!

RUBBERMAN: The pleasure is all mine! (*a very deep and very odd bow; Firdusi bows facing the other way for obvious reasons*)

FIRDUSI: Emanuel is getting a mother.

PARROT: Anima, sweet Anima.
(*Death appears in thunder and lightning; Firdusi is horrified*)

FIRDUSI: (*screams*) *Entreprise des pompes funèbres!* Sex murder for ever! If you think about the future the present disappears. (*searching for Anima*) I don't even have her photograph.

DEATH: (*Knocks with a bone on the proscenium. Firdusi becomes rheumatic*) In spite of the spectacular stage effects I want to reassure the audience that death has lost all its horror now that the masculine imagination in Europe is obsessed by gynolatry.*

FIRDUSI: (*still upset but a little quieter*) The human soul is like

* The worship of women.

a magic lantern, in the past it projected devils on the wall, now it projects our women over the whole world. (*shudders like an electric eel and destroys the pig's bladder*) That used to be the soul. (*resigned*) Oh, I'll never ever again disbelieve in fairytales, but I will laugh a little. (*laughs louder, a hundred voiced resonance, a rushing echo, then quiets down*) My method for restoring my body's balance.

(*he hitches up his trousers. Death follows him. Anima screams and flees with Rubberman into the Rose room. Firdusi gropes after them clumsily but he is unable to find his way. Meanwhile, the Rose room is lit up. Two shadows can be seen kissing*).

PARROT: Oh, my Anima, sweet Anima. (*very clearly*) Oh my sweet Mr. Rubberman! Oh my sweet Mr. Rubberman! Oh my sweet Mr. Rubberman!

FIRDUSI: (*his head snaps back as he hears the unexpected additional remarks of the Parrot; he notices the shadows, and then rushes to the telephone*) Who are you?

ANIMA: Anima, your dear sweet Anima, the female soul.

FIRDUSI: What are you up to?

ANIMA: Experiments in spiritualism, exorcism. I am having myself saved.

FIRDUSI: Who am I?

PARROT: Oh my sweet Mr. Rubberman.

(*Firdusi staggers to the middle of the stage, lies down flat on the floor and shoots himself with an air pistol. He sprouts horns. Johann opens a curtain which hangs below the Rose room. On it there is a painting of a gigantic cat catching a mouse. There is another curtain. On it are painted a group of gentlemen dressed in black with top hats. Instead of faces there are holes through which heads pop out. First one gentleman speaks and then quickly another answers and so on to the end*.)

FIRST GENTLEMAN: The Enlightenment will come to a bad end. The brain is too heavy and the pelvis much too frivolous.

SECOND GENTLEMAN: And there is no conscience to keep things balanced.

THIRD GENTLEMAN: Death gave all his power to a woman.

FOURTH GENTLEMAN: This is the way a great fantast takes all the magic out of culture.

FIFTH GENTLEMAN: Mr. Firdusi, who was supposed to have been

born of woman, gave his inheritance, his masculine imagination back to his wife, and now her soul suffers.

SIXTH GENTLEMAN: He persuaded a woman to swallow her miscarriage under the impression that she could still give it a proper birth.

SEVENTH GENTLEMAN: Eat this you bird people, or die!

EIGHTH GENTLEMAN: Can't modern science help.

NINTH GENTLEMAN: It's become shameful since everyone in the elementary schools knows its ancestors.

TENTH GENTLEMAN: Man must be willing to suffer the anguish which woman causes him because he knows why she is so different from him. He wisely compensates for the "it is" through the better "it could be" and so rounds out the horizon of his experience.

(*Anima throws herself on Firdusi weeping*)

FIRDUSI: (*stirs himself for the last time*) I forgot!—Quick, a priest!

RUBBERMAN: (*chases after Anima, his tie is gone*) What about the wedding? (*sings*) Joy reigns supreme, conscience is dead. Yes, marriage reform, marriage reform and let us make love in front of scientists!

FIRDUSI: (*stirs himself for absolutely the last time*) Passion needs spirit as a filter or else it floods over the entire body and soul and dirties them both. I have faith in the genius of mankind, Anima, amen.

DEATH: (*with lightning and thunder*) A good, strong faith is like blindness. It covers over unpleasant things, but those things never disappear.

(*Death goes away with Anima*)

Ernst Barlach

When he was only nineteen, Barlach (1870–1938) wrote to a friend that he was convinced that sculpture and drawing alone could not satisfy his ambition, which was to reveal "essential reality and truth." Motivated by metaphysical as well as by artistic considerations Barlach thus made literary work an integral part of his expression. His most important writing was not theoretical but dramatic and between 1912 and his death he composed eight major plays.

*The Dead Day** was his first drama and with it Barlach defines the central theme of all his art: the relationship between God, God-seeker, and ordinary, practical people—or as it was formulated in the play itself: the relationship between a mysterious, absent father, his son, and a mother. Because of the drama's length, only the last part of the last act has been included in this anthology. Nevertheless, the extract is very effective as such. A short synopsis of the action preceding the extract, however, should make it more meaningful.

The father (a distant god) has promised that he will send a winged horse to take his son away from home and out into the world. But to sharpen his son's ambitions he first sends a blind seer, Hole (*Kule*). The mother bitterly opposes the son's longing for his father and a higher life. When the horse arrives she kills it before the son can see it. He senses what she has done and he calls out to his father for help, but there is no answer. Unable to respond creatively to this terrible silence, he breaks under the strain.

Barlach's plays, like his sculpture, have a simple, rugged, folklike character. Thus, *The Dead Day*, in contrast to Kokoschka's drama which had qualities of a big-city theatrical review, uses imagery and language from the country, specifically from North German peasant life. *The Dead Day* is

* Ernst Barlach, *Der Tote Tag* (Berlin, 1912), in *Das Dichterische Werk* (München, R. Piper & Co Verlag, 1956), pp. 84–95. Copyright © 1956 by R. Piper & Co Verlag. Translated for this volume by the editor with permission of the publisher.

also relatively conventional in form. However, most importantly both plays are diametrically opposed to realism; both (to use Barlach's words) try "to look behind the mask."

From The Dead Day

[Conclusion from the Fifth Act of a drama in five acts.]

THE CAST

MOTHER
SON, *who yearns for his father*
HOLE, *blind*
HAIRYBOTTOM, *an invisible gnome; only the Son can see him*
BROOMLEG, *a house spirit*
ELF
HORSE, *which has been killed by the Mother*

Setting: *The large hall of a North German farm house.*

MOTHER: What are you whispering about, shouldn't I know?

SON: We haven't decided anything yet so it's best you don't worry about it; not until we know more.

MOTHER: There's nothing worse than all that whispering. What are you talking about? Tell me!

SON: What are we talking about? I asked him if he could repair a smashed pot. Its contents have spilled out, they are lost forever.

MOTHER: What's been spilled?

SON: The future, a very dainty thing. We have to mend the pot and put a new future in it. But I doubt if it'll be worth eating. (*to Hole*) What do you think? (*Hole is sitting and listening*).

SON: (*taps him on the forehead*) You, yes I mean you. I'd like to know what you think.

HOLE: Me? Ask your mother. She let your miserable life sink deep into hers like roots into earth. She'll feed you and make you strong out of herself. See, a mother can give her son a second life—and you still owe her for the first one.

SON: Owe her? Did my mother really give me my life? Is that why I should thank her and praise her? Can she give something she doesn't have? I'm not like Hairybottom who had only one sire.

Mother alone didn't give me life so she alone can't restore it.
I would be my own step-brother, half a person, and she would
be a strange woman. (*confidentially*) The other life is all wrong.
You better make arrangements—you know what I mean.

HOLE: You'll get back everything, everything. Your torment will
pass away. Relief will come like a whole herd of young horses.

SON: But suppose your relief is just so much salted fish for a thirsty
man? (*frantically*) No, no, Hairybottom made it terribly clear.
Whatever it is that torments me, I don't get it from mother.
(*calls*) Father! Father! (*silence*)

HAIRYBOTTOM: When you were in the fog and called, nobody an-
swered the first time. Call again!

SON: (*begins to call and then loses his nerve*) I can't anymore.

MOTHER: (*has gone to the hearth, turns her back on him*) A father
who doesn't answer his son's cry for help—some father!

HOLE: You're a dreamer. Your soul sweats yearning, it accomplishes
nothing and your eyes see only fog.

SON: Should I look at my mother but close my eyes to my father?
If my father is invisible, how is it that I am visible? When I cry
out how can my father keep silent? Can a person say mother
without meaning father also? Hairybottom is satisfied with only
a father and no mother. For me there can be no mother without
a father.

MOTHER: (*at the hearth, facing away from her son*) When a son
suffocates from a father's silence how can a mother keep breath-
ing? If suffering were a poison I should be dead by now.

SON: Hairybottom, what your father, Hairybelly, can do, my father
can do too. I'm going up to him!

HAIRYBOTTOM: Go up to him? Go up to your father?

SON: Don't you think my father has a hundred times as many tal-
ents as yours?

HAIRYBOTTOM: As mine? Don't you believe it!

SON: I'm going up to him just the same!

HAIRYBOTTOM: If the idea didn't come to you in a dream, you'll
never succeed awake. First dream and scheme, then start and
depart, that's the way to do it.

SON: I dreamt that I rode on the path of the sun.

HAIRYBOTTOM: So you think that's your father's style do you? I
don't believe it. I bet your father is a blacksmith and takes care

of horses for serious riders. He could have gotten a good thrashing for letting a young stallion escape him. Otherwise he's probably a pretty good fellow. But to go up to him—?

SON: A blacksmith? Why a blacksmith?

HAIRYBOTTOM: Because he shoed horses.

SON: How do you know that?

HAIRYBOTTOM: Why? Didn't the horse have any shoes?

SON: There wasn't a nail in his hoofs and he ran across rocky ground as easily as grass.

HAIRYBOTTOM: No shoes? Well, then we don't know anything about your father for sure. A good man—but crazy.

SON: Am I crazy?

HAIRYBOTTOM: All right, all right, he isn't crazy. A crazy man's son would have to be crazy. But a stay-at-home, that you are, and also a bed-wetter, you know that yourself, and a—your mother herself says so—an eavesdropper.

SON: An eavesdropper? And—

HAIRYBOTTOM: Your father was all of those things too. You'll have to look for him in that direction.

SON: An eavesdropper? An eavesdropper, Hairybottom? Where?

HAIRYBOTTOM: Him? Where do you eavesdrop? It shouldn't be any different for him?

SON: A son who eavesdrops on his father? What a wretched son!

HAIRYBOTTOM: But your sort, and every son, gets the kind of father he deserves.

SON: Well, what does that mean, Hairybottom? Am I no better than an eavesdropper?

HAIRYBOTTOM: Who knows! Maybe you eavesdrop at the wall where the Other begins, the Other which no man understands. That kind of person! Someone who knows that only one wall is there and that on the other side something lives, something you can hear breathing if your ear is up tight against the wall. If you were that kind you might perhaps be eavesdropping on your father, just like your father might be eavesdropping on you. Now be a Peeping Tom, knock a peephole in the wall. That's what you should do so that you could see what your father looks like.

SON: A blacksmith, and now an eavesdropper. Hairybottom, you old fiddler, you certainly play a fine tune on me with those ideas.

HAIRYBOTTOM: There are fiddlers and fiddlers. What I play is played on very delicate strings. Don't you hear anything way down deep inside you?

SON: Do you hear it too?

HAIRYBOTTOM: What do you hear?

SON: I hear the sun rushing about above the fog.

HAIRYBOTTOM: That must be a beautiful sound! But the likes of us Hairybottoms and Hairybellies will never hear it. The sun?

SON: Words can't rush around fat head! Do you think I'm the sort who makes a word and puts it into his pocket and acts as if he had really grabbed hold of something? Don't you hear anything yet?

HAIRYBOTTOM: I'll never hear it—it's not for my insides.

SON: It would break your heart and you could still rejoice.

HOLE: Tell me more!

SON: Tell you? If you want to talk about such things—tear your tongue out! (*full of disgust*) Go ahead and let your wormy ideas gnaw your insides out! Let those sayings of yours drop their load behind them!

MOTHER: Oh my love! Goodness me!

SON: Love, goodness! What kind of love? What kind of goodness? I tell you it's garbage. Talk garbage. Talk garbage. That's your style.

MOTHER: (*cuttingly*) If it's my style, it's yours.

SON: But how? Say—what is it, it sounds like a muffled bell, in the depths—slowly and gently in heavy beats and the mountain trembles to its very core—listen—there it goes again—do you hear it?

HAIRYBOTTOM: None of our tribe has ears for that kind of thing. He hears the giant heart of earth beating!

SON: Oh yes, streams are rushing down there.

HOLE: Streams of suffering.

SON: (*kneeling*) Waves, waves, waves they're rising up out of bottomless depths. Gates swing open—listen—tremendous thundering, like surf.

HOLE: Gates of hope.

SON: Open and shut, open and shut. You could fall and be swallowed up completely.

HOLE: We all are, and don't know it.

SON: Yes—to really plummet all the way down, down to the very depths!

HOLE: His yearning pounds down there in vain.

SON: (*stands up*) It's faded away. But now, who could have stabbed me? Nobody, I suppose because it stabs and cuts me all by itself. Echoes struggle inside me from above and below and at the same time sharp steel sneaks up and jumps at me like a flea and then, suddenly, it bites into me. Not even mother—where is she— (*gestures as if he doesn't see anything*) Am I crazy or are they? How did I get into this fog—wasn't I here before? And didn't I call for mother and didn't I let myself be dragged back into the hut?

MOTHER: He doesn't see us. He thinks he's out in fog.

SON: How much longer should I keep asking about the owner of that knife?

MOTHER: He's on his guard against coming into the hut again.

SON: Shouldn't I try to call my father again? Perhaps my voice will carry out here— Father! (*he listens*).

SON: (*quietly, still listening*) Can a father keep silent so long when he knows about his son's misery? Mother never stopped her fussing—(*the mother walks up and stands close to him*).

SON: Father, listen to me. I'm calling you—loudly and softly— What kind of mother was it who begot me from such a father? What am I to think when she feels obligated to hide him like a dirty corner in her house? Is she afraid that I would dig a dishonorable grave for his memory, plant a smelly shrub on it and cut a bouquet for her from it every morning? No, no—father if only I could hear your voice. (*he stretches out his hand*) If your hand would only touch mine. If only I could feel your hand. Next to you I'm very small, like a child playing all alone in the wide, wide world. I want to feel your hand and know it's really you, and feel safe again.

MOTHER: And I stand next to him and could touch his hand but I don't dare. He thinks he's with his father and he's all smiles. He's in sunshine and he thinks only of him. Honestly, I'm not sure if I wouldn't be perfectly happy to give him away if only he'd smile just once, like he's doing now—only at me!

SON: I've got to get away! (*wanders about*) And sooner or later it's got to get lighter. The sun is rushing around up there. I hear

the pounding of its hoofs, sparks sizzle about in the fog. He must
see me down here, alone, in trouble. He has to send help even
if it's only his horse again, yes, it's got to be his horse—it's not
possible for it to be lost! The hut is far behind me. I'll never
find my way back. Yet they say that you can be close by a place
in the fog and miss it. Suppose I shouted. And mother shouted
back and then I would be inside again, with Hairybottom by the
hearth. (*he moves forward quickly*) No, no, no. I have to get away
from here. Wait a minute, someone's coming, and how! (*in his
delirium he thinks he has run into a lost traveller*) Are you lost
too? Yes, good advice is hard to find. Ask the fog, it will know
for sure. But if you have a voice shout to the four winds "mother."
And when you hear "son," there you'll find a hut and if you're
hungry you'll find a good meal—only tell them not to wait for
me—take my place at the table—farewell! (*he walks away and
then suddenly stops*) I wonder who he was? He didn't look like
any one in particular. I didn't even think of asking him his name.
He's calling—Why, it sounded like my voice almost, but muffled
by the fog. What if mother heard him, mistook him for me, and
welcomed him in? I can't let that happen. I can't let him call
and fool my mother. Where is he? (*looks about*) There—there—
he's calling again and it's my voice. I have to go back, back home
—mother!

MOTHER: (*touching him*) Son, there you are.

SON: (*embarrassed*) Yes, it's the same old story—did you hear all
that shouting?

MOTHER: And I answered, just like the first time—and there you
were again. Are you happy to be back?

SON: But what about the other one? He was lost and looking for
the hut.

MOTHER: If you had only brought him in with you!

SON: I lost him in the fog but he should be near by. Is dinner ready?
Is it good? You know, I've invited him to dinner.

MOTHER: Everything is ready. All he has to do is walk in. He's wel-
come.

SON: Call him mother. Like you called me. Otherwise, he might
just wander away.

MOTHER: You call him while I set the table.

SON: Not me. My voice is like his. He'd think an echo was teasing
him. He called first, you know.

MOTHER: He called "mother." Now how could a stranger shout something like that for you! Think how upset I would have been if he had come instead of you. A lot of people can say "I'm here" in the fog. And you know, you can expect something of a person and be deceived.

SON: He didn't say anything about himself, who he was—he crossed my path and loomed up before me like a tower.

MOTHER: In the fog everyone looks like a giant. You looked that way to him too.

SON: (*to the door*) But he wanted to get to the hut. He should be here any minute. I invited him to dinner and—I would like to see how his form matches my voice.

MOTHER: We'll set a place for him so that he can sit down and eat as soon as he comes in—he will be hungry and tired—only come now and sit down.

SON: But what will he think if we're already eating when he comes in? I promised him my place and he's going to have it!

MOTHER: A traveller is always happy if he gets a full bowl and warm corner. He isn't going to bother anyone, or take anyone's place at the table. He had better hurry, we can't wait any longer.

SON: He must be lost. I'll go out after him.

MOTHER: Perhaps he's gone off somewhere. Who knows, he might have been a goblin.

SON: No, no. He's no more a ghost than I am. It was as if he had stepped out of a mirror, right at me, big as a house.

MOTHER: Oh, let's drop the subject. Let's wait and see. Come along now. (*but they hesitate to sit down to dinner*).

SON: Not here. That spot is reserved for him.

MOTHER: Just eat. Why don't you dig in?

SON: All right mother. And give something to Hairybottom too.

HAIRYBOTTOM: Listen!

MOTHER: (*throws some food to him*) Shut up and stuff your trap with this.

HAIRYBOTTOM: Listen! Don't you have ears?

SON: Do you think that he—?

MOTHER: Say, wasn't he told to play the fool before dinner? Didn't he have enough room? And now, I suppose I'm to let my food spoil on the table? Tell him, boy!

SON: (*to Hairybottom*) Go to the door and look outside. It won't hurt to light a torch; take one from the hearth.

HOLE: Nobody is lost outside in the fog. And nobody is going to miss finding the hut because nobody is looking for it.

SON: Don't bother getting your herd of consolations moving, old man, my own are hiding in ambush. Just watch out so that they don't trample all over you.

HOLE: Oh, you're ridiculing them, are you? Go ahead my friend, but I'm afraid you're desperate and you're only ridiculing your own hopes.

SON: Wait, wait. Haven't you chased all my hopes away? But they're back in spite of everything! They circle about but they find their place again just the same.

MOTHER: Hope for comfort—but not that kind. You kill all my hopes.

SON: What do you see Hairybottom?

MOTHER: (*passionately*) Nothing, nothing, a terrible nothing destroys all my hopes.

SON: He was here. He stood right in front of me when I was lost in the fog. What we saw, Hairybottom and I, you have to see when it comes.

MOTHER: But you weren't outside in any fog. ⎫ (*simultaneously*)
HOLE: You were standing right here in front of us. ⎭

MOTHER: Your eyes fooled you. ⎫ (*simultaneously*)
HOLE: Your imagination gave you illusions. ⎭

HOLE: Nobody was out of sight—not you from us nor we from you. We heard everything you said.

SON: I wasn't lost in the fog? I didn't leave the hut? That really didn't happen—and you didn't hear anything? And you didn't hear the man speak?

HOLE: Nobody's outside.

MOTHER: Nobody! You made yourself a miserable illusion out of wind and air.

SON: But his voice! (*jumping up*) Am I not I and what about you? Yes I know! I'm here in the hut, in the old house. If you don't say so the words will jump out of your mouth anyway. You are you! I am I!—Yes, yes, yes, yes! "The old hut"—it sounds like rattling chains! You and me—two hangmen who urge each other up the ladder. (*grabs his head*) Stop, stop! You're running around like crazy people! A thousand years disappear, and another thousand and still another! Absurd time—is it trying to make a beggar out of eternity? Cut a thousand bridles and are a thousand years

destroyed just like that? Time forgot to let the old hut loose, and so—hippity hop it chases after her. But eternity isn't asleep either, and there was a whistle like something from the beginning to the end of the world, and the heavens were torn open by an enormous explosion. A dozen moons rushed out, like a swarm of bees—ha, and the lively little years were ordered to come back, were grabbed back, were gathered together by the hundreds—the thundering millennia were brought back again under eternal law —take a look, take a look you gluttons always hungry for the future—you're back in the stall! Today is today again—and the hut is still here, undamaged, the timbers were only loosened a little—and all of us, how many were there—only four? Four travelling together without saying one word to each other, without even finishing our mouthful of food? I know that two of them will deny that they travelled even a hundred years. They'll claim that we didn't get past noon today. Is it worth arguing about? People like that only believe something if they can poke it with their finger. Say, old Hairybottom, are you still standing by the door—what have you been doing for the past thousand years? Standing around gaping? Go ahead and eat old boy, those bones are still fresh. Oh—and—what was I thinking of, how could I forget! The one outside, what happened to him? We'll have to look for him, call and shout to him. Was he a messenger or was he the man himself, a man with comfort and help for me—he can't just pass by—(*he tries to go to the door*).

MOTHER: (*holds him back*) Listen to me. Listen to your mother.

HAIRYBOTTOM: Listen to your father instead.

SON: Leave me alone. I have to go.

MOTHER: You're eating stones. Is that supposed to keep you alive?

HAIRYBOTTOM: Listen! It's dancing up there in the fog, on four unshod hooves.

SON: You'll see for yourself mother. How could I let things like what you call fact and propriety stand in my way, even for a second. Now I know—your walls are my doors. Your seeing is my blindness. Your yes is my no.

MOTHER: (*lets him go*) Go, damn you!

SON: (*deeply shocked*) Mother, what do you mean?

MOTHER: What do I mean? I can't hold back the misery you cause me any longer!

SON: (*falls and seizes her hands*) Give me your blessing!

MOTHER: (*tears her hands away and seizes the knife*) Look at this!

SON: Yes, yes, what do you want?

MOTHER: I killed your horse with this. It won't ever dance again. Hairybottom is lying. Look why don't you, I served him to you for dinner. You still have his flesh between your teeth. That's the truth and Hairybottom lies. My blood (*she stabs herself*) will be silenced and will stop screaming on your account.

SON: Oh cursed motherson!

HAIRYBOTTOM: Blood. Blood on the floor and it covers up the other spot.

SON: Not one word more Hairybottom or I'll throw you into the deepest cellar. (*to Hole*) What are you looking for? Don't step on her!

HOLE: Give me the knife.

SON: Oh, so you think things aren't quite over yet and you want to help them along? Here take it—(*gives it to him*)—so take it— you could give me all his sharp brothers and sisters and I still wouldn't do anything. It's not our style. Father didn't do it either. We let others do it for us. If you could see, you would be impressed by my servants. I'm surrounded by nothing but fists, all holding knives. (*he gestures*) Lazy ones, do your duty! (*thinks it over*) No, wait. Not that way. I'm not used to so much ceremony. Who am I that I should play the great man! (*he tears the knife away from Hole*) I prefer mother's way. (*kills himself*).

(*Hole feels the body, then tries to leave the hut*)

HAIRYBOTTOM: Stop! I'm as good as a staff. I know the way.

HOLE: Where am I supposed to go now?

HAIRYBOTTOM: A road doesn't have to lead to a place, only away from a place.

HOLE: You and me! But which road would suit us both?

HAIRYBOTTOM: A road for messengers so that the world will know what we know.

HOLE: And what do we know?

HAIRYBOTTOM: Where blood comes from. Let them think about this. Everyone gets their best blood from an invisible father.

HOLE: Your shouting sounds pretty strange to me.

HAIRYBOTTOM: But like any shout that comes from the blood, it's true. But what is strange is that mankind refuses to learn that its father is God.

Wassily Kandinsky

The Yellow Sound by Wassily Kandinsky (1866–1944), written in 1909, occupies a significant place in the history of theater as one of the first abstract dramas and also one of the earliest of modern light-and-sound "events." Kandinsky created here a *Gesamtkunstwerk* ("Total Art") by using symbolic sets, the play of colored light, dancers, and music. The drama was first published in the *Blaue Reiter* "Almanac," where Kandinsky was most careful to give it a proper theoretical and historical frame of reference by introducing it with his own essay on dramatic theory and by also featuring an article on Scriabin's *Prometheus,* a piece which clearly anticipated the ideas in *The Yellow Sound.**

Although Kandinsky's play is "abstract," in the light of his well-publicized ideas its purpose, its message, is unmistakable and coincides perfectly with the definition of drama put forward by the noted German Expressionist Georg Kaiser: "Vision" dedicated to "the regeneration of man." This didactic purpose was central to all of Kandinsky's art and represents one of the most important aspects of Expressionism. There is, of course, another side to the movement (represented in this anthology by Kokoschka's *Sphinx and Strawman*)—the revelation of a world without meaning, a world become absurd. Kandinsky, on the contrary, gives us an ecstatic spectacle which expresses his faith in the ultimate triumph of the spirit.

* Wassily Kandinsky, *Der Gelbe Klang* in *Der Blaue Reiter* (München, 1912). Copyright © 1965 by R. Piper & Co Verlag. Translated for this volume by the editor by arrangement with The Viking Press, Inc., and Thames and Hudson Ltd., who are publishing a new translation of *Der Blaue Reiter* in their forthcoming series *The Documents of 20th Century Art.* The music was written by the Russian composer Thomas von Hartmann. Unfortunately, the score was lost during the Russian Revolution. See also Kandinsky, "Über Bühnenkomposition," and L. Sabanejew, "'Prometheus' von Skrjabin," *Der Blaue Reiter.* Alexander Scriabin (1872–1915) was a Russian composer. His *Prometheus,* written between 1909 and 1910, called for a full orchestra, a color organ, and perfume! Kandinsky also wrote (but never published) *The Green Sound* (1909), *Black and White* (1909), and *Violet* (1911).

The Yellow Sound

CAST

FIVE GIANTS
INDISTINCT CREATURES
TENOR, *behind the stage*
A CHILD
A MAN
PEOPLE IN LOOSE AND FLOWING ROBES
PEOPLE IN TIGHTS
CHOIR, *behind the stage*

PRELUDE

In the orchestra several indefinite, vague chords.

On stage it is dusk, *curtain* dark blue which at first is whitish and then becomes a deep intense dark blue. After a while a small light becomes visible in the center of the stage. It becomes brighter as the blue deepens. After a while music. Pause.

Off stage a choir is heard singing, but no one can tell precisely where the sound is coming from. It is vital that the bass voices be heard. The singing is even, devoid of feeling, and interrupted by full stops which are indicated by dots.

First *Deep Voices:*

> Dreams hard as stones . . . and talking rocks . . .
> Clods with mystifying questions. . . .
> Heaven shakes . . . stones melt . . .
> Up and up, higher and higher the invisible . . .
> Rampart . . .

High Voices:

> Tears and laughter . . . prayers and curses . . .
> Happiness and blackest slaughter together . . .

All:

> Darkest light on the . . . sunniest . . . day
> (quickly and abruptly)
> Dazzling bright shadow in the darkest night!!

The light disappears. Suddenly everything is dark. A long pause. Then the introduction in the orchestra.

PICTURE 1

The stage must be as deep as possible. Far back a wide green hill. Behind the hill a rather deep blue curtain, smooth and mat in texture.

Soon the music begins, first in the upper registers, then quickly down to the lower. At the same time the background turns dark blue (the change must be synchronized with the music). Offstage a choir is singing something without words. It sounds stiff and mechanical. At the end of the song a general pause: no motion, no sound. Then darkness.

Later the whole scene is illuminated. From right to left (the spectator's right and left) five bright yellow giants (as large as possible) move into sight. They look as if they are hovering above the ground.

They remain standing next to each other at the back of the stage —some with hunched others with sagging shoulders. They have strange blurred yellow faces.

They turn *very* slowly, look at each other and make simple movements with their arms.

The music becomes more distinct.

Soon afterward a *very* deep singing without words by the giants becomes audible. The giants *very* slowly draw closer to the footlights. Vague red forms fly quickly from left to right. They look a *little* like birds having large heads. The music mirrors this flight.

The giants keep singing but softer and softer. As they do they seem to fade. Behind them the hill slowly grows larger and brighter until it is white. The sky now becomes pitch black.

The front of the stage turns blue and gradually opaque.

The orchestra struggles with the choir and conquers it.

A dense blue haze hides the whole stage.

PICTURE 2

Gradually the blue haze yields to pure, very intense white light. At the back of the stage, a hill quite round, dazzling green and as large as possible.

The background is violet, moderately bright.

The music is shrill, violent with repeated A's and B's and B's and

A-flats. These single tones are finally swallowed up by loud stormy sounds. Suddenly everything is silent. A pause. Again A and B whimper sorrowfully but also clearly and sharply. This lasts for some time. Then another pause.

At this moment the background turns a dirty brown. The hill turns a dirty green. Exactly in the center of the hill a black spot of no particular shape appears, sometimes it is distinct, sometimes blurred. As the spot changes the brilliant white light becomes grayer in abrupt stages. To the left on the hill there appears a *large* yellow flower. From a distance it resembles a large bent cucumber. It steadily becomes more brilliant. The stalk is long and thin. Out of the middle of the stalk grows one small, thorny leaf. It points off to one side. A long pause.

Later, the flower rocks very slowly from right to left, *in complete silence*. Still later the leaf begins to move, not with the flower but independently. Still later they both rock in an uneven tempo. Then, as before, they move separately. A very thin B sounds when the flower moves—a very deep A when the leaf moves. Then they rock together while both notes accompany their movements. The flower trembles violently and then is quite still. But the notes continue to be heard. Now a number of people enter from the left in long, flowing brightly colored robes (some all in blue, or red, or green, etc. None are in yellow). They carry very large white flowers similar to the one on the hill. They crowd together into a tight group and march up to and past the hill. They come to a halt on the right side of the stage and stand tightly bunched. They speak out in mixed voices:

> The flowers cover everything, cover everything,
> cover everything.
> Close your eyes! Close your eyes!
> We are looking. We are looking.
> Cover the conception with innocence.
> Open your eyes! Open your eyes!
> It is over. It is over.

First they recite all this in unison, as if in ecstasy (very clearly). Then they repeat everything as separate individuals: to each other and to the audience in alto, bass, and soprano voices. B is heard with "We are looking, we are looking," A with "It is over, it is over." Here and there voices become passionate and excited. Here and there someone

screams as if possessed. Here and there voices become nasal, sometimes reciting very slowly and sometimes with furious rapidity. In the first case a dull red light suddenly obscures the whole stage. In the second, darkness alternates with a dazzling blue light. In the third, everything suddenly turns a pale gray (all the colors vanish!). However, the yellow flower is brighter than ever.

Gradually the orchestra begins to play and soon the music drowns out the voices. The music then becomes agitated and shifts back and forth from fortissimo to pianissimo. The light brightens somewhat and now the colors of the people can be made out vaguely. Tiny figures move over the hill, from right to left very slowly. They are a dull gray-green. They look straight ahead. The moment the first tiny figure appears the yellow flower shudders convulsively. Suddenly it disappears, and just as suddenly all the white flowers turn yellow.

The crowd now moves as if in a trance to the footlights while gradually dispersing.

The music fades away and the above recitative is heard again.* People now stand about half enraptured. They turn around. Suddenly they notice the tiny figures which continue to move in an endless procession over the hill. The people turn away and make several quick steps toward the footlights, stop, turn around and then remain absolutely motionless, transfixed.† Finally, they violently free themselves from their paralysis, throw away their flowers which seem to be saturated with blood and run in a tight group to the footlights.‡ Suddenly everything is dark.

PICTURE 3

At the back of the stage: two large red-brown rocks, one jagged and the other larger and rounded. The background: black. The giants (of Picture 1) stand between the rocks and whisper quietly to each other. Sometimes they whisper in pairs and sometimes together in a group. They move only their heads. Their bodies remain motionless. Beams of brilliantly colored light are projected from all sides. In quick succession blue, red, violet, green repeatedly alternate. Then all these beams meet and mix in the center of the stage. Nothing moves. The

* [Kandinsky's note:] Half a sentence chanted in unison, finished by a *single,* very faint voice. This is frequently varied.

† [K's note:] This action must be very precise, done as if upon command.

‡ [K's note:] This action should be free and irregular.

giants are almost invisible. Suddenly all the colors vanish. For a moment everything is pitch black. Then a dull yellow light begins to flood over the stage. It gradually grows more intense until the whole stage is a brilliant yellow. As the color intensifies the music becomes lower and darker (its movement is like a snail drawing back into its shell). While this happens nothing is seen on the stage, no objects, only light. When the light is most intense the music melts away. The giants become visible again. They stare straight ahead without moving. The rocks have disappeared. Only the giants are on the stage. They stand farther away from each other and have grown larger. The background and the floor are black. A long pause. Suddenly, backstage a shrill tenor voice, filled with fear shrieks. Words are sung very quickly and unintelligibly (for example, one often hears an A note and words like kalasimunafakola!). A pause. Everything becomes dark for a moment.

<div align="center">PICTURE 4</div>

Left on the stage, a small crooked building (like a very humble little chapel) without a door or a window. On one side of the building (on the roof) a little crooked tower with a small broken bell. From the bell a rope. A child pulls the rope, slowly and regularly. The child wears a little white shirt and sits on the ground (facing the audience). To the right a very stout man stands, dressed all in black. His face is white and indistinct. The chapel is dirty red. The tower a shrill blue. The bell, lead. The background, a smooth gray. The man in black stands with his legs spread wide apart and with his hands on his hips.

The man (commanding in a very loud but beautiful voice): "Silence!!"

The child drops the rope. Everything grows dark.

<div align="center">PICTURE 5</div>

The stage is gradually bathed in a cold red light which slowly becomes stronger and yellower. At this moment the giants appear at the back of the stage (as in Picture 3). The same rocks are also there.

The giants are whispering again (as in Picture 3). At the moment when their heads are again close together the very same cry as before is heard backstage, but very quick and short. It is dark for a moment: the same events are repeated.* As soon as it becomes light (white light

* [K's note:] The music, of course, is also repeated each time.

without any shadows) the giants begin whispering again but they now gesture weakly (the gestures must be varied but weak). Here and there one of them spreads his arms apart (this movement also should be merely suggestive) and then cocks his head to the one side and looks at the audience. Twice all the giants suddenly drop their arms, grow a little taller and without moving look steadily at the audience. Then a kind of tremor runs through their bodies (the shock is similar to that which convulsed the yellow flower). They whisper again and weakly stretch out their arms as if lamenting. The music becomes gradually shriller. The giants are motionless. Many people appear from the left dressed in tights of various colors. Their hair is colored to match. So are their faces. (These people look and move like puppets.) First come gray, then black, white and finally colored figures. Movements vary in each group. One moves quickly as if straight to some goal; another slowly as if with great difficulty; another erratically with individuals making here and there joyous leaps; another cautiously with figures constantly looking all about in various directions; another solemnly, melodramatically with folded arms; and yet another on tiptoe each with a raised arm, palm up; etc.

They distribute themselves in various ways over the entire stage: some sit in small closed groups, some alone. Some stand in groups and some stand alone. The division should be neither "beautiful" nor precise. But there should be no *confusion* either. The figures look in various directions, some with heads held high, others with heads lowered, some bent very low. As if greatly fatigued, they rarely shift their positions. The light remains white. The music changes tempo frequently, occasionally it even becomes very slow and feeble. At just such moments a man in white (left and at the rear) makes vague but very rapid motions, sometimes with his hands and sometimes with his legs. Occasionally he sustains a particular motion for a longer period of time and also keeps a suitable pose during that period. It is a kind of dance. Only the tempo changes frequently, sometimes following the music and sometimes not. (This simple action must be worked out with great care so that what follows is expressive and surprising.) The others, one by one, begin to stare at the figure in white. Many begin to gawk. Finally all are looking. But the dance ends abruptly: the figure in white sits down, stretches an arm out as if in solemn preparation for some immensely significant act and then slowly bends it toward his head. The tension of the entire scene is

very expressive. But the white one simply places his elbow on his knee and rests his head in his hand. It is dark for a moment. The same groups in the same poses are seen. Many of the groups are lit from above by colored lights of various strengths: a fair-sized seated group is bathed in strong red light, a similarly sized standing group—pale blue, etc. The brilliant yellow light is (with the exception of the giants who are clearly lit) concentrated only upon the seated figure in white. Suddenly all the colors disappear (the giants remain yellow), and a weak white light plays over the entire stage. In the orchestra single colors begin to speak. Figures in corresponding colors attract attention to themselves from different parts of the stage, their movements are varied: quick, hasty, solemn, slow. They all look upward. Some remain standing. Some sit down again. Then they are all overcome by a great weariness and all activity stops.

The giants whisper. But they stand erect and motionless as the choir is heard backstage singing in its stiff and mechanical fashion. This lasts only a short time.

Then separate colors are heard in the orchestra again.* The rocks are touched by a red light and they shake.

There is movement at different points.

In the orchestra B and A are repeated a number of times: separately and together, sometimes very sharp and sometimes barely audible.

Various people leave their places. Some go hurriedly, some slowly to other groups. Single figures form smaller groups of two or three or melt into larger groups. The large groups break up. Some figures run quickly from the stage while looking about in all directions. In this way all the black, gray and white people disappear; only the brightly colored figures remain.

Little by little everything begins to move arhythmically. In the orchestra—confusion. The shrill scream of Picture 3 is heard. The giants tremble. Various lights crisscross each other on stage.

Whole groups rush off the stage. Everyone begins to dance: dancing begins at different points and gradually sweeps everyone into its

* One may assume that Kandinsky has in mind something similar to the parallels he drew between color and music published in *Concerning the Spiritual in Art* (1912): "In music a light blue is like a flute, a darker blue a cello; a still darker, the marvelous double bass; and the darkest blue of all—an organ." "The intensification of yellow increases the painful shrillness of its note, like that of a shrill bugle." "The vermilion now rings like a great trumpet or thunders like a drum," etc.

rhythms. Running, jumping, running to each other and from each other. Some remain standing and only move their arms, but these furiously; others only their legs or only their head or only their body. Some combine all these movements. *Sometimes* there are group movements. Whole groups *sometimes* make one and the same motion.

At the moment when the greatest confusion reigns in the orchestra, in the dancing, and in the lighting effects on stage, at that moment everything suddenly becomes dark and silent.

Only the yellow giants at the very back of the stage are still visible. Then slowly they are also swallowed up by the darkness. It is as if the giants were snuffed out like a lamp, i.e., like light blinking several times before complete darkness.

PICTURE 6

(This picture must appear *as quickly as possible*.)

A dull blue background, as in Picture 1 (without black borders).

In the middle of the stage a bright yellow giant with a blurred white face and huge black eyes.

He slowly lifts both arms (palms down) up along the side of his body and grows taller and taller.

At the very moment when he is as high as the stage and his figure looks like a cross everything suddenly becomes dark. The music is expressive, similar in mood to the action on the stage.

Oskar Kokoschka

"The Saying" (1911)

Coerced, a vision, a world
Appears to conciousness.
And then again the creation,
From the image which constrained it, frees itself.
Space takes shape like water, air and earth.
Fire burns it forever and
Consumed it.

"Allos Makar" (1913) *

The ribs twist about the deceptive repose.
Within itself heart compresses and swells.
To what is past and gone flys backward
White earth from the winter sun.
Out over all the prospect hushed
Drifts that changeless wave of dust-formed shadowplay.
And into the unrest a great weakness moves.
The heart beats thundering, afraid to be alone.
There came from somewhere down below
The shrieks of boistrous, violent birds.
A little man and a little woman strangle a snake.
One looks at the other's eminence fearfully.
And one lost power because of the other.
And now the worm wriggles out from shrieking beaks.
Let a paper scrap fall, crushed by the struggle.
Stooping in the dust I took it and read it.
The lips laugh at deceptive repose,
"Something else is happy."

* The third part of a three-part poem inspired by Kokoschka's relationship with Alma Mahler (the widow of the composer Gustav Mahler who later married Franz Werfel). The title *"Allos Makar"* is Greek and can be translated as meaning "Something else is happy." It is also somewhat of an anagram for Alma and Oskar. "The Saying" and "Allos Makar" are used by permission of the author.

Wassily Kandinsky

"Different" (1912) *

There was a big 3—white on dark brown. Its upper loop was the same size as the lower loop. So many people thought. And yet this upper loop was
SOMEWHAT, SOMEWHAT, SOMEWHAT
larger than the lower one.

This 3 always looked to the left—never to the right. At the same time it looked slightly downward, for only in appearance did this figure stand perfectly straight. In reality, not easily discernible, the upper
SOMEWHAT, SOMEWHAT, SOMEWHAT
larger part inclined to the left.

And so this big white 3 always looked to the left and a little downward.

Or perhaps it was different.

"Seeing" (1916)

Blue, blue arose, arose and fell.

Sharp, thin, whistled, and penetrated, but did not pierce through.

On all corners a rumbling.

Thick brown hovered seemingly for all eternity.

Seemingly. Seemingly.

Spread your arms wider.

Wider. Wider.

And cover your face with a red cloth.

And perhaps it is not yet displaced at all: only you have displaced yourself.

White leap after white leap.

* "Different" ("Anders") is from *Klänge* (München, 1912). *"Seeing" ("Sehen")* is from the Dada review *Cabaret Voltaire* (Zürich, 1916). Both translations are based upon R. Manheim's translations in *Concerning the Spiritual in Art* (New York: George Wittenborn, Inc., 1947). Used by permission of the publisher.

147

And after this white leap again a white leap.

And in this white leap a white leap. In every white leap a white leap.

It is not good that you overlook the gloom: it is precisely in the gloom
 that it dwells.

And that is where everything begins————

————there was a crash.

Paul Klee

"The Two Mountains" (1903) *

A reign of light
clarity on two mountains:

the mountain of animals
the mountain of gods.

But between them the dusky
valley of men.

When
sometimes, one of them
looks up
he is gripped
by foreboding,
by unquenchable longing he
who knows
he knows not, longing
for them who know not
they know not
and for them who know that they know.

"Poem" (1906)

Water
Waves on the water
A boat on the waves
On the boat-deck, a woman
On the woman, a man.

* The translations are taken from Anselm Hollo, *Some Poems by Paul Klee* (London, 1962). Used by permission of Anselm Hollo.

"My Star" (*1915*)

> My star
> Rose deep
> Below
> My feet.
>
> Where does my fox
> Go in the winter?
> Where does my serpent
> Sleep?

"Last Things Last" (*no date*)

> In the heart's center
> the only prayers
> are steps
> receding.

War and Revolution

Expressionist attitudes toward war and revolution have already been commented upon in the opening Introduction. Although all German Expressionists longed for a revolutionary "breakthrough" to a better world, they formed no united front. Some, like Kandinsky, with a faith which knew no national or party bias, envisioned artists, before statesmen and politicians, as the true leaders of revolution. Some with idealistic patriotism were ready to die for a Germany that they believed would become an instrument for world regeneration. Others were socialists. A few became political activists; most hoped that their art could somehow help regenerate the world, or at least Germany; and all reacted to events in an individualistic, visionary, and emotional way.

The items used in this part of the anthology have been chosen for two reasons: because they effectively express individual views which were also representative of the views of hundreds of artists; and because the authors of these items were especially sensitive to the experience of war or revolution or both. The selections, with one major exception, are arranged in rough chronological order and fall into two groups. The first is a sampling of wartime statements, while the second illustrates the various responses made by Expressionists to the revolutionary conditions of postwar Germany, 1918–21. The major exception mentioned above is Heinrich Vogeler's autobiographical reminiscence, *A Painter's Experience*. In spite of its late date—1938—it merits inclusion here first because it captures so well the mood of the entire era (1900–1933) and states so directly the feelings of most Expres-

sionists during that era. Of course, few other Expressionists finally made the political decision Vogeler made: to join the Communist party and emigrate to Russia.* However, Vogeler's evolution from Art Nouveau aestheticism, through Expressionism, to a form of social realism typifies the evolution of a number of Expressionists. Although "realistic" *styles* were not always the end-result, after the war Expressionists spoke much about making their art relevant to the common man and took practical steps in that direction as well.†

The next items—by Franz Marc, and Käthe Kollwitz‡— —not only demonstrate these artists' perceptive reactions but also document the general change in attitude of Germans (and all Europeans for that matter) toward the war, a change from high flown idealism to blank despair. Then, with the German Revolution of 1918, the enthusiastic idealism of the Expressionists was rekindled and became, if anything, more intense than ever.

A sobering introduction to this period are the two postwar journal entries by Käthe Kollwitz included here. They were written in 1921 and 1922, in other words, *after* the initial utopian expectations of the Revolution had been completely dispelled.

Next appear some typical examples of Expressionist responses to the Revolution—first, some selections from the two most important revolutionary artists' associations: the closely linked November Group and Workers' Council for Art. Both were organized in Berlin in 1918 for the purpose of supporting socialism in Germany. The November Group actually took its name from the November Revolution, having been founded that very month. Its *Manifesto, Circular Letter,* and *Guidelines* indicate that, although "socialist," the group

* For Vogeler's biography, see p. 155.

† The emergence of the style called *"Neue Sachlichkeit"* ("New Objectivity") was probably less important in this respect than the formation of revolutionary artists' associations, the founding of new art schools (e.g., the Bauhaus), and the reorganization of museums. The first state museum of modern art anywhere was founded during this revolutionary period, in Berlin in 1919.

‡ For biographies see Franz Marc, p. 65; Max Beckmann, p. 105; Käthe Kollwitz, p. 165.

sought no ties with any specific party. As far as art was con-
cerned it was similarly undogmatic. The initiators of the
Group were the Expressionist painters Max Pechstein and
Cesar Klein,* and the association soon included leading archi-
tects, poets, critics, and scholars irrespective of aesthetic bias.
The Workers' Council for Art was formed in December 1918
and merged with the November Group one year later. Its
most important publication was the stirring *Yes!—Voices of
the Workers' Council for Art (Ja!—Stimmen des Arbeitsrats
für Kunst)*. This manifesto included a very interesting ques-
tionnaire on the relations between artist and public and be-
tween artist and the hoped-for socialist state: "Questions
Which Need Clarification." All thirteen questions have been
translated for the anthology along with an unfortunately but
necessarily small sampling of extracts from the often-lengthy
answers submitted by the 114 sponsoring artists and critics.
Extracts from replies by architects Walter Gropius and Bruno
Taut and painter Karl Schmidt-Rottluff are admittedly mea-
ger, but they nevertheless point up some of the major concerns
of postwar German art.† (Perhaps, one can even say postwar
German *Expressionism* when speaking of this group.)

In this period both Gropius and Taut can, with some jus-
tice, be linked with the Expressionists, at least with regard
to their visionary ambitions and vehement rhetoric. Gropius'
manifesto *What is Architecture* is certainly Expressionist in
tone. Written the same year that the Bauhaus was founded,
it stresses, however, that return to the discipline of the crafts
which Gropius took as the basis for his educational program
there, a discipline which sounds superficially "un-Expression-
istic." On the other hand, the Expressionist position reflected
by the manifesto was not abandoned at the Bauhaus—it
should be recalled that Feininger, Klee, and Kandinsky were
given teaching appointments at the school.

The concluding pieces in this section are by Max Pech-

* For Pechstein's biography, see p. 178. Cesar Klein (1876–1954), painter, print-
maker, and designer; member of the New Secession.

† For biographies, see Karl Schmidt-Rottluff, p. 28; Walter Gropius, p. 173; Bruno
Taut, p. 174.

stein, Ludwig Meidner, and George Grosz.* They have been selected because they indicate the range of Expressionist reaction to defeat and revolution: from Pechstein's fanatic determination to keep working to Meidner's nearly hysterical desire for a pure, new beginning; to Grosz' bitter determination to give "an absolutely realistic picture of the world."

* For biographies, see Max Pechstein, p. 178; Ludwig Meidner, p. 110; George Grosz, p. 185.

Heinrich Vogeler

Born 1872 in Bremen. Died in Russia 1942. Studied at the Düsseldorf Academy. Joined the Worpswede group 1894. Traveled to Ceylon 1906, to England 1909. Served in army 1915–18. Arrested because of his peace appeal to the Kaiser in 1918. Member of the Workers and Soldiers Council, Bremen 1918. Founded and directed the Commune Barkenhoff 1918–19. Traveled to Russia in 1922–23 and 1926. Co-founder of the ARBKD (German Revolutionary Artists' Group), Berlin 1928. Emigrated to Russia in 1931.

Vogeler became popular with the general public for his elegantly decorative Art Nouveau designs. However, in the years following the war he repudiated such work and then, after an Expressionist period, he developed a form of socialist realism in keeping with his commitment to communism. Vogeler, a friend of Rilke, was no fanatic nor was he filled with hate like Grosz. Paula Modersohn-Becker* gives a description of the young Vogeler which makes his later development all the more significant: ". . . a really charming guy, happy-go-lucky . . . he lives in a world of his own with *Walther von der Vogelweide* and *Knaben Wunderhorn* as constant companions. . . . In his studio he keeps a guitar and when he plays old love songs he is just too lovable for words."

Vogeler's "A Painter's Experience" was published in *Das Wort,* a communist periodical which provided a fairly liberal forum for anti-Nazi Germans in exile. One topic which was repeatedly and heatedly debated on its pages was Expressionism; Vogeler's autobiographical sketch was an important contribution to this debate.†

* Paula Modersohn-Becker (1876–1907). Sometimes classified as an Expressionist, she was the leading painter of the Worpswede group.

† Heinrich Vogeler, "Erfahrungen eines Malers," *Das Wort* (Moscow, 1938), Vol. III. No. 6, 84–94. Arguments by Herwarth Walden (the guiding spirit of the Expressionist periodical and gallery *Sturm*), by famous communist intellectual Georg Lukács and the art historian Klaus Berger were also featured as part of this debate. Berger's article appears in Part Six of this anthology, pp. 204–6.

"A Painter's Experience"

Once there was a painter who had already retired to the country as a young man to get away from academic and city life. He purchased a small farm; and he plowed, spaded and transformed a desolate piece of heath into a beautiful garden. His painting was rooted in this personal creation: a petit-bourgeois romantic who believed that this small bit of property made him independent and free. The experiences of his youth were: garden, spring, and his love for a woman. He dressed all his feelings, since they were quiet and beautiful feelings, in the quiet and beautiful *forms of bygone ages.* (The art of the Minnesingers appealed to him.) His love of nature made his pictures charming. Soon he was the darling of the middle classes. His art had nothing to do with the restless ugliness of the present. Therefore he was quite successful financially. But he was not at all satisfied. Our romantic became more and more restless. But real life did not stir him, rather the artistic representation of life in literature: he read Maxim Gorki, at first reluctantly, then with torment, then deeply moved, and finally with great eagerness. It was Gorki who finally convinced him that beyond his sweet dream world there was another world in which good people suffered inhumanly without reason.

. . . he was trapped in an arts and crafts formalism, in Jugendstil.

He pulled himself together and thus he produced under great tension and pressure the etching "Neugeburt": beams of light cut up the small world of the copper plate, they dramatically illuminate the essentials—a hand appears out of the clouds, touching a young mother as if awakening her: in her lap there is a newborn child: under heavy clouds which draw apart, a man can be seen in the distance dragging a cross, almost overwhelmed by its weight: *events are experienced by means of completely abstract forms.* For the first time in the work of this artist there appears *Expressionistic* elements. *It was a passionate attempt to be rid of all past bourgeois art, an attempt to destroy old art completely.* It was an attempt in terms of *form* only, since the *content* was still individualistic, private and utterly divorced from social realities. A revolt without perspective, without a goal. Nevertheless, some good came from this experiment: it decisively brought our painter back to reality. The etching, in his opinion, was a finale to

the past. He began to spend all his time with his children. Once again his life was completely "private." All the pictures which he made now had a *realistic* quality: their content had to do with playing in his enchantingly beautiful garden with the birds of the forest, with flowers and with pets. Yet in spite of these motifs one could detect a striving for monumental effects. . . .

War broke out. He enlisted but without enthusiasm. The romantic went to war, risking everything on this card—life or death! The war lasted for a long time and all the old certainties vanished: all those ideas about middle class honor, morality and religion were utterly destroyed for him and hundreds of thousands of others—our artist experienced this in a shattering way. Chaos everywhere, hope nowhere. He was convinced that he would never paint again.

1917. In front of our painter lay the pamphlets and decrees distributed by victorious revolutionary workers in Russian army coats. He, a German corporal, rubs his eyes: dare one talk about something like this? Dare one permit something like this to happen? Nationalization of the soil, of the means of production! He remembers his own attempt to establish craft studios, an attempt which was ruined before it was even started, the sneering money men: "Yeh, if your scheme could show a profit. . . ." And our corporal says to himself: "The whole business is quite simple; at one blow a thousand problems would be solved. This is the way out of chaos!" The painter in him finishes the thought: "This is the real basis for a creative process of incalculable dimensions!" . . . In Brest-Litovsk there are peace negotiations. The painter on leave sits in his tiny study. He has to take action and he writes:

The Fairy Tale of Our Dear Lord
(A letter from Corporal X to the Emperor. January 1918)
A protest against the peace of Brest-Litovsk.

For some time, as the year 1917 was drawing to an end, people in Germany noticed the most remarkable things—up in the sky and throughout the land. Most remarkable, however, was God's appearance on the Potsdamerplatz, Berlin in the late afternoon of the 24th of December—a sad old man distributing pamphlets. On top: "Peace on earth, good will to man," and beneath in clear simple letters the Ten Commandments. The police grabbed him, he was convicted and, according to martial law, shot. A few people who had received the

pamphlets and had defended the words of the old man were sent to
the insane asylum. God was dead. . . ."

The painter wrote and wrote and unburdened his heart of all the
filth and misery, of all the lies and deception of the last gruesome years.
He felt free as never before. It was a soaring exuberance which
could find its ultimate fulfillment only in death. After three days
the corporal, who had sent his protest against the Brest-Litovsk peace
to the Emperor and in facsimile via his company commander to the
Chief of Staff, was arrested and committed to an asylum. There he
was a calm and quiet guest and soon he began to work and express
himself artistically. He made a sketch for an etching *"Der Zusammen-
bruch."* It was not without mysticism: rising flares light up the
misery of war and then change themselves into the seven vials of
God's wrath from Revelations. This work with its hard, sharp, ab-
stract forms had all the characteristics of *Expressionism.* The director
of the asylum refused to permit him to work any more explaining:
"You are here in order to relax!"

"When we are confused we should pull ourselves together!" This
was the answer of the very sensible madman.

After two months our government inspected madman was sent
home and placed under police surveillance. There he studied social-
ism beginning with the French Utopians. Putting theory into prac-
tice he established contact with revolutionary workers in the nearby
Hansa city—they read the "Letter to the Emperor," printed it as a
pamphlet and distributed thousands of copies. This inspired the
painter to further activity. His tiny estate became on Sundays a meet-
ing place for Russian and Belgian prisoners of war who were working
on larger neighboring estates; small farmers and day laborers also
came, and most importantly, revolutionary workers from the city. And
did the painter's work now become *realistic?* No. He was not able to
escape Expressionism. The beam motifs remained and they divided—
now he knows it was all merely abstract, formal and schematic—they
divided a darkening world into zones of light and dark ruin. An oil
painting, "Frauen im Kriege," showed a woman (blue and violet)
fleeing with despairing and exalted gestures through a Galician ceme-
tery, its crosses ablaze like a burning forest in vermillion and yellow.
Then a desperate struggle of someone with a floating figure, in the
distance Romanticism gallops off. Everything is angular, arbitrary
and abstract. . . .

November 1918. The password is "Home," according to the sailors. In the Hansa city the rule of the Soviets is established. There, during a tremendous demonstration of the dockworkers, the painter is elected to the workers'-and-soldiers' council. At every new political action he is forced to discard pieces of bourgeois baggage which he still had (one drags along a lot more than one realizes). Class distinctions became clearer and clearer to him. Not only abstract, theoretical, but practical—sensed, touched and completely real. Where were the conditions for Expressionist fantasies now? The situation demanded representation on posters in the most realistic way: large and simple, so that every worker and peasant could understand. There was no time for experiments. Our painter's Expressionism was now—completely dead.

* * *

For him, Expressionism signified the very last stage of bourgeois art, a road to the complete negation of reality, to nihilism, to the abstract. (But art is sensuous!) It was bourgeois art's dance of death. (Even a dance of death can be aesthetically exciting.) By means of willful, rebellious—even if the intention was *subjectively* revolutionary!—distortion and destruction the Expressionists believed, or rather the majority of the Expressionists believed, that they were *objectively* revolutionary. Here lies their error, an error that was often tragic. The poverty of content taken over from bourgeois art remained, in fact content became still poorer because positive aspects were destroyed along with everything else. The Expressionists believed that they were revealing the essence of things, but instead they revealed putrescence.

But what they did had some *historical* value: they opened our eyes! They revealed the utter hopelessness of bourgeois art in its last stage; and its ultimate end—*the pure formalistic discipline of abstraction.*

Franz Marc

"In War's Purifying Fire" *

IN THE BEGINNING WAS THE DEED.

What we soldiers have experienced out here in the past few months is beyond belief. Years will pass before we will be able really to understand this fantastic war as a fact, as something truly part of our own experience.

Perhaps those who have stayed behind have dug a little deeper than we have into its secrets. Out here, anxious and expectant, our heads filled with orders, riding and marching without rest, sleeping a couple of hours at a time like a bear—it's impossible to think. We just experience things, simply and directly; and our consciousness wavers between two questions: is this absurd soldiering a dream? or are our occasional memories of home a dream? Right now it seems that both are fantasy rather than fact.

We are camped right now with munition wagons at the edge of a forest. It sounds like a storm with the thunder of cannon in the distance and everywhere there are small bursts of shrapnel. Both are part of the landscape, like the echo too, which multiplies every shot and carries it far away into the distance. Suddenly a terrific whirring noise moves over us in a gigantic arc; its sound is uneven, constantly ranging from a shrill whistle all the way to a deep rumble; like the long high screech of a bird of prey; one scream right after the other like an animal which knows no other call. Then, in the distance, a dull thud. They are enemy heavy artillery shells roaring past us toward some unknown target. One shot follows another. The sky is an autumnal blue, absolutely clear, and yet we sense the channels cut through that sky by every shot.

An artillery duel, even for the gunners themselves, often has something mystical and mythical about it. We are the children of two different epochs. We of the twentieth-century experience daily that

* "Im Fegefeuer des Krieges," *Kunstgewerbeblatt* (Leipzig, 1915), XXVI, 128–30. See also Marc's "Briefe," *Aufzeichnungen und Aphorismen*, 2 vols. (Berlin, 1920), for more of Marc's reactions to the war. For Marc's biography, see Part Two, p. 65.

all the sagas, all mysticism and occult wisdom once was truth and someday will again be truth. What Homer sang about Zeus the invisible, the thunderer striking down his enemies from afar, and of Mars with his invisible arrows—we made it come true. And yet all our knowledge does not protect us from a mystical terror.

They tell us that the little city of "S" is being shot to pieces by the enemy, so it would seem that we are sitting safe and sound under the zenith of these gigantic shell trajectories. We will stay here all night with the shells whistling over us through the starry sky. We sleep wrapped in our overcoats. The horses drop their heads and rest standing up.

Now each of us is alone and can dream and think if sleep doesn't carry us off.

Perhaps some of us, halfway between waking and sleeping, in a small corner of our brain can still struggle with a few ideas:

No great war was ever less of a race war than this one. Just where is the Germanic race nowadays? This word has never had a more spectacular fiasco than at the present moment. People will become accustomed finally to substitute "Deutsch" for "German"; to that end the Deutsch eagle will receive another pair of powerful talons for its coat of arms; actually, I would like to draw the new Deutsch eagle when this war is over.

Yes indeed, when the war is over someday, what then in Germany?

Will there be an artistic Germany along with a political Germany?

For several years we have been saying that many things in art and life were rotten and done for; and we pointed to new and better possibilities.

Nobody was interested!

But we didn't know that the great war would come with such terrible suddenness, pushing words aside, sweeping dirt and decay away to give us the future today.

BUT NEW WINE SHOULD BE PUT IN NEW BOTTLES.

The great war will also put an end to many things which the twentieth century mistakenly preserved, including the pseudo-art which Germans up to now have good naturedly tolerated.

The urge to give structure to the new in music, poetry, and art was so weak in the last generation that Germans were satisfied by the worst and most shabby repetitions of good older art forms. The *Volk*

as a whole, however, had a foreboding of the war, more so than any individual, and therefore it was bracing itself for it.

During such a waiting period art was not relevant, as a collective *Volk* effort it was not of tune with the times.

The *Volk* knew that it first had to fight its way through a war in order to shape for itself a new life and new ideals. One could hardly expect the *Volk* to accept new artistic concepts at the eleventh hour. One does not sow fine seed when a storm is building up.

And the storm broke suddenly and destroyed many a delicate seed.

I doubt whether many of the new and strange forms which we modern painters in Germany created before the war will take root. We will have to begin working from the very beginning again; first on ourselves in the school of this great war, then upon the German *Volk*. Because when Germany is able to relax again, it will also ask about its art, something that Germany always possessed in her periods of greatness.

In the Gothic age the German was an artist, in the nineteenth century, a poet and musician. Since the Gothic we Germans have become, as builders of form, incredibly weak; we have done other things for the world, and now this last thing: this dreadful war. Those out here who are living through it and are beginning to realize what we shall conquer by it, they realize full well that one cannot put new wine in old bottles. Our will to a new form will restructure this new century.

TO HIM WHO HATH, SHALL BE GIVEN.

How many of Christ's thoughts nowadays are still unknown and unused, suppressed. Every age has the Christ it deserves and it takes from this inexhaustible spring as much as its jugs will hold.

The great Nazarene has intuitively grasped the laws of nature. His speech with all of its rich imagery has not lost any of its power compared to our scientific formulations. His deepest insights are still congruent with our newest discoveries; we still hear the murmuring of this living source close by at our side.

In terrible times such as ours all the age old questions are being asked again; many dead, talked to death questions rise out of their graves. All the big experiences of world history are major moments of judgement for humanity. The most venerable notions and dogmas are reconsidered. What was important yesterday is now abolished and ignored. Only the good things remain, the authentic and true things

which are rich in meaning; they will survive, refined and hardened by the purifying fire of this war.

For centuries we Europeans have been working collectively and earnestly to create such an authentic (authentic in terms of human knowledge) and true treasure, a heritage which has survived every war, pure and without blemish—the "exact sciences." For the first and only time has the "absolute" blessed the human spirit so that a realm was created which also was "not of this world," but nevertheless pervaded everything that is part of this world with feeling and order. The sciences recognize no national boundaries and politics have no place in their realm. All modern people, all good Europeans, are under its juristiction.

Vestigio terrent! We certainly cannot approve of some reputable German scholars who have violated the spirit of that which is highest in European consciousness; they have done something which could signal the general disintegration of that consciousness: "they reject out of their great respect for the dignity of the German nation all the honors and related privileges given them by English universities and academies and learned societies." That is not good. Here fences are being erected on the free forum of learning; they cannot stand very long, because learning is more powerful, it is a spiritual power which extends into the infinite; nevertheless, the attempt is not good because it is so utterly futile. All the passionate patriotism of the present moment cannot justify it.

The real enemy is not found where the arrows come from. Our German culture and nationalism must be active and aggressive in quite another direction.

Should the war bring us what we desire, and in proportion to our sacrifices—this fantastic equation leaves us quite breathless—should this happen we Germans must shun nothing more passionately than narrowness of feeling and national ambition. This would spoil everything. To him who has shall be given. Only with such a motto will we be a spiritual victor and the first among the Europeans. The European type of the future will be the German type; but before that happens, the German must become a good European. Right now he is not that everywhere and in every case.

Germanic qualities will spill over all boundaries after this war. If we stay healthy and strong and do not wish to lose the fruit of our conquests we will need immense power of assimilation and a life force

of such power that it will be able to pervade everything without any fear of or consideration for the foreign or the new things which our power in Europe will bring. Just as France was once the heart of Europe, now Germany will play that role—but only if she is not thwarted by a narrow-hearted nationalism. People back home should keep this in mind. We who are at the front breathe an air which is freer and more spiritual. We fight the enemy; he is a soldier to us; we defeat him but we are not trying to exterminate French culture. But many an announcement from back home sounds very much as if that indeed were what should be done. Are those back home afraid of what we shall conquer? We are not storming across frontiers in order to build Great Walls of China around our country. We are rich and strong enough to dispense with forts in time of war so we can do without fences in peace time. We need be no more fearful and narrow-hearted in spiritual things than in anything else. And the situation should be no different in art. In earlier times we were never afraid of foreign influences. Have Moorish-French influences harmed the German Gothic? And don't we still enjoy these graceful treasures when we meet them? And certainly the oriental influence from the Gothic up until the Renaissance cannot be counted as a loss to German art. Our German Bibles are no less German as a result.

Thus it will be well within our power to assimilate Latin art, threatened as it is by overintellectualization and disintegration—not to preserve it but to enrich ourselves out of an awareness of the fresh power, the joy and the richness of our spirit.

No foreign treasure dare be foreign to us, not if we wish to remain rich and fertile.

Käthe Kollwitz

Born 1867 in Königsberg, East Prussia. Died 1945 in Moritzburg.
Studied in Berlin 1885–86; in Munich 1888–89. Settled in Berlin
1891. Member of Secession. Member of the Prussian Academy of
Fine Arts 1919. Visited Moscow 1927. Forced to resign from the
Academy by the Nazis 1933.

Käthe Kollwitz is known primarily for her dramatically re-
alistic prints dealing with the suffering of the lower classes.
She identified with those classes and upon her marriage in
1891 to Dr. Karl Kollwitz, a physician who worked with the
poor, she settled in a working-class district in Berlin, where
she remained for most of her life.

Her most important works were the etching series *The
Weavers* and *Peasant War* and the woodcut series (inspired
by Barlach) *The War.* Although she criticized Expressionists
for their "eccentric studio art," she herself emphasized: "Ex-
pression is all I want."

Kollwitz' *Journal,* her most important literary work, is not
only a most moving document but clearly reveals her essen-
tially expressionistic point of view.* For example, one of the
most important entries is that of August 22, 1916, in which
she writes about the terrible effect which the death of her son
Peter had upon her and her art.† Hers is a typically expres-
sionistic dilemma. A very emotional person who needs emo-
tional stimulus in order to work, in the face of a truly power-
ful emotional experience—the death of her son—she dis-
covers that she is unable to create. Her reaction to the war in
general was almost as intense, and her March 19, 1918 entry
gives voice to a bitterness that is wider than that of a mother
grieving for her son. One should also remember that Koll-
witz had been an internationally minded socialist for years.
She welcomed not simply the end of the war but the revolu-
tion as well!

* The translations have been taken from Hans Kollwitz, ed., *The Diary and
Letters of Käthe Kollwitz,* trans. Richard and Clara Winston (Chicago: Henry
Regnery Co., 1955), pp. 72, 87, 99, 104. Reprinted by permission of the publisher.

† He was killed at the beginning of the war, in 1914.

She was, however, not a true revolutionary. Although she paid tribute in one of her works to a communist "martyr" of violent revolution—Karl Liebknecht—she justified this by insisting: "As an artist I have the right to extract the emotional content out of everything, to let things work upon me and then to give them outward form. And so I have the right to portray the working class's farewell to Liebknecht . . . without following Liebknecht politically." Kollwitz, as a matter of fact, frankly confessed in her journal entry of June 28, 1921 that she could not accept the harsh reality of revolution. This entry with beautiful simplicity exposes the romantic character of most expressionistic dreams of revolution. But unlike some expressionists, Kollwitz never lost her sense of reality. With time she regained her composure, as her November, 1922 statement reveals. These words make it quite clear that, in spite of everything, she was determined never to stop working for others through her art.

Journal Entries

AUGUST 22, 1916

When I feel so parched, I almost long for sorrow again. And then when it comes back I feel it stripping me physically of all the strength I need for work.

Made a drawing: the mother letting her dead son slide into her arms. I might make a hundred such drawings and yet I do not get any closer to him. I am seeking him. As if I had to find him in the work. And yet everything I can do is so childishly feeble and inadequate. I feel obscurely that I could throw off this inadequacy, that Peter is somewhere in the work and I might find him. And at the same time I have the feeling that I can no longer do it. I am too shattered, weakened, drained by tears. I am like the writer in Thomas Mann: he can only write, but he has not sufficient strength to live what is written. Only it is the other way round with me. I no longer have the strength to form what has been lived. A genius and a Mann could do it. I probably cannot.

For work, one must be hard and thrust outside oneself what one has

lived through. As soon as I begin to do that, I again feel myself a mother who will not give up her sorrow. Sometimes it all becomes so terribly difficult. . . .

MARCH 19, 1918

Yesterday I kept thinking about this: How can one cherish joy now when there is really nothing that gives joy? And yet the imperative is surely right. For joy is really equivalent to strength. It is possible to have joy within oneself and yet shoulder all the suffering. Or is it really impossible?

If all the people who have been hurt by the war were to exclude joy from their lives, it would almost be as if they had died. Men without joy seem like corpses. They seem to obstruct life. . . . When someone dies because he has been sick—even if he is still young—the event is so utterly beyond one's powers that one *must* gradually become resigned to it. He was dead because it was not in his nature to live. But it is different in war. There is only one possibility, one point of view from which it could be justified: the free willing of it. And that in turn was possible only because there was the conviction that Germany was in the right and had the duty to defend herself. At the beginning it would have been wholly impossible for me to conceive of letting the boys go as parents *must* let their boys go now, without inwardly affirming it—letting them go simply to the slaughterhouse. That is what changes everything. The feeling that we were betrayed then, at the beginning. And perhaps Peter would still be living had it not been for this terrible betrayal. Peter and millions, many millions of other boys all betrayed.

That is why I cannot be calm. Within me all is upheaval, turmoil.

Finally I ask myself: What has happened? After the sacrifice of the boys themselves, and our own sacrifice—will not everything be the same?

All is turbulence.

JUNE 28, 1921

Went to the theater with Karl*; saw *The Weavers* at the Grosse

* Karl Kollwitz, her husband.

Schauspielhaus.* The inflammatory effect of the mass scenes. "Let Jaeger come out, let Jaeger come out! Let Hoelz come out!"

I was overcome by something of the same feeling I had when I saw *The Weavers* for the first few times. Of the feeling that animates the weavers, the desire for eye for eye, tooth for tooth, the feeling I had when I did the Weavers; my weavers.

In the meantime I have been through a revolution, and I am convinced that I am no revolutionist. My childhood dream of dying on the barricades will hardly be fulfilled, because I should hardly mount a barricade now that I know what they are like in reality. And so I know now what an illusion I lived in for so many years. I thought I was a revolutionary and was only an evolutionary. Yes, sometimes I do not know whether I am a socialist at all, whether I am not rather a democrat instead. How good it is when reality tests you to the guts and pins you relentlessly to the very position you always thought, so long as you clung to your illusion, was unspeakably wrong. I think something of the sort has happened to Konrad. Yes, he—and I too —would probably have been capable of acting in a revolutionary manner if the real revolution had the aspect we expected. But since its reality was highly unideal and full of earthly dross, as probably every revolution must be, we have had enough of it. But when an artist like Hauptmann comes along and shows us revolution transfigured by art, we again feel ourselves revolutionaries, again fall for the old deception.

NOVEMBER, 1922

On All-Soul's Day Karl and I went together to the Reichstag memorial meeting for the dead of the World War. At such moments, when I know I am working with an international society opposed to war I am filled with a warm sense of contentment. I know, of course, that I do not achieve pure art in the sense of Schmidt-Rottluff's, for example. But still it is art. Everyone works the best way he can. I am content that my art should have purposes outside itself. I would like to exert influence in these times when human beings are so perplexed and in need of help. Many people feel the obligation to help and exert

* *The Weavers* by Gerhart Hauptmann (1862–1946), hailed as the first socialist drama in German literature when it was written in 1892. Its subject, the rebellion in 1844 of Silesian weavers against their exploiters, inspired one of Kollwitz' greatest series of etchings, "The Weavers."

influence, but my course is clear and unequivocal. Others must follow vague courses. Pl., for example. In the spring he wants to clear out, go around wandering and preaching. He wants to preach *action,* but inward action, a turning away from the outmoded forms of life that have proved wrong. Preparing the soil for a new life of spiritual liberation. And then there are all the groups preaching a new eroticism ("religious bohemia"). It is reminiscent of the Anabaptists, of the times when—as now—the great turning point in history is proclaimed and it is announced that the millennial kingdom is upon us.

Compared with all these visionaries my activities seem crystal clear. I wish I might go on working for many long years as I am working now.

The November Group*

Manifesto (1918)

We are standing on the fertile soil of the revolution.
Our slogan is: *Freedom, Equality, and Fraternity!*
We are uniting because we have human and artistic convictions in common.

We believe that our first duty is to dedicate all our energies to the moral regeneration of a young and free Germany.

We plead for excellence in all things and we shall support this plea with all the means at our disposal.

We insist upon an unlimited freedom of expression as well as public acknowledgement of it.

We believe it is our special duty to gather together all significant artistic talent and dedicate it to the collective well-being of the nation.

We belong to no party, no class. We are human beings, human beings who work tirelessly at the task appointed us by nature. It is a task, like any other if it is to benefit the whole *Volk,* which must take

* Translations were made from Diether Schmidt, ed., *Manifeste, Manifeste, 1905–1933* (Dresden: VEB Verlag der Kunst, 1964) pp. 156–59, by permission of the publisher. Excerpts from *The Workers' Council for Art* are from *The Architectural Fantasy* by Ulrich Conrads and Hans G. Sperlich, trans., ed., and expanded by Christiane Crasemann Collins and George R. Collins (New York: Frederick A. Praeger, Inc., London: The Architectural Press). Used by permission of the publishers.

into consideration the general public good and requires the appreciation and recognition of that general public.

We respect every achievement in every sphere and we are of the opinion that the most competent men will assume the heaviest duties, submitting themselves to such duties for the sake and benefit of the whole *Volk*.

Our goal—each at his place in hard, tireless, collective, creative work.

We feel young, free, and pure.

Our spotless love belongs to a young, free Germany and we shall fight against all backwardness and reaction, bravely, without reserve, and with all the power at our command.

We send our fondest greetings to all those who have heard the call and feel responsible—Cubists, Futurists, and Expressionists. Join us!

Circular Letter (December, 1918)

Potsdamer Street 113, Villa II

Very Honored Sir:

The future of art and the seriousness of the present moment compels us revolutionaries of the spirit (Expressionists, Cubists, Futurists) toward unity and close cooperation.

Therefore we direct a most urgent appeal to all creators in the visual arts who have broken with the old forms to join the *November Group*.

Planning and realizing a far-reaching program, with the help of responsible people in various art centers, should result in a thorough interaction of the *Volk* and art. We must also strive to reawaken sympathy among like-minded peoples of all lands. We were already united as brothers a long time ago by common creative instinct. As the first sign that we have found each other again we are planning a common exhibition. We hope that it will be shown in all the major cities of Germany and then later throughout Europe.

The Working Committee:

M. PECHSTEIN, C. KLEIN, G. TAPPERT,
RICHTER-BERLIN, M. MELZER, B. KRAUSKOPF,
R. BAUER, R. BELLING, H. STEINER,
W. SCHMID.

Guidelines of the November Group (January, 1919)

I. The November Group is the (German) alliance of radical artists.

II. The November Group is not a union for the defense of economic interests, nor is it (merely) an association for exhibition purposes.

III. The November Group wishes to exercise a decisive influence upon all artistic matters by merging into a general alliance all like-minded creative forces.

IV. We demand a voice and an active roll in:

1. all architectural projects as a matter of public concern: city planning, new settlements, the public buildings of government, industry and the social services, private building projects, the preservation of monuments, the suppression of artistically worthless architectural monuments.

2. the reorganization of art schools and their curricula: the suspension of authoritarian supervision, the election of teachers by artists' associations and students, the elimination of scholarships, the unification of architecture, sculpture, painting, and design schools, the establishment of studios for work and experimentation.

3. the transformation of museums: the suppression of biased collecting policies, the elimination of an overemphasis upon the acquiring of objects having only scholarly value; their transformation into people's art centers, unprejudiced centers of timeless principles.

4. the allotment of exhibition halls: the elimination of special privileges and capitalistic influences.

5. legislation on artistic matters: giving artists equal rights as spiritual creators, the protection of artistic property, the elimination of all duties and taxes on works of art.

V. The November Group will demonstrate their solidarity and their achievement by continuous public announcements and by an annual exhibition in November. The central committee will supervise these continuing announcements and exhibitions. All members are entitled to equal exhibition space and will not be judged by any jury. The central committee will also arrange all special exhibits.

From Yes!—Voices of the Workers Council for Art *(Berlin, 1919)*

QUESTIONS WHICH NEED CLARIFICATION

I. Curriculum. What must be done to reform thoroughly the education of all those who work in the visual arts?

II. State Support. In what ways should the socialist state aid art and artists? (Purchases, art commissions, museums, schools, exhibits, etc.)

III. Public Housing. What guarantees should one demand from the state so that housing in the future is planned in accord with far-reaching cultural considerations?

IV. The Transfer of Creators from the Fine Arts to the Crafts. How can the broad mass of the art proletariat be persuaded to enter the crafts and avoid destruction by the economic catastrophe which seems imminent? What must the state do so that the education of the next generation is based upon a thorough mastery of craft?

V. The Artist in the Socialist State.

VI. Art Exhibits. How can one interest the *Volk* once more in a total work of art—the unification of arcitecture, sculpture, and painting? State-supported testing places to take the place of salon art exhibitions.

VII. How can creators from the various arts unify the arts?

VIII. Color and the Image of the City. Ideas for the use of color in the city, bright colors for houses, painted facades and interiors, and the elimination of easel paintings.

IX. The Designing of Public Buildings by Artists. What practical demands must be made upon the government so that public buildings are designed by artists rather than, as is the case now, by engineers and building officials?

X. Harmony with the *Volk*. How can the efforts of modern artists reach the *Volk* and harmonize with it?

XI. What steps must be taken so that at the right moment the above material, which has been privately compiled, can be effectively publicized? Newspaper articles, lectures, exhibitions, sufficient press coverage.

XII. How shall the closest contact possible be established with foreign
art associations which have similar ideals?

XIII. Point of view on the issue of artistic anonymity.

*Selections from Answers Given
by Several Artists to the Above Questions*

WALTER GROPIUS*

V. Art and state are irreconcilable concepts. They are by their very
nature opposed. The creative spirit, vital and dynamic, unique and
unpredictable, refuses to be limited by the laws of the state or by the
straitjacket of bourgeois values. And if the state uses force to interfere
with the free development of such "abnormal" creators it is actually
cutting its own life's blood supply. Thus our age is suffocated by a
world of shopkeepers, is trapped in a quagmire of materialism. The
real task of socialism is to destroy the evil demon of commercialism in
order that the creative spirit of the *Volk* might once more flourish.
The mentality of our nation has already been profoundly shaken by
the recent disaster and after the total collapse of the old life it has
been made so sensitive that it might make Germany more receptive
to the new spirit than any of the other European nations. For war,
hunger, and pestilence have jarred us out of our obstinacy, they have
aroused us out of our inertia and self-satisfaction, they have finally
awakened our sleepy and lazy hearts. Through pain we have been
taught once again to feel. Feeling is, after all, the source of inspiration,
feeling leads to finding, to that creative power which organizes and
structures, in short—in the broadest sense—to a passion for building.
And this passion for building, for structure—*this architectural spirit*
—is the natural antithesis to the world of shopkeepers, to the spirit
of disintegration and destruction which is the deadly enemy of all
art.

VI. Art exhibitions are the misbegotten creatures of an art starved
Europe. Since art is dead in the actual life of civilized nations it has
been relegated to these grotesque morgues and there prostituted. To-

* Walter Gropius. Architect. Born 1883 in Berlin. Died 1969. Studied in Munich
and Berlin 1903–1907. Army service 1914–18. Association with revolutionary artists
groups 1918–19. Director of Bauhaus 1919–28. England 1934–37. United States 1937.

day a work of art no longer occupies a well-defined and hallowed place in the midst of the *Volk,* it is free as a bird and has become merely a luxury object in the salons of the bourgeoisie. An art exhibition is its warehouse and market. The *Volk* leaves empty-handed and has no conception of a living art. Therefore, in place of the old salon art exhibition, let us have *traveling art shows* in temporary, brightly painted huts or even tents, shows featuring not only paintings and sculptures but also architectural models, large and small or stereo and cinematic presentations of architecture. The task of future art exhibitions is to show painting and sculpture in the context of architecture, to show how they function in buildings and thus to make art once again living and vital.

KARL SCHMIDT-ROTTLUFF

I. Training based on craft.* A complete mastery of craft for all architects. Training in construction techniques which require specific materials. The elimination of all false materials. The training of painters and sculptors can only be based upon the knowledge and mastery of materials. For the rest of it, each artist should decide for himself. Actually, we must also demand that all academies for painters and sculptors be dissolved.

* * *

V. The artist should also be free in a socialist state, true to his goals which are always directed toward all of humanity, never toward the state. Rejection of all attempts by the state to integrate art into the total scheme of the state. In life and art the artist must be free. As a logical consequence it follows that the state should mind its own business.

BRUNO TAUT †

I. No schools. Only practical experience on the job!
II. The state must be completely ignored. Only the proletariat

* Schmidt-Rottluff's views here agree with Gropius', but are characteristically shorter and blunter.

† Bruno Taut. Architect. Born 1880 in Königsberg, East Prussia. Died 1938 in Ankara, Turkey. His "Monument of Steel" (Leipzig, 1913) and "Glass Pavillion" (Cologne, 1914) have been cited as masterworks of expressionistic architecture. Associated with revolutionary artists' groups 1918–19. After the early '20s his style became extremely simple and functional.

through the workers' councils at the factories should support projects. One, two, five marks per head depending on the project.

* * *

V. The artist should be a worker, like any other worker. "Art" only during leisure hours. Only strong new directions justify relief from factory or farm labor and work at some conventional trade.

The following questions are also important:

* * *

B. *How can we prevent the glorification of war?* After removal, sell or melt down monuments dedicated to kings, wars, and generals. Those having artistic value (Tuaillon, Rauch, etc.) should be put into museum storage. Eliminate *all* emblems using beasts of prey (imperial eagles, lions, wolves, wild boars, etc.).

C. *What do we do to prevent people from forgetting the war?* The horror and misery of war must never be forgotten. Therefore, as an eternal reminder, monuments on a grand style expressing the horrors and terrors of the war. . . . The Berlin Cathedral must be blown up because it is the worst kind of an excuse for a house of God. In its place—next to the Zwingburg—an antiwar monument. Distribution of literature telling the true story of the war, revealing the money made by war profiteers.

* * *

H. *A monumental architectural project:* something so mighty that it will occupy the spare time of *everyone* perpetually; a vast decoration of earth by us, who are its organon; all means possible must be used to force a general commitment to this project. Murderous and destructive instincts must be transformed into constructive and positive efforts; therefore, a project so vast that it will leave all Europe breathless and cost as many billions and consume as much energy as the accursed war. To concentrate only upon practical matters is boring. Children who are bored, fight—and nations make war, i.e., they murder, lie, steal—therefore, architectural projects are of supreme importance!

Walter Gropius

What Is Architecture? *

What is Architecture? Surely the crystallized expression of man's
noblest thoughts, of his ardor, his human nature, his faith, his religion!
That it once was! But who of those living at this time, cursed as it is
with functionalism, does still understand the all-embracing and cheer-
ing character of architecture? Why do we not wander through our
streets and towns weeping with shame over such wastelands of ugliness!
Let us at least understand this: The grey, empty, obtuse stupidities in
which we live and work will bear humiliating evidence to posterity of
the spiritual abyss into which our generation has slid, forgetting the
great and only art: architecture. We should not be under any delusion
—in our European presumptuousness—that the miserable building
accomplishments of our age could change the total bleak picture. All
our works are only fragmentary. Something that is shaped only by
expediency and need will not satisfy the yearning for a world of
beauty rebuilt from the ground, the rebirth of that intellectual har-
mony which soared to perform the miracle of the Gothic cathedral.
We shall not live to see it. Yet there is one comfort for us: the idea,
the construction of a fervent, daring, and very advanced architectural
concept will be realized in a happier time that is to come. Artists, let
us at last demolish the walls which the erroneous wisdom of our
schooling has erected between the "arts," so that we may all become
"builders" once more! We must want, imagine, and create the new ar-
chitectural concept cooperatively. Painters, sculptors, break down the
barriers around architecture and become co-builders and comrades-in-
arms toward art's ultimate goal: the creative idea of the Cathedral of
the Future which will once more encompass everything in one form—
architecture and sculpture and painting.

However, ideas perish as soon as they are comprised. Therefore

* Walter Gropius, "Einleitung," *Austellung für Unbekannte Architekten* (Berlin,
1919), a pamphlet issued by the Workers' Council for Art. The text was taken in
translation from Ulrich Conrads and Hans Sperlich, *The Architecture of Fantasy*,
New York, 1962, p. 137f. translated, edited, and expanded by Christiane Crasemann
Collins and George R. Collins (New York: Frederick A. Praeger; London: The
Architectural Press Ltd., 1962), p. 137f., by permission of the publishers.

distinguish clearly between dream and reality, between everyday work and a longing for the stars. Architects, sculptors, painters, all of us must return to the crafts! For there is no "art as a profession." Artists are craftsmen in the original sense of that word, and only in rare and divine moments of illumination, which lie beyond their own will-power, can art, unknowingly, burst into bloom from the work of their hands. You painters and sculptors should become craftsmen again; you should smash the frames of "salon art" that are around your paintings, go into the buildings, endow them with fairytales of color, engrave your ideas onto their naked walls—and build in fantasy without regard for technical difficulties. To have the gift of imagination is more important than all technology, which always adapts itself to man's creative will. Today there really does not yet exist a true architect, all of us are only the forerunners of the one who will some time again deserve to be called "Architect," a name signifying Lord of Art, who will make gardens of the desert and will heap wonders to the sky.

Max Pechstein

Born 1881 in Zwickau, Germany. Died in Berlin 1955. Studied
in Dresden. Met Kirchner and Heckel and joined the *Brücke*
1906. Settled in Berlin 1908. Co-founder of the New Secession
1910. Trip to the South Seas 1914. Army service 1916–17. Co-
founder of the November Group 1918. Professor at the Prus-
sian Academy, Berlin 1923. Dismissed by the Nazis 1933. Re-
instated as professor at the Academy 1945.

As Pechstein was a member of the *Brücke,* his painting paral-
leled Kirchner's but was less intense and nervous, more
"French," a difference which may explain why Pechstein, of all
the *Brücke* members, was the first to be accepted by the Ger-
man public. In spite of his relative popularity with the "estab-
lishment," Pechstein after the war became active as an artist
in radical politics. He helped found the November Group and
was instrumental in issuing several manifestoes supporting
socialism. One of the most important was the pamphlet *To
All Artists,* (1919), a compilation of statements, poems, and
prints by fourteen modern artists including himself, Meidner,
Feininger, Klein, and Tappert. Pechstein's declaration "What
We Want" was the major piece.*

That his determination to make art relevant to society did
not interfere with his Expressionist fervor is evident from his
"Creative Credo" of 1920. On the contrary, although this
statement has nothing specifically to do with revolution, its
vehemence seems very much a reflection of the violence and
insecurity of the times.†

"What We Want"

Winckelmann's glorification of the antique is still the basis of art

* Max Pechstein, "Was Wir Wollen," *An alle Künstler* (Berlin, 1919), pp. 18–22.
Translated for this volume by the editor with permission of Maria Pechstein.

† Max Pechstein, "Creative Credo," Kasimir Edschmid, ed., *Schöpferische Kon-
fession,* Vol. XIII, *Tribüne der Kunst und Zeit* (Berlin, 1920). Klee and Beckmann
also contributed credos to this volume. See Parts Two and Three, respectively,
of this anthology for their statements.

education at state academies.* Life and the analysis of life is strictly forbidden there. Craft and technique are not taught. An extremely scrupulous production of very neat drawings disguises the lack of technical knowhow. Every really serious student is left to master the necessary techniques for himself—if he is a painter he has to learn how to prepare his ground, how to use his colors, how to make a technically sound picture of any kind; if he is a sculptor, how to construct an armature, not to mention whether his model can even be realized in bronze or marble. In any case, it can always be cast in plaster!

Actually, the current activity in all academies is the teaching of sham art. Pencil sharpening and smoothing tones are taught instead of technically sound realization of artistic ideas. In academies cleverly composed exercises in patience, so-called studies, flow on in a never-ending stream. Studies for what? and to want end? That's what I want to know!

All that is being produced are experts who draw art. Wake up! Throw off your inertia! Learn to learn from life and to work for life. Then you will find plenty to express without having to go back to old symbols and earlier styles.

Learn creatively and you will become a truly great teacher!

We hope that a socialist republic not only will make the situation in the art world healthy but will create a unified art epoch for our generation. The beginning of a new unity of *Volk* and art will be heralded on the basis of craft, with each artist working in his own fashion. Art will no longer be considered, as it has been in the past, an interesting and genteel occupation for the sons of wealthy loafers. On the contrary, the sons of common people must be given the opportunity, through the crafts, to become artists. Art is no game, but a duty to the *Volk!* It is a matter of public concern.

As for those who do not make the grade, they will not be useless drones but fully qualified, first-class craftsmen, citizens who are useful to the state. What we want is to educate the *Volk* in work and in feeling.

This we demand as the most important aspect of our right to self-determination and this is how we shall demonstrate that we are important not merely for art lovers but for society as a whole. Once

* Johann Winckelmann (1717–68), the first great German art historian. His *On the Imitation of Greek Art* became a cornerstone of neoclassical aesthetic theory.

public awareness of art is stimulated, its appreciation for art will be cleansed and then only a few spiritually lazy people will be left, alone and isolated.

We also demand self-determination in the area of collecting exceptional artistic achievements for the people's state because our hearts are pure (Museums for the Living!). We do not want the new government, like the old regime, to saddle us with people representing the ideas of the old regime. We do not want to be asked after the fact but we want to be a part of a decision making process which will select a man who through his actions has demonstrated the same sense of responsibility that we ourselves have.

Then he, and not some art commission, can be given complete responsibility. The revolution has finally given us the freedom to express and to realize wishes which we have had for years. Our sense of duty tells us that work for us alone must be done by us alone. We demand this and we do this without ulterior motives, keeping our eyes only upon the ideal goal: "the realization of our historical awareness of a world outlook."

The kingdom of creative imagination will replace the obsolete dogmas of different religions and bring God closer to us through creating than either the Catholic church (which tries to satisfy childish natural fantasies, e.g., those saints which protect against fire, flood, and such dangers) or the rationalistic Protestant religion.

Therefore the shout, "Art for the *Volk*!" is no empty slogan.

Our determination is irreproachable; it is not based upon any desire for personal power. Therefore we will be able to breathe new life into the dead ideals of our age. We may be poor in the material sense but we are wealthy in our enthusiasm and in our willingness to sacrifice for the *Volk*. We have faith in our *Volk*.

Let the socialist republic give us their confidence, we already have our freedom. Then, out of the dry earth flowers will blossom to its greater glory.

"Creative Credo" (*1920*)

Work!
Ecstasy! Smash your brains! Chew, stuff your self, gulp it down, mix

it around! The bliss of giving birth! The crack of the brush, best of all as it stabs the canvas. Tubes of color squeezed dry. And the body?

It doesn't matter.

Health?

Make yourself healthy!

Sickness doesn't exist! Only work and I'll say that again—only blessed work! Paint! Dive into colors, roll around in tones! in the slush of chaos! Chew the broken off mouthpiece of your pipe, press your naked feet into the earth. Crayon and pen pierce sharply into the brain, they stab into every corner, furiously they press into the whiteness. Black laughs like the devil on paper, grins in bizarre lines, comforts in velvety planes, excites and caresses. The storm roars—sand blows about—the sun shatters to pieces—and nevertheless, the gentle curve of the horizon quietly embraces everything.

Beaten down, exhausted, just a worm, collapse into your bed. A deep sleep will make you forget your defeat. A new day! A new struggle! Ecstasy again! One day after the other, a sparkling, constantly changing chain of days. One experience after the other. That damned brain! What is it that churns and twitches and jumps in there? Hah! Tear your head off, or grab it with both hands, turn it around, twist it off. Then we'll scrape it out and scratch it out. Get rid of every last little bit. Sand! Water! Scrub it clean. There now!! Almost as good as new! an unused skull. Night! Night! No stars, pitch black. Without desire!

Tomorrow is another day.

Ludwig Meidner*

Aschaffenburg Journal (*August and September, 1918*) †

What many of us did and the way we lived before the war was wrong.

We all hung like Absalom by the hair from the branches of the *Zeitgeist* ("spirit of the times") and none of us had eternity within us, or a desire for a peaceful earth, or for meditation and the healing of our divided consciousness. We were confused, high-strung, and irritable. We were driven to the breaking point by the approach of world catastrophe. No one objected when spleen was proclaimed as the law of life and paradox became the highest spiritual value. And most were not satisfied with their own wild power, the dream of a diabolical palette—they all ran, as if possessed, after money, empty momentary successes. They took all they could from the eager art trade only to waste it in sick debauchery. Oh we were desperately in need and we didn't realize that we were sunk deep in sin. Yet the period achieved rich results in painting. New possibilities were discovered, new unheard-of forms. And even if they were mostly tested on imperfect subjects, their effects were not without power and we were all held spellbound, made breathless and feverish.

Oh, if we could only keep the enthusiasm of this first intoxication so that we could gird ourselves for greater deeds. We have to rise up from our degradation. We have to show the people a better way of life, the old ideals, the old purity, divine clarity, and the power of the soul, all of this as an imperishable revelation in triumphant and joyous planes. Henceforth we will no longer follow deadly reason, the old church dogmas, a political goal or a current fad—rather we shall create a spiritual, transcendental realm on our canvases out of primeval depths of feeling; out of elemental, immediate visions; yes, right out of our own spiritual being.

* For Meidner's biography, see p. 110.

† Ludwig Meidner, extracts from *Aschaffenburg Journal,* in *Septemberschrei* (Berlin: Paul Cassirer, 1920), pp. 15–23. Translated for this volume by the editor with permission of der Magistrat der Stadt Darmstadt, Herr Stadtrat H. W. Sabais.

I too was for a long time without comfort, ruined, Godless, a captive of all the errors and moods of the moment, alone and anxious as an alley cat . . . until one night an inner voice comforted me. . . .

From that moment on I emerged from the cavernous streets of the city and found myself out upon the sunny plain. I dipped furtively into old mystical books until one day I realized that the Bible which was supposed to be dead and done was a source of endless joy and profound truth. Previously I had leafed through it with misunderstanding and prejudice. But now I was transported by the power of the consoling verses of Psalms or by the dreadful words of Isaiah; I was awakened as if from a deep sleep, like dust I was blown skyward. I was happy as a little child and all grief and tension turned into sweetness. Each day became a new and holy call to action. Formerly, as an artist, I had used an unrestrained, nervous, scribbling stroke, I had been interested in the bizarre and in a sneering, driveling kind of existence. Now my emotions became nobler. My composition became clear and delicate touches appeared here and there in rhythmic combinations. When I was young, boredom and restlessness drove me out into the low dives of the suburbs, to spicy French novels, and to the grostesque adventures of the *Psychopathia Sexualis*. But now that I am older a few lines from St. Paul are sufficient to inspire me and set me to work. And tomorrow I shall be inflamed completely by the glory of God, I shall be a regular storm raised by the Almighty. I'm not going to sacrifice my energies to the night but do the works of my faith, joyfully in broad daylight.

Yes, I now have the great consolation, and the faith that I shall ceaselessly create, aspire, pray, sing praises, and fiercely struggle for perfection to Your greater glory, oh Lord. And should I serve You twenty or thirty years, my Lord, let me just die quietly working on a picture. Then Your breath can blow me away and let this exulting and insatiable creator's hand of mine turn to dust. . . .

What we need for the future, all of us, is a fervent and fanatic naturalism; yes, a passionate, virile, and direct truthfulness, like Multscher, Grünewald, Bosch, and Brueghel. We want, of course, to serve the Highest with our work. We have a truly magnificent history to create—and how can we do anything else but use the forms of the outer world for this! Our visions must be as clear and powerful as those of Multscher and Grünewald—let's never forget these two! And let's never forget the noble, certain, and wise craftsmanship of these

two heroes. They painted the way stonecutters cut stone; real great-ness strives for something that will last a thousand years, not for a momentary effect which might amuse people at the next exhibition. Yes, craftsmanship, that rare, laborious craftsmanship which indeed has an austere beauty! . . .

For the past few years we have all been too interested in pictures which were remote from our world. Our goal was geometry and the youngest artists strove like madmen for abstraction and nonobjectivity. All you painters eager for heaven, you'd like to forget the earth and squeeze the spirit straight out from your tubes—immaculate and utterly transcendent. But stop a moment and study the marvelous reality of things.

Look at the trees, they have real wisdom. They take hold of the earth, otherwise they would simply lift their wings and fly to heaven. After all they are so passionately pious. And they should certainly make believers out of us because they are so beautiful. Thus they sink their roots deep into the soil and the wind doesn't budge them.

So let's hold on to the earth with all our might, otherwise we will drift into the blue, into chaos. Let's return to a passionate naturalism, to a deep, loving respect for the objective reality of the world. Because we strive for the transcendental we must master the terrestial. Since we have a burning desire to see God we must first digest the earth and understand it. And please understand that this fervent truth-painting is no easy matter. It is so very difficult because it strives for the very highest. And every man who wants the highest travels the same diffi-cut road.

Well, here [Aschaffenburg] I feel completely at home as a painter. Didn't I live too long in Berlin!? Oh, Berlin! You guillotine of all my hopes for joy. You hangman of all my delicacy, purity, and virtue. Why was I trapped so long in your painful net? Later I'm going to live only in the country, close to the lonely and infinite openness of the plains.

George Grosz

Born 1893 in Berlin. Died 1959 in Berlin. Studied in Dresden and Berlin 1909–1913. In the army 1914–16. Discharged after illness. Drafted again and served until complete breakdown 1917–18. Settled in Berlin. Member of Berlin Dada group 1918. Later joined other revolutionary artists' organizations, including the Red Group (1924) and the ARBKD (1928). Emigrated to the United States 1933. Returned to Germany 1959.

Grosz is most famous for his bitter satirical drawings and paintings attacking German society, works which between 1916 and 1933 were done in styles ranging from Dada collage to *Neue Sachlichkeit* ("New Objectivity") verism. After his emigration to the United States his art, with the exception of the visions of doom inspired by World War II, became gentler and less critical.

His essay "My New Pictures" is an important profession of artistic intention and political affiliation.* In contrast to Meidner's mysticism and Kollwitz' tender idealism, Grosz here presents a relatively tough-minded program which included support for the Communist party. His faith in the communists did not last, but he remained active in radical artists' groups until 1933. Although his best work was filled with hatred—even his autobiography is entitled *A Little Yes and A Big No*—Grosz' negation and hatred, the essay in this anthology indicates, were always activated by a desire to improve life, not degrade it.

"My New Pictures"

Today art is absolutely a secondary affair. Anyone able to see beyond their studio walls will admit this. Just the same, art is something which demands a clearcut decision from artists. You can't be indiffer-

* George Grosz, "Zu meinen neuen Bildern," *Kas Kunstblatt* (Weimar, 1921), Vol. V, No. 1, 11–14. Translated for this volume by the editor with permission of the George Grosz Estate. Grosz wrote the essay in 1920.

ent about your position in this trade, about your attitude toward the problem of the masses, a problem which is no problem if you can see straight. Are you on the side of the exploiters or on the side of the masses who are giving these exploiters a good tanning?

You can't avoid this issue with the old rigmarole about the sublimity and holiness and transcendental character of art. These days an artist is bought by the best-paying jobber or maecenas—this business of commissions is called in a bourgeois state the advancement of culture. But today's painters and poets don't want to know anything at all about the masses. How else can you explain the fact that virtually nothing is exhibited which in any way reflects the ideals and efforts, the will of the aspiring masses.

The artistic revolutions of painters and poets are certainly interesting and aesthetically valuable—but still, in the last analysis, they are studio problems and many artists who earnestly torment themselves about such matters end up by succumbing to skepticism and bourgeois nihilism. This happens because persisting in their individualistic artistic eccentricities they never learn to understand revolutionary issues with any clarity; in fact, they rarely bother with such things. Why, there are even art-revolutionary painters who haven't freed themselves from painting Christ and the apostles; now, at the very time when it is their revolutionary duty to double their efforts at propaganda in order to purify the world of supernatural forces, God and His angels, and thereby sharpen mankind's awareness of its true relationship to the world. Those symbols, long since exhausted, and the mystical raptures of that stupid saint hocus-pocus, today's painting is full of that stuff and what can it possibly mean to us? All this painted nonsense certainly can't stand up to reality. Life is much too strong for it.

What should you do to give content to your paintings?

Go to a proletarian meeting; look and listen how people there, people just like you, discuss some small improvement of their lot.

And understand—these masses are the ones who are reorganizing the world. Not you! But you can work with them. You could help them if you wanted to! And that way you could learn to give your art a content which was supported by the revolutionary ideals of the workers.

As for my works in this portfolio [omitted here], I want to say the following: I am again trying to give an absolutely realistic picture of the world. I want every man to understand me—without that profundity fashionable these days, without those depths which demand a

veritable diving outfit stuffed with cabalistic and metaphysical hocus-pocus. In my efforts to develop a clear and simple style I can't help drawing closer to Carra.* Nevertheless, everything which is metaphysical and bourgeois about Carra's work repels me. My work should be interpreted as training, as a hard workout, without any vision into eternity! I am trying in my so-called works of art to construct something with a completely realistic foundation. Man is no longer an individual to be examined in subtle psychological terms, but a collective, almost mechanical concept. Individual destiny no longer matters. Just as the ancient Greeks, I would like to create absolutely simple sport symbols which would be so easily understood that no commentary would be necessary.

I am suppressing color. Lines are used in an impersonal, photographic way to construct volumes. Once more stability, construction, and practical purpose—e.g., sport, engineer, and machine but devoid of Futurist romantic dynamism.

Once more to establish control over line and form—it's no longer a question of conjuring up on canvas brightly colored Expressionistic soul-tapestries—the objectivity and clarity of an engineer's drawing is preferable to the uncontrolled twaddle of the cabala, metaphysics, and ecstatic saints.

It isn't possible to be absolutely precise when you write about your own work, especially if you're always in training—then each day brings new discoveries and a new orientation. But I would like to say one thing more: I see the future development of painting taking place in workshops, in pure craftsmanship, not in any holy temple of the arts. Painting is manual labor, no different from any other; it can be done well or poorly. Today we have a star system, so do the other arts —but that will disappear.

Photography will play an important role; nowdays a photographer can give you a better and cheaper picture of yourself than a painter. Besides, modern artists prefer to distort things after their own fashion —and they have a peculiar aversion to a good likeness. The anarchism of Expressionism must stop! Today painters are forced into this situation because they are unenlightened and have no links with working people. But a time will come when artists—instead of being scrubby bohemian anarchists—will be clean, healthy workers in a collectivistic

* Carlo Carra, Italian painter. After a period as a Futurist he became during the 1920s a leader in the trend toward a new realism in painting.

community. Until this goal is realized by the working class the intellectual will remain cynical, skeptical, and confused. Not until then will art be able to break out of its narrow and shallow confines where it flows anemically through the life of the "upper ten-thousand," not until then will it become a great stream capable of nourishing all of working humanity. Then capitalism's monopoly of spiritual things will be ended.—

And here also communism will lead to a truly classless society, to an enrichment and further development of humanity.

Expressionism and the Third Reich

The last section of this anthology is a sorrowful epilogue to the heroic ambitions of the Expressionists. After Hitler's rise to power, German Expressionism appeared completely discredited. It was branded as degenerate and bolshevistic by the Nazis and as decadent and fascistic by the communists. In Germany Expressionist artists were stripped of honors, dismissed from teaching positions, and forbidden to exhibit. Their work was removed from public collections and sometimes destroyed. Because of the nature of Expressionism and because of the charges leveled against it at this critical juncture in history, evaluation of this movement during these years takes on special significance.* Although the two essays which follow were not written by Expressionist painters and are not specifically about the visual arts, their effective presentation of the issues, the prominence of their authors, and even the circumstances of their publication combine to make them particularly revealing.

Gottfried Benn's "Confession of an Expressionist" is unique as a defense written by a creator of the first rank who supported the Nazis.† Benn (1886–1956), a brilliant physician specializing in venereal diseases who had also studied theology and philosophy, was one of the major poets of German Ex-

* See the general introduction, pp. 1–12.

† The essay first appeared as "Bekenntnis zum Expressionismus," in *Deutsche Zukunft*, V (November, 1933), 15ff. It was then published in an expanded version as "Expressionismus" in Gottfried Benn, *Kunst und Macht* (Stuttgart, 1934), pp. 59–80. The latter version was used for translation by the editor with permission of Limes Verlag Max Niedermayer Wiesbaden.

pressionism and his support of the Nazis outraged intellectuals everywhere. However, this support was very short-lived. Barely a year after the publication of his essay he confessed his disillusionment: "What I wrote in the introduction to *Expressionism* was written last year [1933], when I was still filled with faith, love, and hope. Today I most certainly would not have written it! Today I would write: Caesar's yap and a troglodyte's brain." In 1937 he was forbidden to publish, and in order to escape Nazi persecution he enlisted in the army medical corps.

One of the most vigorous debates about Expressionism took place on the pages of *Das Wort,* where Klaus Berger's "The Heritage of Expressionism" * figured prominently as the most convincing defense of the movement. The debate was started in this liberal communist periodical by Alfred Kurella (under the pseudonym Bernard Ziegler) and Berger's article was written in direct rebuttal to it. Berger (b. 1901), a distinguished art historian, argues from a Marxist position, of course, but his conclusions run counter to "Ziegler's." There is no denying that attacks upon Expressionism were penetrating and intelligent. Nevertheless, they were so biased and devoid of artistic alternatives that it seems easy to agree with the blunt and courageous statement with which Herwarth Walden concludes his defense of Expressionism in *Das Wort:* "I therefore most strenuously protest that prewar and postwar avant-garde artists are defamed as petit-bourgeois types and even as fascists by those who either live off of the vulgarization of their ideas or have withdrawn into some kind of by-gone world of form!"

A few short items by Ernst Barlach and Emil Nolde have been chosen† as a fitting conclusion to this section and to the anthology. These pieces testify eloquently to the humiliation suffered by artists during the Third Reich. Barlach, more stubbornly independent than Nolde, refused all compromise.

* Klaus Berger, "Das Erbe des Expressionismus," *Das Wort* (Moscow, 1938), Vol. III, No. 2, 100ff. Translated for this volume by the editor with permission of the author. The painter Heinrich Vogeler's contribution to this debate also appears in this anthology; see Part Five, p. 155.

† For Barlach's biography, see Part Three, p. 90. For Nolde's biography, see Part One, p. 30.

But let us not forget that Nolde, in spite of his nationalism, remained true to his vision. He never changed his style and he even risked arrest by continuing to paint after having been forbidden to do so by the authorities.

Gottfried Benn

"The Confession of an Expressionist"

The leadership of the new Germany is extraordinarily interested in questions about art. As a matter of fact, their outstanding intellectuals are the ones who are concerned whether Barlach and Nolde can be called German, whether a heroic style is possible or necessary in literature, who should supervise the repertory of the theatre and determine concert programs, who, in a word, should make art almost daily a matter of extreme urgency for the state and the public in general. The enormous biological instinct for racial perfection which pervades the whole movement keeps this idea uppermost in their minds no matter how great external and internal political, social and pedagogical problems might be: this instinct tells them that art is the center of gravity, the focal point for the entire historical movement: art in Germany, art not as an aesthetic achievement but as a fundamental fact of metaphysical existence which will decide the future, which is the German Reich and more: the white race, its Nordic part which is Germany's offering, her voice, her call to the declining and endangered culture of the West; and for us it is another indication of what Europe until now cannot see or will not see: to what extent this movement took upon itself tremendous duties and responsibilities, burdened itself with incredible spiritual struggles, struggles which it undertakes for that whole part of the world in which Germany occupies the center.

Surely such an admirable interest in art will tolerate a small objection, something which I would like to discuss in connection with a specific problem in the arts. This overwhelming faith in a new greatness for German art is, at the moment, no less an overwhelming rejection of the style and the will to form of the last German epoch. It has become customary to call this whole period "Expressionist." Today's new faith is in absolute opposition to this previous epoch. At a large political meeting which was held a short time ago at the Sportpalast, Berlin, a meeting which was well covered by the press, the curator of the Rhine Heimatsmuseum in the presence of the ministers of the Reich characterized Expressionism in the visual arts as degenerate, anarchistic snobism; in music he called it cultural bolshevism and the whole

movement he claimed was an insult to the *Volk*. Literary Expressionism
is also publicly condemned. A famous German writer has no hesitation
about saying that deserters, convicts, and criminals created this milieu,
that they advertised their wares with ballyhoo worthy of dishonest
financiers pushing watered stock; he said that these artists were utterly
corrupt and he named names, including mine.

As a matter of fact, in some histories of literature, for example
Soergel's *Im Banne des Expressionismus,* I have been named, along
with Heym, as a founder of German literary Expressionism; and I ad-
mit that psychologically I am in its sphere of influence and its methods
(which will be discussed presently) suit my temperament; now I wish
to change and since I am the only one of this dispersed and dis-
credited group who has the honor of being a member of the new Ger-
man Academy of Literature I would like to step forward once more to
speak for this group. To stand up for their names, to recall their
spiritual condition, and to direct attention to certain points in their
defense, in the defense of a generation whose development was blighted
by a war which destroyed many of them: Stramm, Stadler, Lichtenstein,
Trakl, Marc, Macke, Rudi Stephan; a generation burdened by mon-
strous existential problems, the problems of the final generation of a
world which in most respects was utterly ruined.

I

First of all, it must be emphasized that Expressionism was no Ger-
man eccentricity and it was not a foreign conspiracy either. It was a
European style. In Europe from 1910 until 1925 almost no naive—i.e.,
representational—art was produced, only antinaturalistic expressions.
Picasso is a Spaniard; *Léger, Braque* are French; *Carra, Chirico,*
Italians; *Archipenko, Kandinsky,* Russians; *Masereel,* Flemish; *Bran-
cusi,* Roumanian; *Kokoschka,* Austrian; *Klee, Hofer, Belling, Poelzig,
Gropius, Kirchner, Schmidt-Rottluff,* Germans; here the West was as-
sembled and not one of those named was anything but Aryan. In
music *Stravinsky* is Russian; *Bartók,* Hungarian; *Malipiero,* Italian;
Alban Berg, Křenek, Austrian; *Honegger,* Swiss; *Hindemith,* German;
and racially all are pure Europeans. In literature: *Heym, Stramm,
Georg Kaiser, Edschmid, Wedekind, Sorge, Sack, Goering, Johannes R.
Becher, Däubler, Stadler, Trakl, Loerke, Brecht,* pure Germans. Fur-
thermore, *Hanns Johst* also came out of this great wave of talent. We are
faced, then, by an impressive closed front of artists who, without ex-

ception, are European. The outbreak of a new style on so broad a
front speaks without need for further explanation for the absolutely
autochthonous, elementary directness of its forms, for a new European
consciousness. By no means can it be explained as a mere rebellion
against earlier styles: Naturalism or Impressionism; actually it is a
new form of historical existence. An existence in the formal as well as
in the human sense which is of an avowed revolutionary character; in
Italy the major proponent of this new existence, *Marinetti,* advocated
in his basic manifesto of 1909: "the love of danger," "on becoming
accustomed to energy and bold action," "aggressiveness," "the death
leap," "beautiful ideas that kill." Moreover, fascism has adopted this
movement and Marinetti today is "Excellency" and president of the
Roman Academy of Arts. "Adopted" is not even the right word; Fu-
turism helped create fascism; the black shirt, the battle cry, and the
war song, the Giovinezza, all derive from "Arditismus," the warlike
section of Futurism.

Futurism as a style, also called Cubism and frequently designated as
"Expressionism" in Germany, is greatly varied in appearance, but it is
unified in its basic intention which is to shatter reality, to go to the
very roots of things ruthlessly until they are no longer individually or
sensuously colored or falsified or displaced in a changed and weakened
form in the psychological process; but instead await in the acausal si-
lence of the absolute ego the rare summons of the creative spirit—this
style had been anticipated throughout the nineteenth century. In
Goethe we can find countless passages which are pure Expressionism.
For example, such well-known verses as these: "toothless pines chatter
and the tottering skeleton, intoxicated by the last ray . . . ," etc. Here,
instead of rational meaning, an emotional mood connects the different
verses. No particular theme is exclusively developed, but rather feel-
ings, magical associations of a purely transcendental sort determine
relationships. The second part of *Faust* contains innumerable exam-
ples of this, as does most of Goethe's work from his old age. The same
things holds true for *Kleist*; his "Penthesilea" is a dramatically or-
dered, versified orgy of pure emotion. There is also *Nietzsche,* his as
well as Hölderlin's fragmented lyric poems are pure Expressionism:
loading a word, a few words with an enormous amount of creative ten-
sion, actually it is more a matter of *taking hold of words in a state of
high tension*; and then these mystically captured words become alive
with a truly real and inexplicable suggestive power. In the modern

period we can point to *Carl Hauptmann's* richly expressive pieces; and we find in *Paul Fechter's* history of literature (someone who by no means is sympathetic to Expressionism) the interesting reference to *Hermann Conradi* (1862–90), whom Fechter interprets as anticipating *Joyce, Proust,* and *Jahnn*; yes, and *Freud* too; "for Conradi, analysis is an end in itself," says Fechter, it penetrates into "inner reality." This inner reality and its direct revelation as form, that is precisely the art under discussion: we can find it already in parts of *Richard Wagner's* absolute music; *Nietzsche* called it "his flight into primeval states." In painting, *Cézanne,* France; *Van Gogh,* Holland; *Munch,* Norway are both heralds and consummators of this style. Actually we can truthfully say that Expressionism is part of all art; but only at a certain time (namely the period which has just passed), when it springs from many men does it determine a style and an age.

II

I said, that in Europe between 1910 and 1925 there was hardly another style except an antinaturalistic style; there was also no reality, at most only fragments of reality. "Reality" was a capitalistic concept, "Reality," that meant real estate, industrial products, mortgages, everything which could be given a price by merchants and middlemen. "Reality," that was Darwinism, international steeplechases and everything else reserved for the privileged classes. "Reality," that was war, famine, historical humiliations, lawlessness, and naked power. Spirit had no reality. It turned to its own inner reality, its own existence, its biology, its development, its mixture of physiological and psychological forces, its own creation, its illumination. The method used to experience this, to possess this was to intensify the creative power of the spirit, like something from India; it was ecstasy, a particular kind of spiritual intoxication. And ecstasies are hardly disreputable from the ethnological point of view. Dionysos came to stolid shepherds and under his orphic spell these unhysterical mountain people were stirred to frenzy; and later *Master Eckhart* and *Jakob Böhme* had visions. Blissful encounters, old as the hills! Naturally, *Schiller, Bach,* and *Dürer* are important, these treasures, these streams of life giving energy, but they had a different sort of existence, they derived from a different anthropological source, they had a different nature; but nature was also *here*, the nature of 1910 to 1925; yes, and more than nature was here; here we find a complete identity between the spirit and the epoch.

Reality—Europe's demonic concept: only that age, only those
generations which had no doubts about it were truly fortunate; in the
Middle Ages reality was first profoundly shaken when religious unity
was disrupted; it has been shaken to its very foundations since 1900
with the destruction of that scientific reality which for the past
400 years had defined "reality." Since science could only destroy the
old reality, people looked at the new reality within themselves and it
looked back. Externally the oldest remnants of the former reality
disintegrated and all that was left were relations and functions; crazy,
rootless utopias; humanitarian, socialist, or pacifist wastepaper; merely
so much action and business for its own sake; meaning and purpose
became imaginary, formless, and ideological although a conspicuous
flora and fauna of little business enterprises flourished, forever sneak-
ing about under cover of function and concept. Nature disintegrated,
history disintegrated. The old realities of space and time: merely func-
tions of consciousness; even the most concrete powers such as state and
society could no longer be understood, only business and action for its
own sake—the striking remark of Ford, brilliant as a maxim for
philosophy and business: *First make autos, streets will follow*; mean-
ing: first develop needs and the means for their satisfaction will auto-
matically follow; first initiate activity and then it will proceed of its
own accord; yes, it proceeded of its own accord, an ingenious psychol-
ogy for the white race: impoverished but maniacal; undernourished
but lofty-minded; with 20 marks in their pocket they gain a perspec-
tive of Sils Maria and Golgotha and buy themselves formulae for
processes and functions—that was 1920–25, that was the world dedi-
cated to decline; its business, that was functionalism ripe for the
storm which then came, but previously there was only that handful of
Expressionists, those believers in a new reality and an old absolute
who opposed their own existence to this disintegration with an un-
precedented fervor, with the asceticism of saints and in the certain
knowledge that they would suffer hunger and ridicule.

III

This last great art movement of Europe, this last great creative ten-
sion which was so involved in an irresistible destiny that a style de-
veloped out of it, how remarkable that it should be so utterly rejected
today! Basically this Expressionism was the Absolute, the antiliberal

function of Spirit at the very time when corrupt scribblers threw garbage down for the nation to gobble up: fiction writers posing as epic poets with their mishmash of faded psychology and miserable bourgeois philosophy; composers of popular ditties and nightclub comics from a world of bars and low dives. In any case there was struggle, yes, a clearcut historical issue. The question with which Kant had ended one epoch in philosophy and inaugurated another 150 years ago— "How is experience possible?"—was transferred to aesthetics—*How can one create form?* The creation of form was no longer an artistic problem, it was a riddle, a mystery as to why man created art in the first place, why he needs art; what a singular experience within the sphere of European nihilism! It was nothing else but intellectualism and absolutely destructive. As a major issue it was part of that compulsion of the twentieth century, part of that obsession to make conscious the unconscious, to comprehend experience only as scientific knowledge, emotion as perception, the soul as psychology, and love as only a neurosis. It also reflected the general mania for analyzing and dissolving the primeval barriers of silent order, for individualistically attacking the physiological and organic habits developed with great effort by humanity during earlier ages, for revealing more and more of the "it" which even Goethe, Wagner, and Nietzsche mercifully covered with night and terror. But this calling of everything into question was authentic preparation, authentic experience of a new mode of existence, radical and profound; and it produced, yes even in Expressionism, the only spiritual achievement that this wretched group of liberal opportunitists was capable of, that the scientist's world of pure transformation left behind, the only achievement which broke through that atmosphere of big-business rationalism and took the difficult path inward to the creative depths, to the archetypes, to the myths; and attempted, in the midst of the horrible chaos of reality's destruction and the perversion of values, to strive with absolute discipline and system for a new image of man. It is all too easy now to characterize that effort as abnormal and distorted and racially alien. After all, since then the great national movement has been at work creating new realities, has completely reorganized and reconstituted the utterly degenerate classes and obviously has the moral strength to lay the foundations upon which an entirely new art can develop. But we are talking about a period when that had not yet occurred, when everything was empty, when nihilism hovered above the waters instead of

the Spirit of God, when Nietzsche's words held true for an entire generation of Germans, when the only metaphysical activity which life demanded from us was art.

Art, this monstrous problem! For countless generations, Western man has been concerned about art, measured himself against it, consciously or unconsciously examined over and over again all cultural, legal, and epistemological principles in relation to its mysterious nature, its infinitely various and impenetrable existence; and now suddenly art must be exclusively Volkish in all its aspects without taking into consideration the condition of this *Volk*, whether it is declining, developing, stagnant, or furiously active. One ignored that a Volkish and anthropological loss of content had occurred which made any penetration into the material of earlier epochs impossible. Instead one violently attacked as abnormal and racially alien, anti-*Volk* an art which sought its material in its own inward life. One did not appreciate the elementary power and amazing intensity of its brilliant will to style, instead one complained about obvious difficulties by saying: it is purely subjective, unintelligible, crude; and especially: purely formalistic. These criticisms sound very paradoxical indeed coming from our contemporaries who work similarly in modern physics and have inflated their theories into such a big bag of hot air—filled with world-historical significance and exalted wisdom—that the readers of both morning and evening newspapers drool over the splitting of atoms. This monstrous science in which there are nothing but invisible concepts, ingenious abstractions; the whole thing, in Goethe's sense, a senselessly constructed world. To this theory, understood by only eight specialists, five of whom attack it, are dedicated villas, observatories, and Indian temples; however, if a poet submits to his very own experience of words, or a painter to his own love of color, it is anarchism, formalism, yes, even an insult to the *Volk*! Obviously, art must simply float through the air, free like a speck of dust, dropping down to earth outside of time, its determinants, its cultural and intellectual structures; obviously arrogant *Volk*-hating snobs are just peddling garbage. Obviously art, which is free, dare only offer to the public what has been a commonplace for twenty years in grade schools; but science which is astronomically expensive to the nation, to the provinces, to the public, to taxpayers, can fuss with its specialized humbug among widows and orphans. Certainly the new Germany will not

tolerate such a paradox. Our leaders, themselves artists or artistically inclined, know too much about art and about the hybrid character of all synthetic activities not to know also that art too has a specialized aspect, and that this specialized aspect in certain critical periods must be especially active and that art's relationship to life cannot always be a matter of directly representing everyday appearances. Actually, no one, not even its opponents, dares challenge the identity of Expressionism with its period and that period's undisputed achievements and its style which was not considered alien to the *Volk:* it was the aesthetic equivalent of modern physics and its abstract interpretation of the world, the expressive parallel of non-Euclidian geometry which had abandoned the 2000-year-old classical world in favor of irreal spaces.

IV

Actually, no other explanation is possible. Everything which has been interesting, even meaningful in European art for the past twenty years has been genetically related to Expressionism. Now we can attack this European world, and I do so with all my heart for historical and for intellectual–spiritual reasons; but we have to look the past straight in the face: here the old Europe proposed one more new style, a style brought forth by its liberal–individualistic spirit, and everything based upon classical, romantic, and naturalistic points of view was profoundly transformed. What Expressionism might have achieved if the war and history had not interfered can only be a subject for utopian and individualistic speculation. But I am positive, and others agree with me, that all the genuine Expressionists of my generation experienced what I have experienced: precisely they out of the chaos of their life and times experienced an evolution subject to the most urgent inner necessity not given to other generations, an evolution toward a new order and new historical meaning. At this point, in reaction to the irrationalism, violence, and ecstasy which possessed us and surrounded us, an overpowering need for form and for discipline arose. It was precisely the Expressionist who most appreciated the profound objective necessity of technical matters in art, the ethos of craftsmanship, the ethics of form. He demands discipline because he was the most undisciplined; and not one of them, whether painters, composers,

or poets would wish the myth to end in any other way than that
Dionysos should find his final rest at the feet of the serene Delphic
god.*

Expressionism then was art, the last art of Europe, her last breath
as everywhere a long, magnificent, aged epoch died away. An epoch
with Art, now forever over and done with! The early Greeks did not
have art, instead they had holy and political stone carving, odes made
to order, ritualistic arrangements. It began with Aeschylos, then 2000
years of Art. Now it is all a thing of the past. What is now beginning,
what is now making its first appearance is no longer art; it is more and
it is less but now we can only speculate. In what follows if I say art,
I am talking about a phenomenon that belongs to history.

V

There is, however, one legitimate criticism which can be leveled
against the very essence of this last and final style—it did not assume
a historical Volkish mission; it spent its last years disinterested in
politics. But this unpolitical point of view was very much a part of
our tradition: Goethe, Hölderlin, Rilke, George. Moreover, in our
formative years, there was that grand and wonderful Germany intoxi-
cated with its joy and freedom which did not require our attention
when we painted and wrote. Then came the war and, as has been
mentioned, the Expressionists took from it their share. And in those
years politics meant Marxism, meant Russia, the murder of the bour-
geoisie and the intellectuals, the murder of all art as "private idiocy"
(Tretjakow), meant antiheroism, dialectical twaddle, and that func-
tionalism which I have already discussed. This destructive approach
was opposed by Expressionism by means (inner and outer means)
which were not political, namely with a formal absolutism which ex-
cluded all chaos. A few novelists wrote political propaganda, they
tried to subdue history with words and in parliamentarism they found
a satisfying parallel to the wordiness of their epic prose. But the Ex-
pressionists were not interested in society small talk, they were inter-
ested in an abstract world. They made art.

Admittedly, they had no instinct for politics. And perhaps they had

* Apollo.

a shocking number of biologically defective qualities, also moral weak-
nesses, yes, and some had criminal tendencies, that has been demon-
strated, I won't deny it. But as for such epithets like "deserters, con-
victs, criminals, degenerates, libertines, trash, and swindlers," the
question arises as to whether or not all artists did not look like that
from close up? There has been no reasonable and cultivated art since
Florence, none, none which developed with full public approval and
in terms of an established set of values; for centuries art has been an
art of reaction and an art of genesis. Later, when an epoch comes
to an end, when the race is dead and the kings are at rest, and in the
entrance hall the servants lie asleep forever, when kingdoms have col-
lapsed and even the ruins standing between the eternal seas have
crumbled to dust, then in retrospect everything seems to have been
beautifully ordered, as if one had only to reach up to snatch a ready-
made crown, magnificent and gleaming; but all that actually was
achieved through bloody struggle and terrible sacrifice, torn from the
underworld and wrestled out of the shadows. Perhaps we waste too
much time these days with the degenerates and refuse to recognize
that here too several works and several men will survive; their ex-
pressive method has raised their spirit and the disintegrating, suffer-
ing, shattered existence of their century into those spheres of form
where above ruined cities and destroyed empires only the artist can
give human immortality to an epoch and a people. I believe it, and
I am convinced that those whom I see coming after us will also be-
lieve it.

Never again will there be art in the sense of the past 500 years;
Expressionism was its last phase; our spiritual condition simply can-
not be conceived as too critical, or too final; total transformation lies
ahead of us; a new race will appear in Europe. Many friends of the
National Socialist [i.e., Nazi] movement are skeptical about this move-
ment's theories of race and breeding; they claim that those ideas are
too naturalistic, too materialistic—we would rather sit around the
table and dream while the ravens circle about and Barbarossa's beard
grows through the stone. But I say that you cannot view these matters
too naturalistically, in fact, you can view them only naturalistically;
propaganda affects the germ cells; the word influences the genitals,
no doubt about it; nature's cruelest fact is that brain life changes the
character of the germ cells, that the spirit is an active and organizing

force in the evoltuion of life: there is unity here: what is defined po-
litically will be developed organically.

What is defined politically will not be art but a completely new
though already quite recognizable race. I have no doubt that the
Ghibelline synthesis of which Evola spoke is approaching politically
that moment when Odin's eagles fly to meet the eagles of the Roman
legions. This eagle as a coat of arms, the crown as mythos and several
great intellects as the world's spiritual inspiration. Mythologically
this means: the return home of the Norse gods, white man's earth
from Thule to Avalun, imperial symbols there: torches and axes, and
the breeding of superior races, solar elites for a world half-Doric, half-
magical. Infinite distances being filled with possibilities! Not art.
Ritual around torches and fire. There were three great periods of
genius for the German people: 1500, with innumerable painters in
their midst, second only to those of the Mediterranean; the seven-
teenth and eighteenth centuries filled with music. Poetry began in the
eighteenth century, it was the beginning of a long period which ex-
tended up to the present day; Expressionism was its extreme projec-
tion, a kind of *Monts Maudis*—a naked Inferno, perhaps, but still
part of that great epoch. Now a pause for two or three generations
and then the fourth age will begin, there are dreams and visions—
it is approaching, difficult to grasp—God.

The race, there it is: in spirit and deed, transcendental realism or
heroic nihilism, these marks of a tragic and individualistic era cannot
be completely eradicated; but all in all this race is profoundly fortu-
nate in comparison to us, their individuality will have balance, be
more universal than Faustian. The architecture of the South, fused
with the lyricism of the Northern foglands; the stature of the Atlan-
tids, their symbols will become grand songs, oratorios in Amphithea-
ters, choirs of fishermen, symphonies of conch shells, in limestone halls
blending with the horns of primeval hunters. Infinite distances being
filled, a great style approaching.

The race, there it is: it looks back in time: *our* century, *Götter-
dämmerung, Ragnarökr*—"humane" and liberal times: perfunctory
and vague ideas about everything; nothing is seen round and whole.
Nothing clearly defined, everything ideological, evasion everywhere.
But one group hammers away at the Absolute—succumbing to it yet
transcending it spiritually in hard, abstract forms: image and verse
and flute melody. Poor and clean, disdaining bourgeois interest in

fame, in the wealth of a guzzling rabble. They live off of shadows, they make art. Yes, this tiny group in the face of the ultimate transformation of whole worlds lives art, which is to say: lives ready for death, lives sustained by Germany's devout blood.

Klaus Berger

"The Heritage of Expressionism"

"Today we now know whose spiritual child Expressionism was and, when followed to its ultimate conclusion, exactly where it led: to fascism."—This was the brilliant thesis propounded by Bernhard Ziegler with such impressive hate-love à la Gottfried Benn in the September [1937] issue of this publication [*Das Wort*].

It is a fact, of course, that the Expressionist Benn marched straight to Goebbels. However, the game didn't amuse him and he stopped playing. Gerhart Hauptmann traveled the same route but on his hands and knees; but does this make the *Weavers* fascist? Johannes R. Becher came over to us from Expressionism while Franz Werfel got all the way up to the dear Lord in Heaven. But none of this proves anything about the sociological foundations of this "European style." After all, the sociology of art isn't a political address book.

It is a complete waste of time to examine the single case of Benn in order to uncover the influences of army life, the border territories, and confused cultural values. What is really involved here is the Expressionist movement.

This movement really defined itself on the eve of the war, before there was any talk about fascism. It continued until the mid-'20s. And it wasn't limited to Germany; Italy and Russia were also involved. However, France preferred Cubism and kept itself more-or-less aloof from Expressionism.

Historical materialism teaches us to examine basic principles and thus puts us on the right track: *Expressionism develops when capitalism enters its imperialistic phase and develops revolutionary tensions and possibilities*. After "stabilization" the movement simply has to give up. In Italy the boss of the Futurists and destroyer of museums, Marinetti, became a "Classicist" and the general director of museums. Ten years later Hitler made pseudo-classicism—pasted columns and all—his official style. The Expressionists were relegated to a museum for degenerate art.

Actually Expressionism is no style in the real sense of the word. Style is the expression of a particular social reality; Expressionism

merely suggested revolutionary possibilities and it persisted in Italy, Germany, and Russia only until 1923 (heroic epochs of revolution and war-communism). After that it was liquidated.

Impressionism was supported by liberal finance capitalism as it blossomed during the last third of the past century; its ideology penetrated all the way down to the petit-bourgeoisie; and little by little even the philistines reconciled themselves to it. Impressionism was a real style.

But Expressionism was and always will be an affront to the middle class; it is "unintelligible." To put it briefly, as far as a social base is concerned, Expressionism floats. It and other avant-garde movements lack a foundation upon which they can "realize" themselves. The superstructure simply hangs there; it is more advanced than the economy. If the expected revolution fails, it is hardly the fault of Expressionism. This situation can best be compared to what happened in France in the eighteenth century. There, an intellectual and an artistic revolution anticipated social upheaval from 1750 on. And revolution came, back then; but in our own day it didn't.

But back then, just as now, destructive criticism was more powerful than positive achievement. Anyone who wants to build up must first tear down, and tear down intelligently. The "self-destructiveness of bourgeois thought" for which Bernhard Ziegler criticizes Expressionism could have been very creative and could have cleared the way for a new world; and actually this is what was happening in many of the strong works. Furthermore, we shouldn't forget that art, visual art, even as a creative process, is always destructive. Every heritage, insofar as it is actively developed, is destroyed, is in fact vital only as a process of continuous destruction.

That a few Expressionists became fascists is no more consequential than the fact that others became communists. Expressionism collapsed and failed in 1925 because without the support of successful political action it could not destroy the bourgeoisie. I don't want to identify Expressionism with socialism completely. I only want to claim: in every revolutionary situation between 1910 and 1925 Expressionism was a good *beginning* for socialistic development, especially when compared to the heritage of bourgeois art. Expressionism can never serve fascism because fascism seeks its ideological supports (as far as cultural heritage is concerned) in styles which antedate fully developed capitalism—in the columns of classicism (just as political reac-

tionaries did 100 years earlier), in absolutistic and emotional Baroque modes, in the guild spirit of the old German masters.

If one were to follow Ziegler's line of thought, every artistic accomplishment of our century, including the Bauhaus and all of its achievements, all the leftist avant-garde efforts to overcome the corrupt ideas of the nineteenth century, all of this only helped Nazi barbarism to succeed. If Expressionism as such is a completely corrupt heritage, and the nineteenth century as well, then the future must belong to those who go back the farthest for their "good" heritage I would rather not trace out the implications of this race back into history which some wish to run with the fascists.

Well, what then?

No doubt about it, in the destruction of nineteenth-century values Expressionism had its positive side, it had many successes and it posed many timely questions, although it did not always give satisfactory answers to those questions. Before we write off Expressionism and discard it completely in order to jump back 150 years, let us examine it very closely and profoundly, and then surpass it honorably (in the three-fold Hegelian-Marxist sense of the word)! *

It is in this sense that our mission must be to cultivate the heritage of Expressionism.

Many of its former vanguard champions took this very path; let us follow their example. Picasso's struggle for Spain is of exemplary significance. The German Expressionist painters, the architects of the avant-garde, oppose Hitler, and this without prearrangement. Now let us create the ideological preconditions which will enable them to join the Peoples' Front. After all, Expressionism was first and foremost the noble spirit of our twentieth century. Its descendants must and will be on our side. To succumb to the leveling and reductive tendencies of the Nazis would be wrong politically, socially, and artistically. Instead, let's occupy this high ground and cultivate it. It will bring us just that much closer to complete victory.

* The word translated "surpass" is *aufheben* in German, meaning (1) to negate, (2) to elevate, (3) to preserve.

Ernst Barlach

Letter to Otto Nagel *

Güstrow, May 6, 1934

Dear Colleague,

I would like to answer you and thank you in detail but these few words will have to do, otherwise it won't get done at all. Answers which are postponed usually stay that way. There are certain formulations which I could use, but they wouldn't agree with you or me since my letters are often intercepted and opened. Anyway, I've risked these formulations many a time—so let's forget about them today. But meanwhile there is no need to suppress the observation that after living in Germany for sixty years one has to be told now how to be German. Of course you and Frau Kollwitz feel the same way. We don't have to waste time about this. Various demands have been made upon me from various directions and I've heard some really surprising things about myself—even a few kind things. All and all, this uproar has aged me. I just hope that things aren't as bad with Nolde as you indicate. But these days nothing surprises me—and the way death has made itself at home among my friends! It's a miracle that I'm still alive, but why should we marvel about something that unimportant? Overnight the point can be reached where one can say: "Enough, I don't want any more." Still—you must go on, it is an uncompromising "must." In the last ten years I've seen almost no exhibits, but I know that yours count; only now I am no longer able to run my eye over occasional reproductions of your works. People are always telling me that things will be different in a little while. But I can't imagine what this "different" could be like; meanwhile, nothing is more certain than change. The man who said that, though, can't be gotten hold of. I'm still in the Academy, but of course I'm completely inactive.† However, I still look forward to opportunities,

* Ernst Barlach, Brief an Otto Nagel, in *Die Briefe, 1925–1938*, Vol. II (München: R. Piper Co Verlag, 1969). Copyright © 1969 R. Piper Co Verlag. Translated for this volume by the editor with permission of the publisher.

Otto Nagel (b. 1894), painter, printmaker, and writer on art; one of Käthe Kollwitz' closest friends.

† Barlach was expelled from the Academy in 1937.

just like those in other respects, since in spite of my age I'm still eager
to produce something really worthwhile. The few opportunities I've
had until now (I could cite several from Mecklenburg) were basically
trifles. I don't want to be scalped over nothing. It has to be worth-
while. All my best to Frau Kollwitz and tell her that my apparent
lordly position here by the sea and the forest is only a facade but also
that the ship which almost sank this winter is now sufficiently ship-
shape so that one can steer a course with it.

All my best wishes to you! Sincerely,

E. BARLACH

Letter to Hans Barlach*

Bad Harzburg, February 9, 1938

. . . Meanwhile they have decided to remove my work from the war
memorial in Hamburg. When that's done all my larger works will have
been disposed of and obliterated. In Magdeburg, Lübeck, Kiel, Güs-
trow, and Hamburg. My other works in museums have also been re-
moved. I'm not complaining, but I'm not in the least repentant or
reformed.

* Ernst Barlach, Brief an Hans Barlach, *In Die Briefe, 1925–1938*, Vol. II (Mün-
chen: R. Piper Co Verlag, 1969). Copyright © R. Piper Co Verlag. Translated for
this volume by the editor with permission of the publisher.

Hans Barlach, the artist's brother.

Emil Nolde

To Dr. Josef Goebbels, the Minister for Information and Propaganda, Berlin*

<div align="right">

Seebüll bei Neukirchen
July 2, 1938
</div>

Most honored Herr Minister.

When North Schleswig was ceded to Denmark I became a Danish citizen and as part of the German minority there joined the N.S.D.A.P.N.† I respectfully request, according to law, that my pictures be returned to me. They are the following:

> A nine part work: *The Life of Christ* (9 pictures)
> *Large Sunflowers*
> *Blonde Girl*
> *Wet Day*

and also the watercolor with tulips and amaryllis (on loan, Moritzburg Museum, Halle).

I also request, most honored Herr Minister, that the defamation raised against me cease. This I find especially cruel, particularly since even before the National Socialist [Nazi] movement I, virtually alone among German artists, fought publicly against the foreign domination of German art, against the corruption of art dealers and against the intrigues of the Liebermann and Cassierer era. It was a battle against vastly superior forces which for decades hurt me financially and professionally.

When National Socialism also labeled me and my art "degenerate" and "decadent," I felt this to be a profound misunderstanding because it is just not so. My art is German, strong, austere, and sincere.

After the cession of North Schleswig it would have been easy for me to become a world-famous artist for political reasons, if I had not placed my loyalty to Germany ahead of all other things, and if I had not taken

* From Diether Schmidt, ed., *In letzter Stunde, 1933–1945* (Dresden, 1964), p. 152f. Translated for this volume by the editor with gracious permission of Stiftung Seebüll Ada and Emil Nolde.

† The Nazi Party.

every opportunity at home and abroad to fight for party and country; yes, in spite of my defamation, or because of it so much the more, I could testify to the world-historical significance of National Socialism.

Certainly I may hope that my request will be granted.

Heil Hitler
EMIL NOLDE

"The Second World War" (circa 1945) *

. . . I don't want to write about the war. One night a gentleman said to me: "Artists are nothing but children." He didn't know I was a painter. Only I will say a few words about causes and results and a little about my own losses.

Revolutionary upheaval in Germany swept into power a class of people which previously had never been noticed. People in trouble, failures and adventurers, and also young, inexperienced idealists joined together and followed the parade.

We artists who mostly lived in another world could not avoid these stormy events. We also had faith, faith in what was good. And what was evil had been disguised. But as time passed, little by little, we were forced to admit that the evils, the difficulties we suffered in our own profession were no exceptions. Utterly astonished we heard of a scientist, a doctor, a businessman, yes even an inventor who was treated just as we artists were. There were no exceptions. The best people were removed and persecuted by their inferiors. I became convinced that any regime which deliberately suppressed what was unique and superior had to collapse. And collapse it did, along with the whole German nation, along with all its citizens, the few who were truly wonderful, the many who were harmlessly ordinary and the evil ones.

The German people have been endowed with the lowest and with the highest qualities, with the most gruesome instincts but also with a most noble spirituality. It is a wide range, probably wider than that of any other people—and, as a terrible consequence, furious struggles within and without, revolutions and wars.

Germany now lies prostrate, crushed, and shattered. Everything

* Emil Nolde, "The Second World War," *Reisen, Ächtung, Befreiung, 1919–1946* (Köln, 1967), p. 129ff. Translated for this volume by the editor with gracious permission of Stiftung Seebüll Ada und Emil Nolde.

which made life worthwhile has vanished. Where in your desperation dare you look for help?

Dare one assume that out of all this pain, out of the deepest depths there might possibly develop a fresh young, unknown German spirituality?

. . . Our beautiful home on Bayernallee was destroyed by bombs. . . . we lost watercolors, drawings, and prints by Kokoschka, Klee, Jawlensky, Feininger, Rohlfs, Nauen, Pechstein, Heckel, Schmidt-Rottluff and Kirchner, Werner Scholz, Gustav Wolf, Philipp Harth, lithographs by Daumier and Gauguin, Josephson's colored drawings, and a few other things. It grieves me that I was unable to protect them.

The war raged on mercilessly, destroying everything. New, monstrously powerful weapons were promised; a consolation and encouragement which kept the war going. The big cities and their large populations suffered severely. More and more of Germany's beautiful old towns went up in flames. Transportation and communication broke down. Masses of refugees rolled in from the east. Germany with its fanatic and inadequate leadership was defeated. Air power ended the war. Germany's defeat was horrifying and total.

And what if we had won the war? Germany's spirituality—her most beautiful attribute—would then have been utterly eradicated.